Home
artist

DATE DUE

Home

artist

Learn to Draw and Paint in 20 Easy Lessons

Reader's Digest

The Reader's Digest Association, Inc.
Pleasantville, NY/Montreal/Sydney/London/Singapore

A READER'S DIGEST BOOK

This edition published by The Reader's Digest Association, Inc., by arrangement with Amber Books Ltd.

FOR AMBER
Project Editor: Sarah Uttridge
Design: Hawes Design

FOR READER'S DIGEST
U.S. Project Editor: Kimberly Casey
Copy Editor: Barbara Booth
Canadian Project Editor: Pamela Johnson
Australian Project Editor: Annette Carter
U.S. Project Designer: Mabel Zorzano
Associate Art Director: George McKeon
Executive Editor, Trade Publishing: Dolores York
Associate Publisher: Rosanne McManus
President and Publisher, Trade Publishing: Harold Clarke

Library of Congress Cataloging in Publication Data

Home artist: Learn to Draw and Paint in 20 Easy Lessons
 p. cm.
 Includes index.
 ISBN-13: 978-0-7621-0816-9
 ISBN-10: 0-7621-0816-9
 1. Art--Technique. I. Reader's Digest Association.

N7433.H66 2006
751.4--dc22

2006049393

Address any comments about *Home Artist* to:
 The Reader's Digest Association, Inc.
 Adult Trade Publishing
 Reader's Digest Road
 Pleasantville, NY 10570-7000

For more Reader's Digest products and information, visit our website:
 www.rd.com (in the United States)
 www.readersdigest.ca (in Canada)
 www.readersdigest.co.uk (in the UK)
 www.readersdigest.com.au (in Australia)
 www.readersdigest.com.nz (in New Zealand)
 www.rdasia.com (in Asia)

Printed in Singapore

1 3 5 7 9 10 8 6 4 2

A NOTE TO OUR READERS

The editors who produced this book have attempted to make the contents as accurate and correct as possible. Illustrations, photographs, and text have been carefully checked. All instructions should be reviewed and understood by the reader before undertaking any project. The directions and designs for the projects in this publication are under copyright. These projects may be reproduced for the reader's personal use or for gifts. Reproduction for sale or profit is forbidden by law.

Picture Credits: All © IMP

*"Art washes from the soul
the dust of everyday life"*

—Pablo Picasso

contents

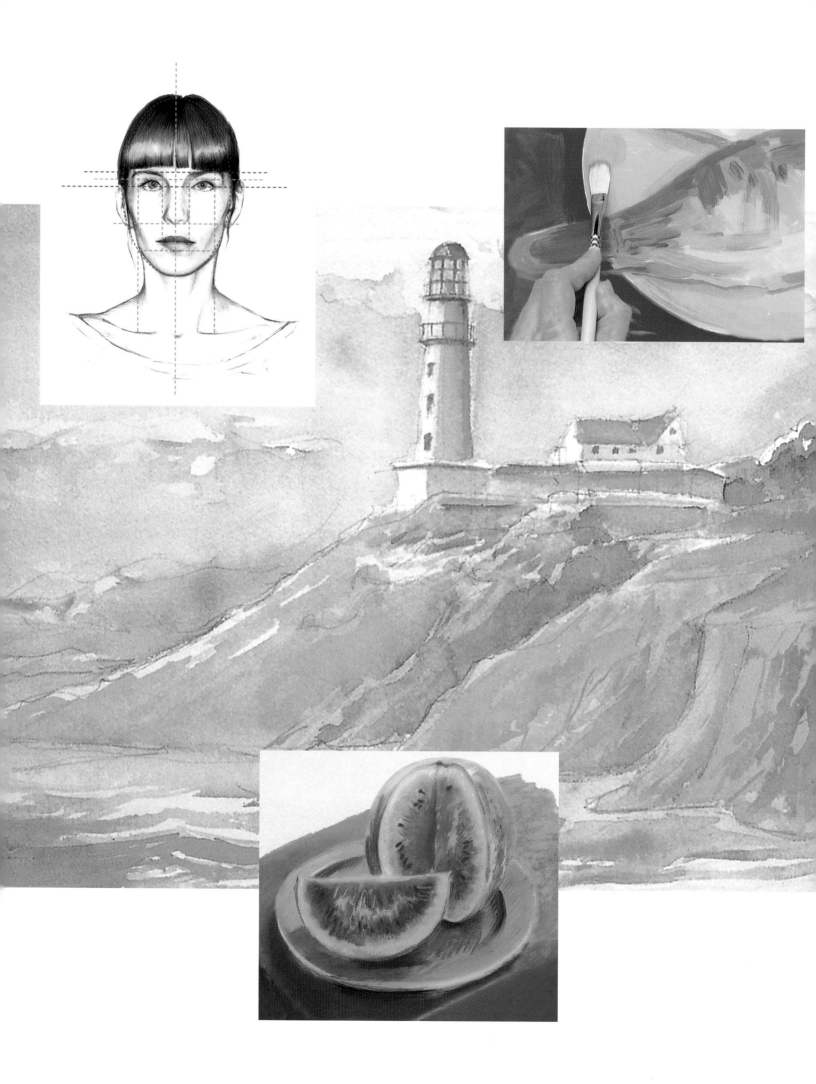

introduction

Welcome to *Home Artist*. Whether you're a beginner or you're simply looking to broaden your skills, this is an ideal place to start. This book covers a wide variety of media, including oil, watercolor, pastel, pencil, charcoal, acrylic, gouache and collage. Each technique is clearly explained clearly and includes plenty of visual examples, providing all the information you need to get started right away. There's a plethora of useful tips from experienced artists, along with practical advice on subjects like selecting the right kind of paper or brushes to creating the perfect workspace.

In the second half of the book you'll find 20 creative projects to help you practice and develop the techniques and skills learned in the earlier chapters. Each of these includes suggestions on how you can apply the methods to your own artwork.

Filled with step-by-step instructions and engaging little-known facts, *Home Artist* is a valuable resource you'll refer back to again and again.

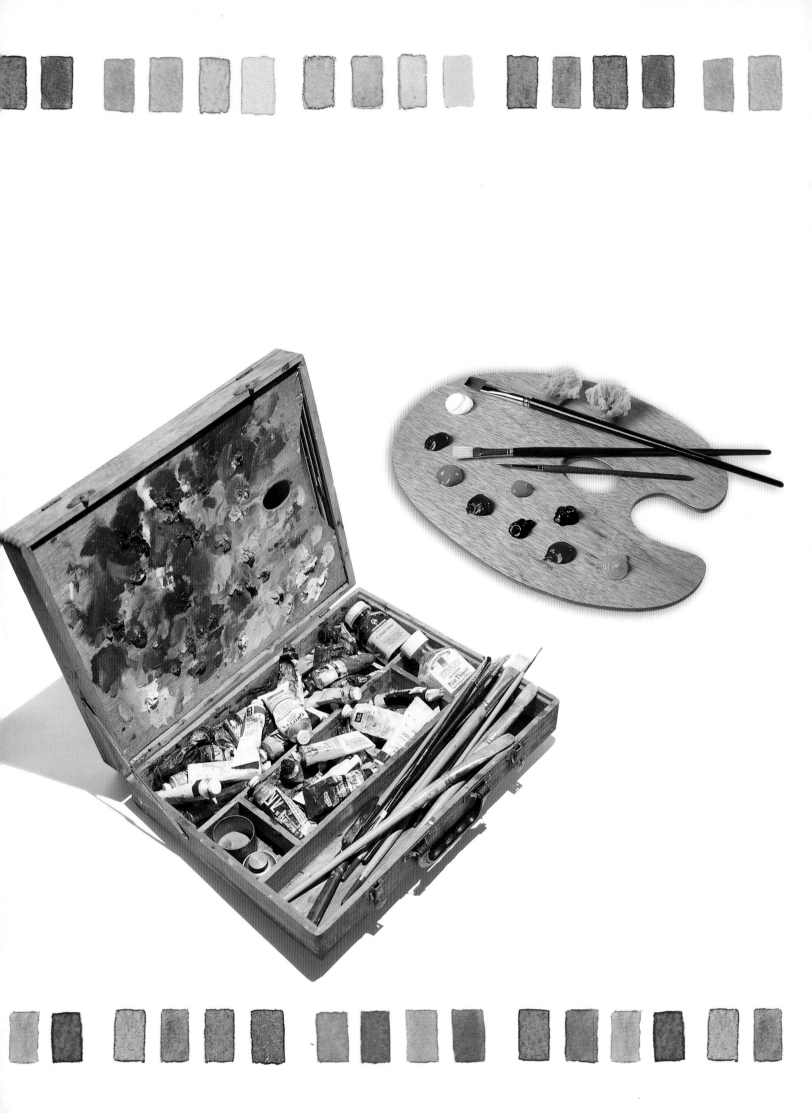

getting started

Getting started can seem overwhelming when you're an absolute beginner, but this section provides a reassuringly straightforward introduction to the media and techniques covered in this book. Whether you're wondering about the difference between oils and acrylics, how to use pastels or what exactly mixed media means, you'll find all of the answers here. There's also a handy list of the basic materials and equipment you'll need for each technique and a look at practical issues, such as creating a work space and framing your finished artwork.

Drawing

RAWING IS THE SIMPLEST, quickest way to put your ideas on paper—and it's often the safest way to start a painting, too. In this book you'll find out how to make all kinds of drawings, from quick sketches to finished pictures, using a full range of drawing media, including pencil, pen and ink, charcoal, colored pencil and Conté crayon. And if you're one of those people who thinks they can't draw, don't worry—we've developed a whole range of tried-and-tested techniques to help you, from working with simple shapes to working out perspective lines.

Artist's viewing grid

Shaping up

Discover how combining simple geometric shapes can improve your drawing technique.

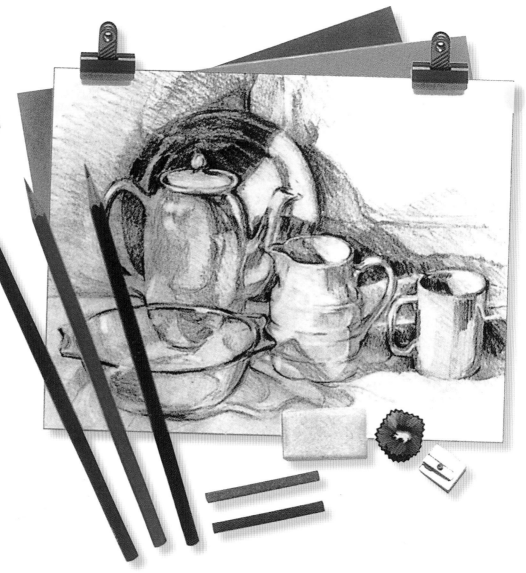

The Basics

- HB, 2B and 4B pencils
- rollerball or felt-tip pen
- set of colored pencils
- putty eraser
- 8½ x 11 in. (A4) size spiral-bound artist's sketchbook

12

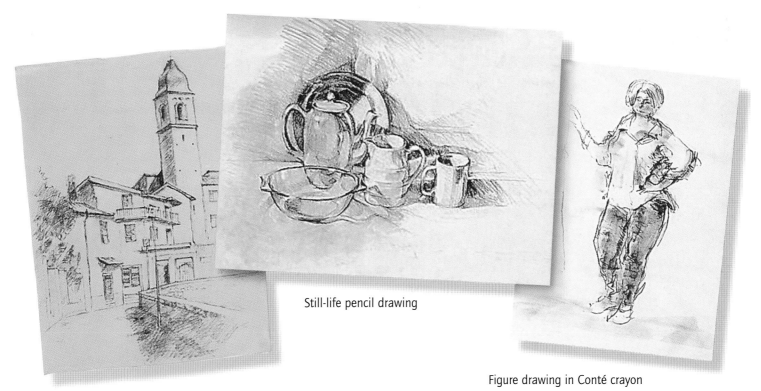

Still-life pencil drawing

Pencil drawing on colored ground

Figure drawing in Conté crayon

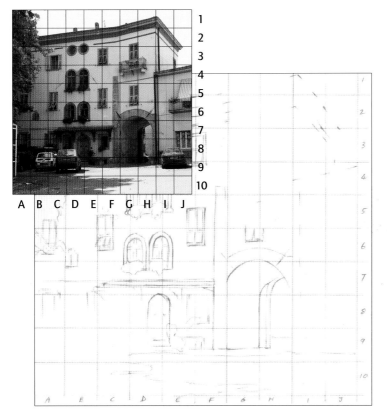

Can't Draw, Won't Draw!

You will discover how easy it is to boost your drawing confidence by using a simple grid method to transfer what you see to your paper, one square at a time.

Crosshatching

Using fine lines to create areas of light and shade is just one of the many techniques you'll learn for creating more lifelike drawings.

Watercolors

THIS SECTION covers both transparent watercolor and its opaque cousin, gouache. Both media are as much about technique as they are about materials, which means that although you'll soon be producing great-looking pictures, the challenges and possibilities remain almost infinite. Fortunately, those challenges don't extend to paper: Modern watercolor sheets are sold in blocks of various weights, and if you stick to a heavier weight, there's no need to stretch the paper before you start painting.

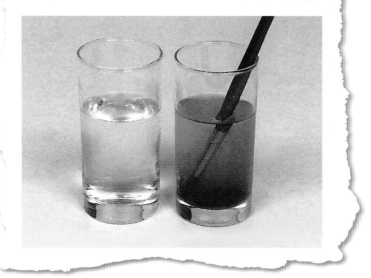

Expert Tip

Keep your brushes and colors clean by painting with two jars of water.

Paint Know-How

Watercolor paint comes packaged in tubes as well as in traditional pans. Tube paint is more easily soluble, making it a better choice for painting large areas of flat color. Watercolors also come in two grades: The less-expensive student-quality paints are fine if you're starting out, but you'll find that the colors of artist-quality paints are much purer and deeper.

The Basics

- box of pan colors or 6–8 small tubes
- block of heavyweight paper
- small round and medium flat brushes

Monochrome still-life study in
two tones

Flower study in three colors

Seascape painted using washes of
overlaid color

A Layer at a Time

The trick is to build up the transparent paint
a layer at a time so that the underlying colors
show through.

Finishing Touches

Then, as a painting nears completion, you
can brush in the finer details using less dilute
mixtures of paint.

White's All Right!

Another key watercolor technique is to let the white of the paper
shine through thin, transparent washes of color. It saves on paint,
and the results can be stunning.

Oils and Acrylics

The Basics

- 10–12 tubes of color
- small round, two medium- and two large-bristle brushes
- oil paper
- turpentine
- palette

Expressive Medium

For surface texture and expressive brushwork, oils are hard to beat.

FOR TEXTURE, VERSATILITY of expression and sheer tactile pleasure, it's hard to beat oil paints or their modern cousins, acrylics. With slow-drying oils you can play with colors and correct mistakes on the canvas. Acrylics are cleaner to work with and can be used thickly, like oils, or watered down like watercolors. Although they require a little more investment, both media work as well on inexpensive oil paper as they do on canvas or wooden board, and both employ the same equipment. To keep your starting costs even lower, buy small tubes or try mixing your own colors using the tips and techniques in the upcoming chapters.

16

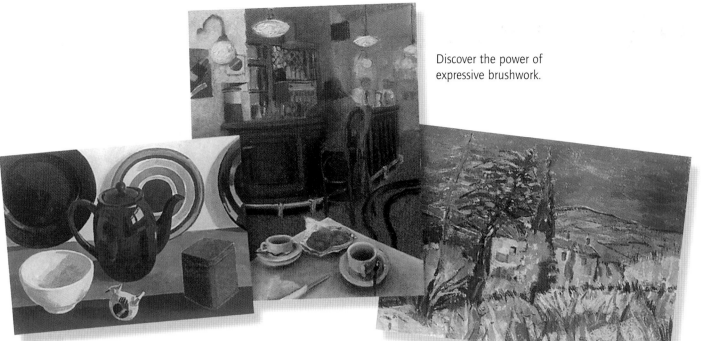

Discover the power of expressive brushwork.

Master the art of using saturated color in acrylics.

Learn how warm and cool colors create perspective.

Slap It On!

Both oils and acrylics can be applied thickly to bring surface texture to your paintings.

Play Away!

With oils you can mix colors, adjust details and hide mistakes while the paint is still drying.

Pastels

PASTELS ARE STICKS of pure pigment bound in gum or oil. You can draw with them, use their full length to lay broad areas of flat color, or grind them into powder and spread it around. The only other equipment you need is a pad of textured pastel paper, which has a rough surface to grip the pigment dust, and spray-on fixative to hold the dust in place (hair spray makes a good substitute). Pastels are not only easy to use, they are also renowned for their vibrancy. On page 118 you will learn how to make the most of them and the possibilities they offer.

Get Set, Go!

You can buy pastels in boxed sets or choose a few basic colors and blend them to make others.

Choices Galore

Pastels come in more than 80 colors and many different varieties, including soft, oil, hard, water soluble and pencils.

Fast Work

Oil pastels are one of the best mediums for sketching (below).

Lifelike

Discover how different strokes can be used to provide realistic textures (left and below) to your paintings.

Oil Pastels

Because they are bound in oil, the pigments of oil pastels can be physically blended on the paper in much the same way as paint.

The Basics

- set of soft pastels (there is currently no standard naming system for colors)
- textured pastel paper (available in a range of different colors)
- fixative or hair spray

Soft Pastels

These crumble on contact with the paper, enabling you to create and blend colors by mixing the dust with your fingers or a soft cloth.

Mixed Media

Traditionally, Mixed Media means combining two or more drawing or painting media in a single picture. Included in this section are guidelines on how to get started in a host of craft-oriented picture-making techniques, including collage, stenciling, printmaking and mosaics. And of course, they can all be practiced by trying out our specially commissioned step-by-step projects.

Fabric Fun

Appliqué—sticking fabric to paper or board—is simple, inexpensive and fun.

Fine Print

Blocks for the ever-popular medium of block printing can be home-made from a wide range of materials (left), including cardboard, plywood, plasticine and polystyrene packing.

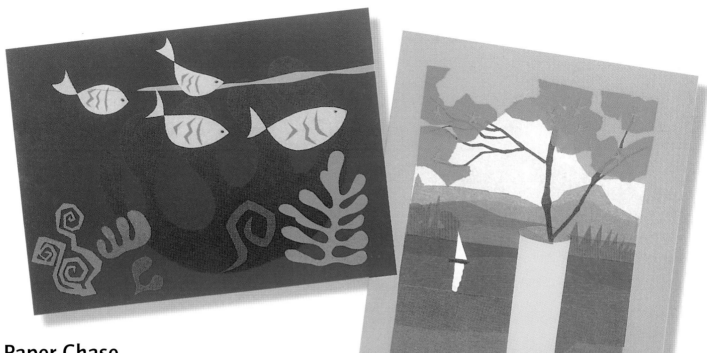

Paper Chase

Just two of the attractive paper collage projects featured in the Projects section on page 236.

Piece of Resistance

Learn how to use candle wax to resist layers of water-soluble paint to create uniquely subtle color effects.

Cut Above

The art of collage is inexpensive, easy to learn and extremely rewarding.

Stamps can be made from plastic erasers by drawing your design on the flat surface of the eraser and cutting around the pattern with a knife.

Setting Up Your Work Space

You may not have your own studio, but with good planning you can make the most of your existing space.

Expert Tip

Look after your brushes; in time well-cared-for brushes will adapt themselves to your style of painting.

A WELL-LIT CORNER near a window is the ideal place to work. If possible, choose somewhere out of the way where you can leave your pictures and equipment undisturbed by domestic routine. If you don't have space for an easel, you can easily work on a small board. Think about how you like to work, and lay things out where you can reach them. Make sure you have plenty of containers for clean water. You'll also need rags and tissues, and it's a good idea to lay cloths under your works-in-progress and materials.

Mounting and Framing

You've Been Framed!

Expensive, but well worth leaving to the professionals.

Expert Tip

Use L-shaped card croppers to determine the size of the frame mat (border).

PICTURE FRAMING is a specialty craft that's best left to the experts, who will also be able to advise on the best kind of frame for your work. A less-expensive option is to buy a ready-made frame or a framing kit, both of which are available in art-supply stores. As a general rule, choose a frame that's 2–3 in. (50–75 mm) larger all around than your work, with a mat (border) that picks up on or complements one of the dominant colors in the painting. If your work is in oils or acrylics, give the painting a coat of picture varnish before framing.

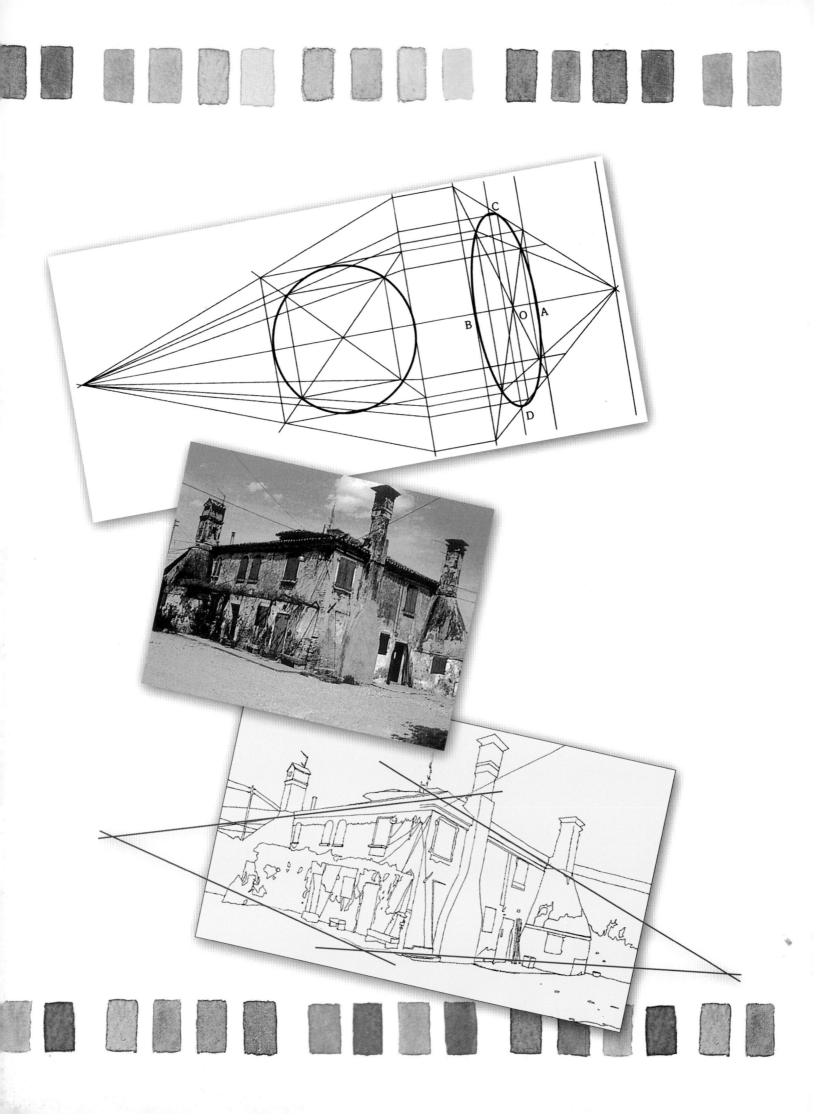

basic art principles

You've gathered your art materials together, decided on a subject, and you're ready to make a start, but before you jump in with both feet, take a few moments to think about the composition of your picture: How is it put together? This chapter covers some of the most useful basic principles to help you achieve this. As well as learning about color, perspective and the intriguingly named Golden Section, you'll discover why the things you don't see are just as important as the things you do.

pale

intense

Introduction to Color

WHEN IT COMES to color, a little scientific knowledge can help the artist go a long long way. To the scientist, colors are perceived by the eye as light reflected at different wavelengths. At one end of this visible spectrum of wavelengths is blue; at the other is red; in between is every color the eye has ever seen—or will see. To the artist colors are pigments—materials that reflect light at specific wavelengths, causing the eye to perceive them as colored. When pigments are mixed, so is the light reflected from them. So to truly understand color, you need to understand the behavior of light.

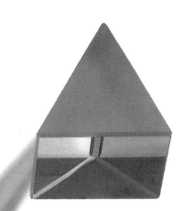

White Light

When white light passes through a prism (above), it is split into a spectrum of its component frequencies, producing colors. A rainbow is a naturally occurring example of this effect.

Pure Light

When all the different frequencies of light are combined, they cancel each other out—an effect the eye perceives as the "color" white.

Reflected Light

Colored pigments reflect light and absorb more and more of it when mixed. Ultimately, this results in no light—in other words, the "color" black (below).

Classnotes...

An understanding of the scientific background behind color immediately clarifies some of the terms artists use again and again to describe color—or more precisely, the pigments that are used to create color.

Color (hue): A description of the specific frequency of light reflected by a pigment, such as red.

Intensity (brilliance): The amount of light reflected by a pigment. This depends on the density of the pigment on the paper or canvas. The opposite of intense is pale.

Tone (value): The relative lightness or darkness of a color as perceived by the eye. Often confused with intensity, although an intense yellow will still be light in tone, and a pale indigo may well be dark. Because colors, when viewed in black and white, have different tones, color and tone are somewhat interchangeable. The terms are often used interchangeably as well, which adds to the confusion.

The Color Wheel

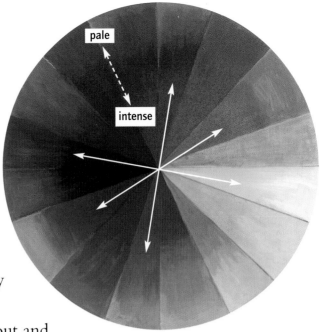

W HEN THE SCIENTIST'S color spectrum is turned full circle, it becomes the artist's color wheel—an object that expresses the fascinating relationships between different colors. To begin with, there are the three primary colors—red, yellow and blue—from which all other colors are mixed. Secondary colors—oranges, greens and violets—result from mixing two primaries. Tertiary colors result from mixing all three primaries; as their proportions increase, they begin to cancel each other out and eventually form a dark, almost black, brown. Colors toward the blue side of the spectrum wheel are known as cool, while those toward the red side are known as warm. And finally, directly opposite each other on the wheel, there are the pairs of complementary colors—red/green, violet/yellow and blue/orange—all of which have a special relationship.

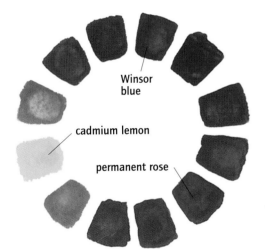

Primary Wheel

A color wheel mixed from three primary pigments— Winsor blue, permanent rose and cadmium lemon. In practice it's difficult to mix more than three colors from just three primary pigments.

Commercial Wheel

Here, colors come in a more varied range of pigments that can't easily be mixed. The range varies from medium to medium. But because no pigments are completely pure, the earthy neutrals in particular are very difficult to mix from primaries alone.

Classnotes...

Because pigments have natural imperfections, the light they reflect is never as pure as prism light—and the more pigments you mix together, the more their flaws can combine to make the color muddy. In theory you should be able to mix any color from the three primaries. In practice there is a point where you have to switch to nonprimary pigments (i.e. colors) or you will end up with a murky mess. Some hues, like cobalt blue, are impossible to mix from other colors. White and black are not really "colors" at all; they simply flatten everything they're mixed with.

Unmixable: Modern paints employ over 30,000 dyes, but some colors, such as cobalt blue (below), are impossible to mix from others.

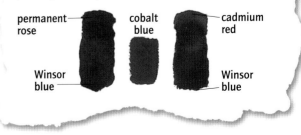

Warm and Cool Colors

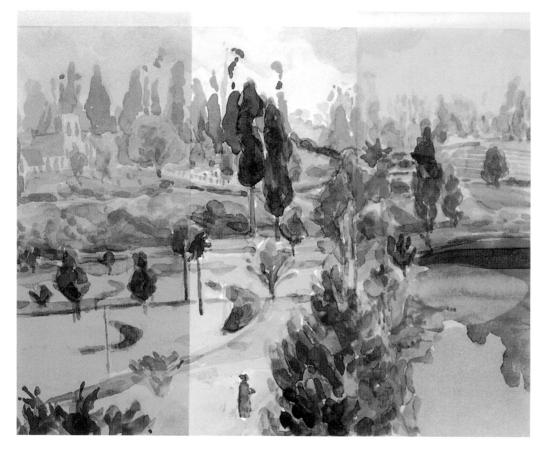

Because of its transparency, watercolor can exploit the properties of warm and cool better than any other medium. The outer thirds of this tropical landscape are overlaid with strips of tinted acetate to show how dramatically the mood of a painting can be altered with warm or cool washes of watercolor.

Blue acetate cools the scene to the point where it resembles the English countryside.

The central panel shows the actual painting without color adjustments.

Pale yellow acetate has a warming effect that conveys the impression of sweltering heat.

COLORS ARE LIKE PEOPLE: Some are dominant and attract attention; others just fade into the background. The colors that attract are the warm reds, yellows and oranges, while the cool blues and greens tend to recede from view. Watercolor is the perfect medium for using these properties of color to emphasize certain parts of a painting or to increase its sense of depth. By laying transparent washes, you can warm or cool entire areas with just a few brushstrokes to achieve almost magical effects.

Atmospheric Perspective
The warm colors in the foreground come forward while the misty blues in the distance appear to recede, creating the illusion of infinite depth and space.

Using Warm and Cool Colors

This painting of lemons in strong sunlight is predominantly warm in color, yet the artist still makes use of the principles of warm and cool colors to convey qualities of light and depth.

Choosing violet—the complementary of yellow—for the shadows creates a very simple yet convincing impression.

In the absence of perspective lines, the violet shadows also create a sense of depth.

The lemons are already a warm color. But the impression of strong sunlight is created by warming them even further with dashes of red.

Because warm colors attract, they tend to become the focus of attention and pull themselves into the foreground. They also have a natural link with sunlight, so areas that are warmed by the sun's rays tend to be similarly warm in color.

Cool colors have an association with distance and background because of the way the Earth's atmosphere distorts light and appears to make the colors of distant objects shift toward the cool (blue) part of the spectrum. Not surprisingly, cool colors also have an affinity with shadows. This effect becomes even more pronounced when a warm color is placed against its cool opposite, or complementary, on the color wheel: The cool one naturally becomes the shadow. In fact, all warm/cool relationships are like this; you can't see the effects of one without the other.

Nor are the effects solely reliant on the apparent colors of things. The beauty of watercolor is that when a transparent wash is laid over the top of any color, it warms or cools it according to its hue in much the same way as the sun pops out from, or slips behind, a cloud. Try re-creating this effect for yourself by laying a single wash over an old sketch. You'll find that your work takes on the kind of atmospheric quality that watercolorists enjoy.

Classnotes...

Although colors are said to be either warm or cool, in reality different hues of a primary color can have degrees of warmth or coolness, depending on their distance from the red (warm) or blue (cool) part of the color wheel. For example, cadmium red is a warm red, but alizarin crimson, which is closer to blue, is a cool red. Similarly, blues become warmer the closer they are to red. Yellows fall in between; they warm up as they approach red and cool down as they head toward blue. Warm reds, warm blues and pure yellows tend to advance; cool reds, pure blues and cool yellows tend to recede.

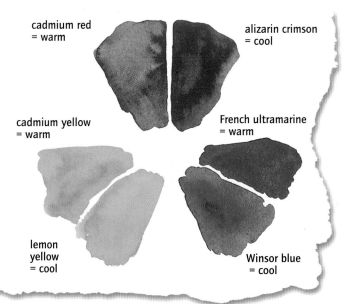

cadmium red = warm

alizarin crimson = cool

cadmium yellow = warm

French ultramarine = warm

lemon yellow = cool

Winsor blue = cool

High-Key Primaries

Watercolor primaries can be high-key (vibrant) or low-key (muted). The still life on the left was executed with the three high-key primaries permanent rose, cadmium lemon and Winsor blue. On the right are the same three colors in diminishing strengths.

permanent rose

cadmium lemon

Winsor blue

IN THEORY it is possible to mix any color using only the three primaries—red, yellow and blue. In reality the impurities in paint pigments make the task virtually impossible. Even so, a cool yellow, a crimson or bluish red and a pure, greenish blue will give you a basic high-key watercolor palette that is as vibrant as it is varied.

Classnotes...

For a balanced trio of high-key primaries, start by choosing a red. Permanent rose is a pure, transparent color on the crimson side. It doesn't fade, and it mixes well with both other primaries to make a range of oranges and violets according to strength. Cadmium lemon is less transparent but achieves a similar transparency on paper when diluted in a wash. Winsor blue is cool and transparent, with a high tinting strength. Its exceptional purity produces clean, bright mixtures. Another option is French ultramarine, which, like Winsor blue, is strong enough to hold its own in mixtures and produces rich deep-toned washes. When mixed with permanent rose, it yields a delightful purple, but because of its reddish tinge, the greens it produces when mixed with yellow can appear grayish.

Mixing the colors: When it comes to actually mixing the colors, remember that in watercolor you have two options—mix them physically in your pan, or optically, by laying a wash of one on top of another. For optical mixing it's generally best to follow the order yellow-red-blue.

Winsor blue

cadmium lemon

permanent rose

Secondary and Tertiary Combinations

Red and Yellow

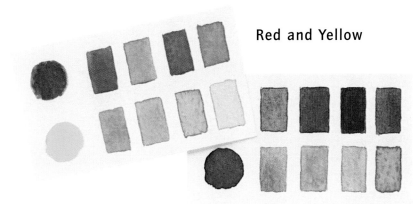

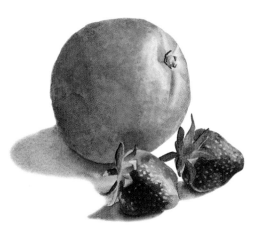

Secondary colors made by pairing permanent rose with cadmium lemon

Tertiary colors made by adding Winsor blue to the secondary mixtures

The result, aside from the stems, is a vibrant study in just two primary colors.

Red and Blue

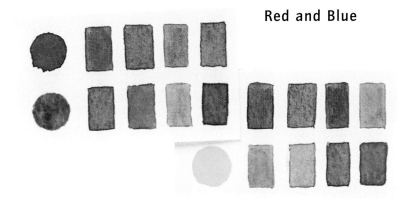

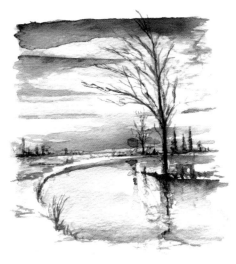

A landscape without green? Mixing permanent rose with Winsor blue yields a wealth of distinct and quite delightful violet and purple secondary colors. Add a splash of cadmium lemon for an even greater range of tertiary colors, while sacrificing little in the way of vibrancy.

Blue and Yellow

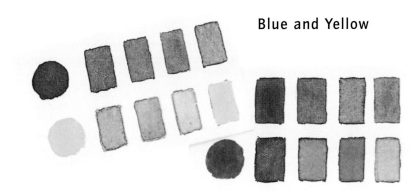

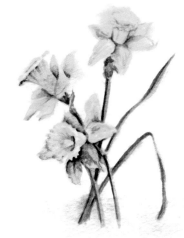

Winsor blue and cadmium lemon produce lively yet natural green secondaries that can be transformed with a dash of permanent rose into warm, earthy tertiary colors.

A spring flower sketch is produced using just the secondary colors from this vibrant blue and yellow pairing.

Linear Perspective

The picture plane is the framed area of what you see—a bit like a scene through a window.

HOW DO YOU represent three dimensions on a two-dimensional surface? In the West there is a system of rules for how shapes appear to recede into the distance, known as linear perspective. There are three types of linear perspective, each with their own rules, depending on where you stand relative to the picture plane—the imaginary two-dimensional surface on which the three-dimensional scene before you is superimposed. Once you know what these rules are, you can ensure that every shape you draw obeys them and that your compositions always look right.

One-Point Perspective

As you look straight ahead, the picture plane is what you see superimposed on an imaginary flat surface in front of you (left). At right angles to the picture plane is the ground plane—the imaginary flat surface on which you're standing. In one-point perspective all lines at right angles to the picture plane and parallel with the ground plane appear to converge at the same vanishing point on the horizon, which constitutes your center of vision.

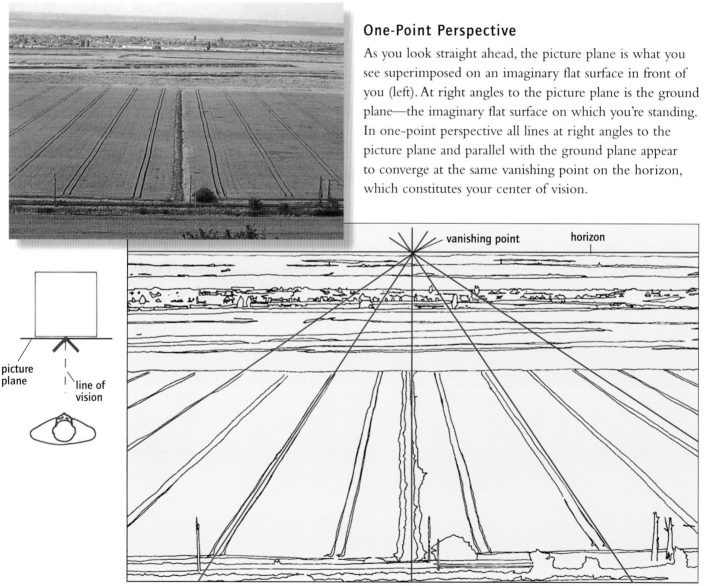

Two-Point Perspective

The two visible sides of this house are roughly 45 degrees to the picture plane. So instead of receding to a single vanishing point, each side recedes symmetrically toward vanishing points far to the left- and right-hand sides of the image. Both vanishing points still lie on the horizon line because the house sits on—and its walls are parallel with—the ground plane. If you imagine the house to be a cube (below), with you standing directly opposite, then the two vanishing points are equidistant from the point you are facing (the center of vision).

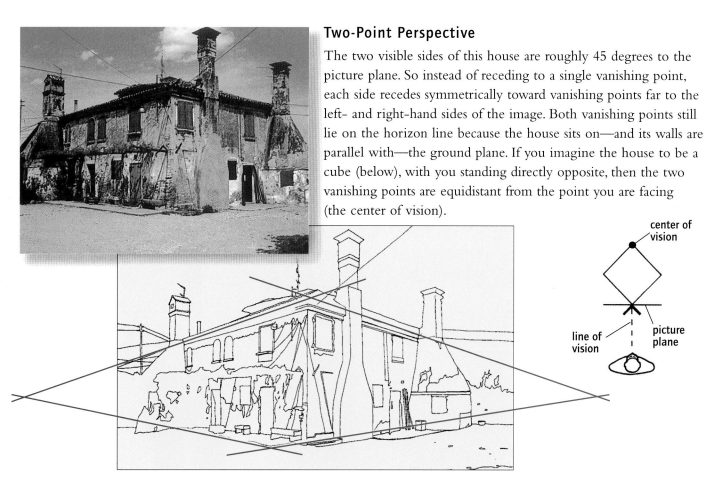

center of vision

line of vision

picture plane

Three-Point Perspective

If an image, such as a skyscraper, is so tall—or you are so close to it—that its vertical sides appear to converge and tilt backward into the picture plane, you need to employ three-point perspective. What is actually happening is that from where you are standing, the image (represented by the cube below) no longer sits on the ground plane, so none of its three planes lie parallel with or at right angles to the picture plane. As a result, you need to establish a third vanishing point for the third plane. In the image on the right, if you extended the vertical sides of the building, they would eventually meet at this third vanishing point.

to vanishing point no. 3

picture plane

ground plane

vanishing point no. 2

The Horizon Line

SOME ARTISTS COMPOSE landscapes instinctively, with an automatic understanding of how different elements change with viewpoint and perspective. But others prefer to apply a conscious process in which certain "rules" apply. Establishing the horizon line is the first step in this process, and it is the cornerstone on which the rules of perspective are based.

Horizon Line

This is the line at which the land or sea appears to meet the sky. From the viewer's perspective the horizon line is always at eye level; as one rises or lowers, so does the other.

Vanishing Point

This is the point at which any two or more parallel lines receding from the viewer appear to converge. In the example at right, the white path is uniform in width but appears to narrow the farther it is from the viewer until it vanishes completely. It is a rule of perspective that the vanishing point is always at eye level—and therefore, always on the horizon line.

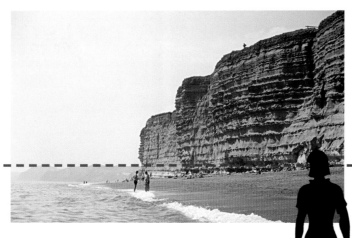

View From the Beach

Here, the horizon line is low, resulting in a correspondingly low viewpoint. Now the elements above the line—the sky and the line of the cliff tops—take prominence in the composition.

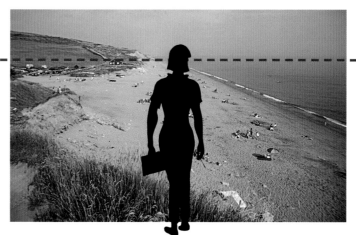

View From a Cliff

Because the horizon line is always at eye level, where you place it naturally determines your viewpoint of the scene. Here, the line is high and so is the viewpoint; you are looking down on the scene, and the ground takes prominence.

Points of View

Where you place the horizon line establishes your viewpoint. As these three paintings show, it also goes a long way toward determining which elements in the composition take prominence—and therefore how "involved" you are in the scene.

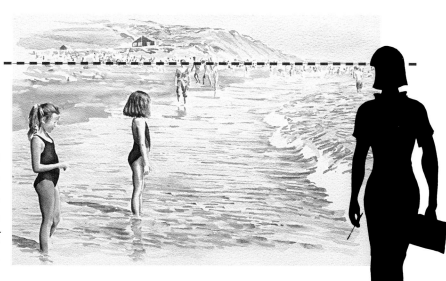

High Viewpoint: High Horizon

From a high viewpoint the artist is essentially an observer. Although the girls are in the foreground, they appear small relative to the background; the beach is the focus of the composition.

Mid Viewpoint: Mid Horizon

As the viewpoint lowers, the artist naturally becomes more involved in the scene. There is a shift of emphasis to the girls, even though they are roughly the same size as in the first painting.

Low Viewpoint: Low Horizon

From this low viewpoint the artist becomes deeply involved in the scene. The girls are now clearly the dominant element in the composition and are conveniently thrown into relief against the merging sea and sky.

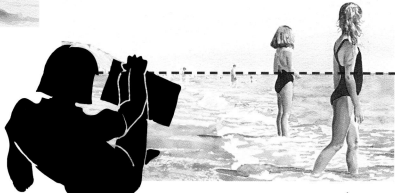

Did You Know?

Hidden Horizons

In cityscapes the horizon line (in red) is often obscured. But you can find it quite easily by following the lines of perspective (in blue) to their natural vanishing point and then drawing a horizontal line at this point.

Negative Shapes

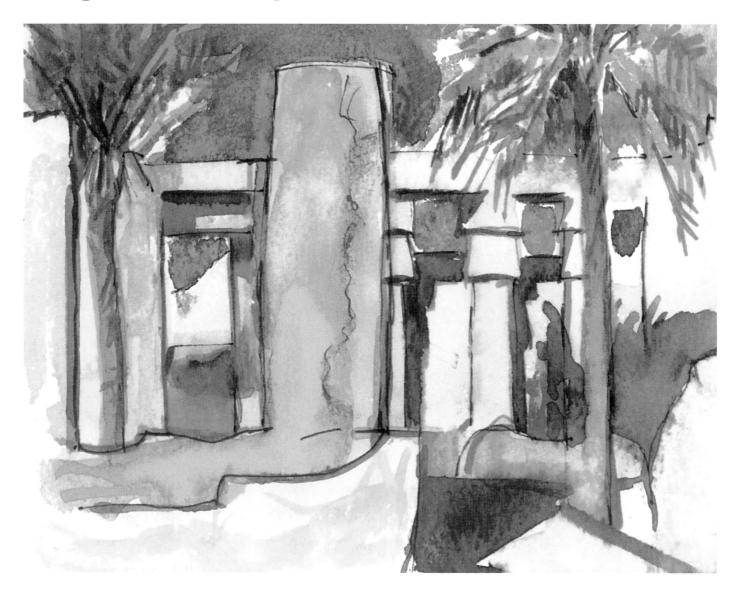

THE BOLD, THEATRICAL ARCHES of an Egyptian temple (above) make for an arresting composition. But just as interesting as the structure of the building itself is the pattern of shapes that it forms against the background of blue sky. These "negative" shapes can be just as important in a composition as the "positive" shapes formed by your chosen subject matter. Far from being areas of nothingness, their shape, color and positioning often take on a rhythm and energy all their own. In a sense, you have to train yourself to focus on what isn't there as well as on what is. If you can consciously paint negative shapes rather than simply paint around them, your picture will be all the stronger for it.

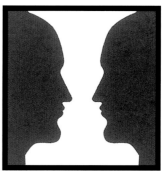

Optical Illusion

Is it a vase or two men facing each other? It all depends on whether you see the silhouettes or the space between them.

Demonstration: Seeing Negative

There are two ways of seeing any object: Look at the subject itself, or at the shapes it creates against its background. For example, one way to draw the stepladder on the right would be to sketch the metal frame. But you could just as easily ignore the ladder itself—as in this demonstration—and concentrate instead on reproducing the shapes between the rungs. For the purposes of this exercise, the ladder is transposed onto a black background. Once you've trained yourself to see negative shapes more clearly, you'll be able to picture both the subject and the spaces around it.

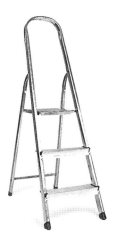

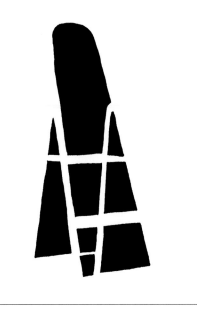

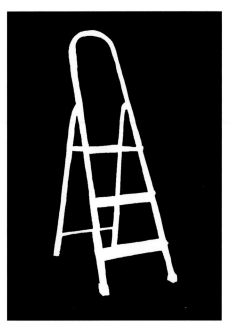

1 Place the ladder open at an angle in front of you. Study the interior shapes. With a pen, sketch these negative shapes between the rungs and the outer metal frame of the stepladder.

2 Still focusing on the shapes, block them in with black ink using a small, flat brush. Take care to stay within the outlines of the shapes, then draw the outline of the stepladder in pen.

3 The outline of the frame creates more shapes. Complete the picture by inking these in with the brush. Suddenly a white stepladder emerges from the assortment of negative shapes you have painted.

Classnotes...

Familiarity with objects can actually impair your ability to draw them, because you draw what you *think* you see, not what you actually see. As an exercise, try drawing a familiar object upside down, such as a chair. You'll find that this forces you to see the object more in terms of its lines, negative shapes and spatial relationships.

Materials:

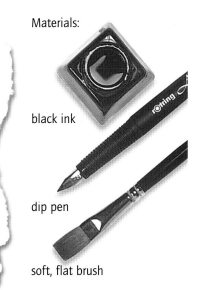

black ink

dip pen

soft, flat brush

The Golden Section

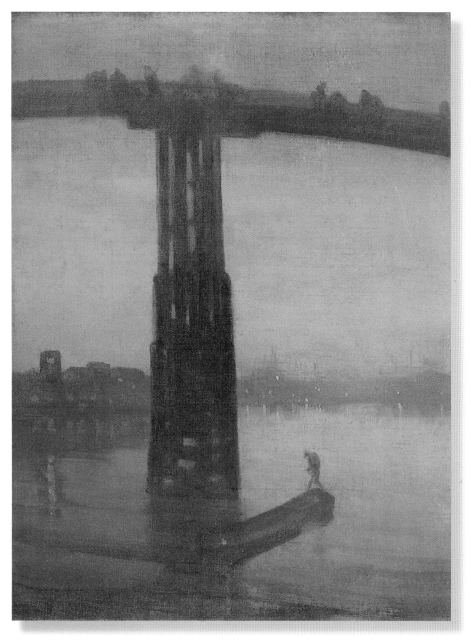

Nocturne: Old Battersea Bridge, James McNeill Whistler, oil on canvas

Master Class

The Golden Section subdivides the Golden Rectangle (above) by roughly a third of its width and a third of its height. The theory goes that by using these subdivisions to position the main elements in a picture, as the celebrated nineteenth-century American painter Whistler has done (left and below), the composition will automatically be aesthetically pleasing.

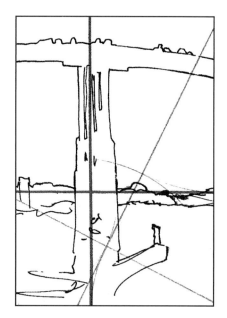

THE ANCIENT GREEKS believed there was an aesthetically "perfect" way of positioning elements within a picture, based on a geometric division of its frame into what they called the Golden Section. Unbelievably, their system works for any size rectangle, as long as the ratio of its adjacent sides remains at a constant 1:1.618. More intriguing still is the number of artists who have employed the Golden Section to create some of the greatest paintings the world has ever seen.

Searching for Gold

People have argued for centuries how the Golden Section works—and if it works at all. But certainly, most compositions work better if the focal point is off center, both horizontally and vertically, so it is useful to be aware of this rule.

In practice you can divide your paper or canvas into thirds and then place the focal point a third of the way up one of the thirds—this is the rule of thirds. Finding the Golden Rectangle and the Golden Section more accurately calls for some geometry, using a pencil and compass (right). Alternatively, work out the sides of the Rectangle with a calculator: If the short side is S units long, the length of the long side is S x 1.618.

Subdividing the Rectangle

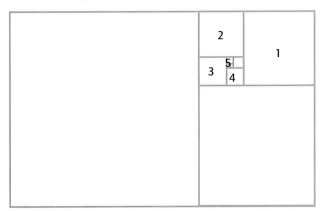

Each time you subdivide the right-hand side of the Rectangle according to the principles of the Golden Section, you create more Golden Sections. You are also left with a set of squares (1–5), called Fibonacci Squares, that are said to be of major compositional significance.

The Golden Swirl

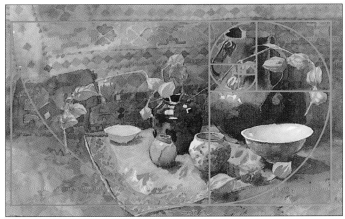

A curved line drawn through the diagonals of the squares in the subdivided rectangle results in a Golden Swirl (above)—a directional thrust that is said to be compositionally pleasing.

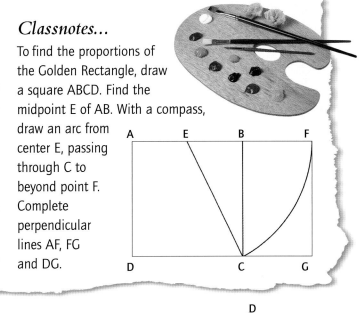

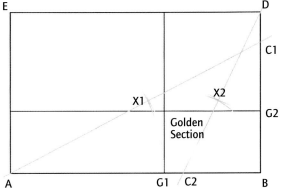

To find the Golden Section of the Golden Rectangle AEDB: If AB is the base, find point C1, which is half the length of AB. Link A and C1. From center C1, draw an arc from B to intersect AC at X1. From center A, draw an arc from X1 to intersect AB at G1.

Repeat for the side of the Rectangle BD, drawing arcs from D–C2 to find X2 and from B–X2 to find G2. Finally, draw a perpendicular line from ED to G1 and another from G2 to AE to arrive at the Golden Section.

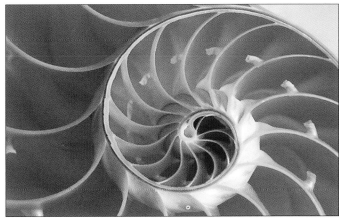

Amazingly, the Golden Swirl has many echoes in nature, from the shells of ancient cephalopods (above) to the structure of pine cones and even the shape of cats' claws.

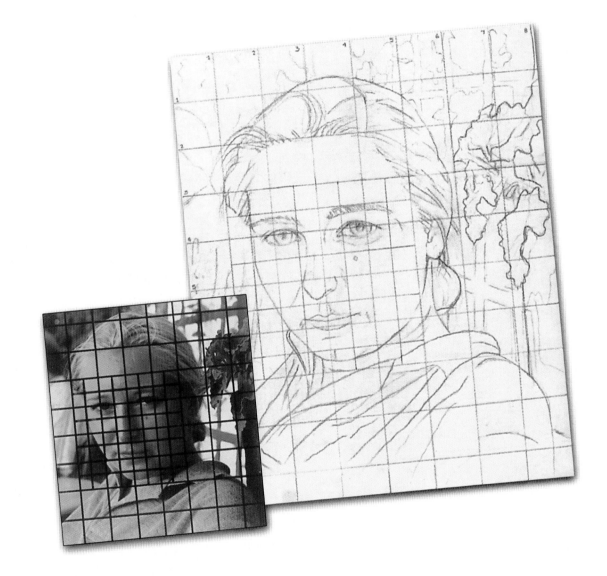

drawing and sketching your picture

Drawing and sketching are probably the most versatile art skills you can acquire, and as well as being fantastic techniques on their own, they provide the basis for pictures in many other media. From simple tracing and transfer methods to sketching in oil pastel and charcoal, this section is packed with hints, tips and tricks to improve your drawing and heighten your confidence. If you're one of those who think they can't draw, this chapter will change your mind!

Using a Transfer Grid

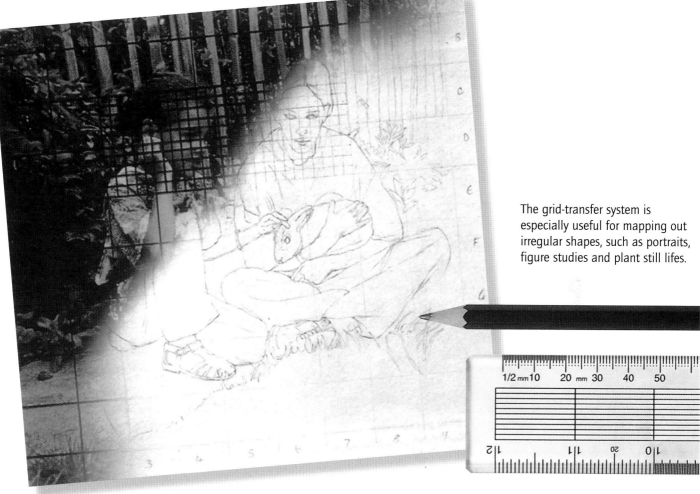

The grid-transfer system is especially useful for mapping out irregular shapes, such as portraits, figure studies and plant still lifes.

One of the easiest ways to find subjects to draw and paint, especially for portraits, is to work from illustrations or from your own photographs. If you're worried about accuracy, the best way to transfer an image like this onto your paper or canvas is to use a grid that divides the image into manageable sections. One method is to draw identical grids over both the reference image and the paper and then copy across. But most people find it easier to have a grid already drawn on a sheet of clear acetate and to lay this over the reference image.

Expert Tip

You can also use an acetate grid as a viewfinder to divide what you see into sections. Simply stick the grid into a cardboard frame, then copy the grid lines onto your paper to act as a drawing guide.

Choose Your Subject

When taking photographs as reference for portrait painting, shoot plenty of different angles—from right and left; from above and below; and full-face, three-quarter and profile views—to give yourself compositional choice. Vary the lighting, too, but avoid bright sunlight and overexposure, both of which will burn out precious tonal detail and make the image hard to define.

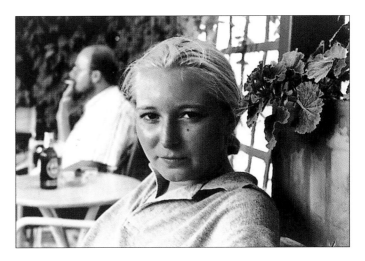

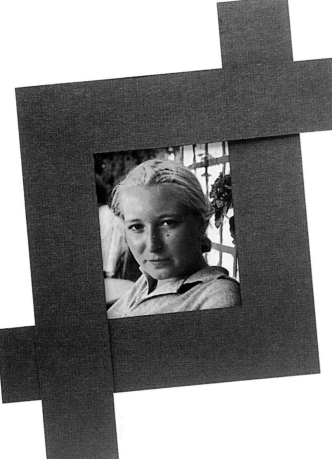

Crop the Image

Even practiced artists find differences between what they see through a lens and what they want to paint. Use L-shaped pieces of cardboard to try out different crops and formats and to mask any unwanted detail, then clearly mark those parts of the image you want to delete. Careful cropping transforms a simple snapshot into a composition suitable for a portrait sketch.

Add the Grid

Lay the grid over the reference image, then draw very light pencil grid lines, spaced to the same scale, on your paper or canvas. Label one axis with numbers and the other with letters. Don't hesitate to switch to a denser grid for areas that are crowded or indistinct. When transferring to paper, put the full image to the back of your mind and concentrate on single squares; it's more accurate, and you can always make fine adjustments at the end. Finally, gently erase the grid line and paint over your drawing.

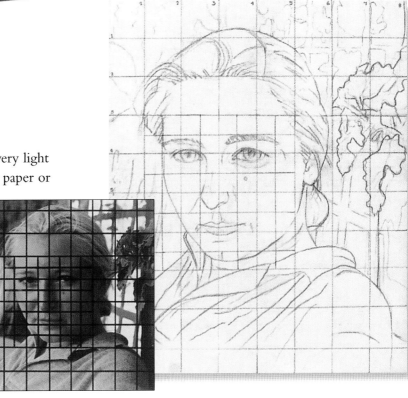

Using Simple Shapes

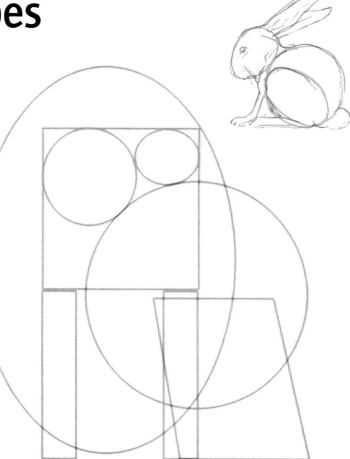

ANIMALS ARE NOT really so difficult to draw, even if they insist on moving. Stare for long enough at any animal and you should be able to visualize it as a series of simple shapes. Most bodies—including ours—can be deconstructed into circles or rectangles. A squirrel, for example, is essentially a series of circles: its head, body, hindquarters and swirling tail. If your family includes a cat or a dog, see if you can deconstruct it in this way. And if it refuses to sit still long enough for you to put pencil to paper, take some photos and work from those.

Angular Hippo

Although portly, a hippo is essentially angular. At its simplest, there is one large rectangle for the body and two smaller ones for the head and shoulders.

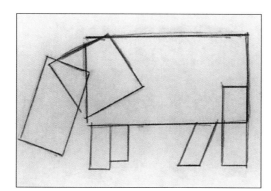

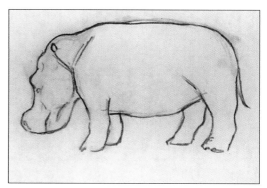

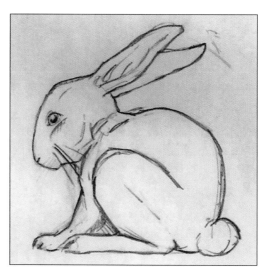

Round Rabbit

This seated rabbit basically consists of a large circle for the body, a smaller, egg shape for the head, and an egg shape tilted in the opposite direction denoting the folded back leg. From here it's relatively easy to add the details.

Elephant

To capture the great bulk of an elephant, limit the basic outlines of your drawing to a few large, sweeping shapes. Using a soft pencil will encourage you to work boldly, but make sure your proportions are accurate before you link the shapes.

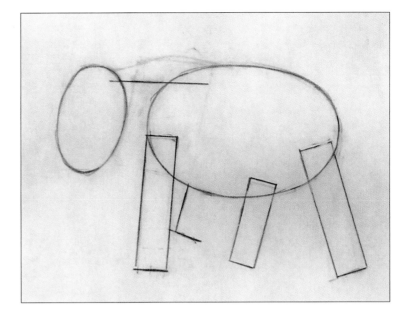

1 Despite its size, an elephant can be reduced to two egg shapes, with rectangles for limbs. Begin with a large oval for the body, then add the head. If necessary, add lines to check that the head and body are aligned correctly.

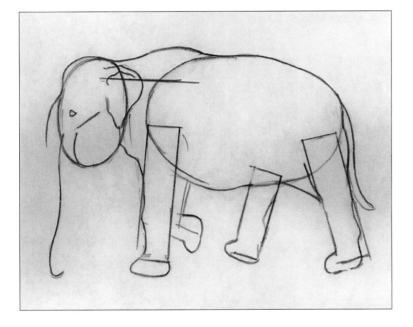

2 Next, start to link the simple shapes. Don't worry about oversimplifying the lines; they can be erased later. Add the rounded shoulders and then draw in the outline of the trunk and ears, adding more shape to the limbs.

3 Continue to round the forms and erase your earlier guidelines. Put in features, such as the mouth, the eye details and the folds in the neck, as well as the toenails. Finally, use the pencil lead on its side to add just a little tonal shading.

Did You Know?

The reason why cartoons work so well is that they exaggerate the simple shapes of a person's or animal's body. The cartoonist has chosen to emphasize the bear's round stomach and stumpy legs.

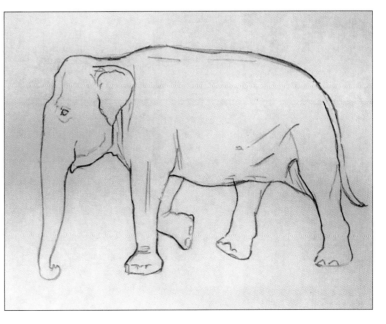

Tracing with Glass

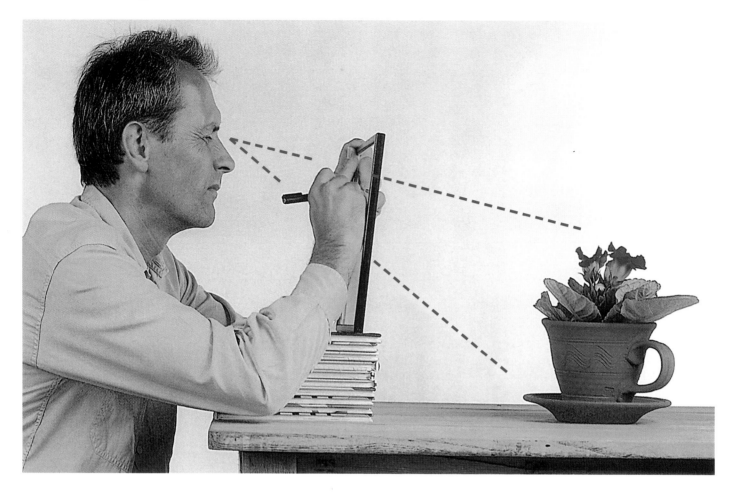

ARTISTS HAVE MANY DRAWING AIDS at their disposal, one of which is to trace the subject at "picture size" onto a sheet of glass, then press-transfer the image from the glass onto a sheet of paper. To do this safely, you need a sketching frame—a glass-covered picture frame with the back removed is ideal. To use the frame, you simply move it toward or away from your subject until the composition seems right, then hold it steady and trace the outline onto the glass in felt-tip pen or brush and ink. The final step is to dampen your paper and press it over the glass so that the image is transferred onto it in reverse (left).

Size 4 round brush
and ink (optional)

Fine-pointed felt-tip pen
(optional)

Picture frame with glass

Using a Sketching Frame

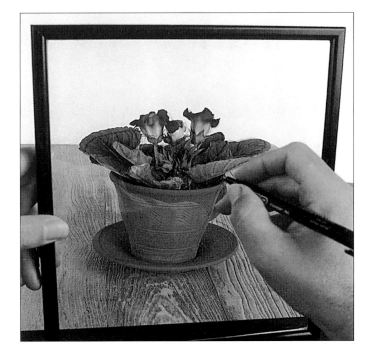

1 A small still-life subject like this plant calls for a sketching frame of around 8 x 10 in. (20 x 25 cm). Draw on it with a felt-tip pen, a brush and ink, or a waxy (but not wax) crayon—anything that will leave an impression on damp paper. Support the frame on some books and move it around until the composition looks right. Try looking through it from different angles, and

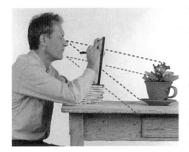

remember, the closer you move it toward the subject, the larger the image on the glass, and vice versa. When you're happy, start drawing; the secret is to keep both your head and the frame absolutely still.

2 When the trace is finished, spray a piece of paper with water until it is slightly damp and press it down firmly on the glass (far left). Leave it for a minute or so, then peel back the paper to reveal the image of your original trace. The image is in reverse, of course, but for most still-life subjects this won't matter.

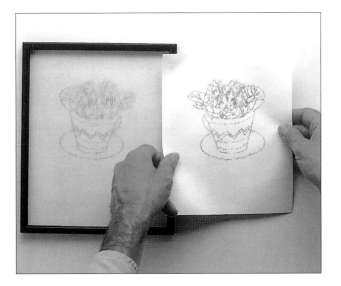

3 If the image needs to be reversed, simply tape the paper up to a window and retrace it onto another sheet.

Expert Tip

If you're not too sure of your drawing skills, you are likely to find that tracing on glass is particularly useful for more difficult subjects, such as portraits or figure studies. Using a sketching frame, you can quickly try out various poses and compositions before your model gets tired. And if you don't like the reverse image, simply retrace onto a fresh sheet of paper, as described in Step 3.

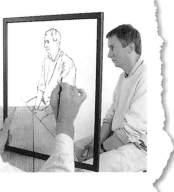

Circles and Ellipses

L OOK AROUND and you'll see circles everywhere. Or will you? A common beginner's mistake is to draw things as perfect circles simply because they know them to be circular. But in fact, when a circle is viewed in perspective, it becomes foreshortened— it appears to change into an ellipse whose width remains the same but whose height changes according to your viewpoint. An awareness of this phenomenon will stop you from falling into the "circle trap"—and improve your drawing immeasurably.

Classnotes...

A simple rule of thumb for drawing ellipses accurately is to measure them—not with your thumb, but almost. Hold a pencil at arm's length and mark with your thumb the width of the ellipse at its widest point. Then repeat for the height of the ellipse. Remember to keep your line of vision constant. As the differences between the mouth and the base of the glass in the pictures above show, circles deform into ellipses at different rates depending on your viewpoint. If this shifts between the time you measure one ellipse and another, your drawing won't look right.

One at a Time
Foreshortening causes circles lying in the same plane to deform into ellipses at different rates (right), so it pays to measure each ellipse individually.

Changing Viewpoint

From above, the glass is a perfect circle. But as the viewpoint lowers, the mouth becomes foreshortened: Its width (its diameter parallel with the picture plane) remains constant; its height (its diameter at right angles to the picture plane) steadily diminishes.

Looking Out for Ellipses

Once you've trained yourself to see ellipses—singly or in groups, in full view or partially hidden—you'll be amazed at how much easier it is to draw circular and rounded objects in correct perspective. Think of the ellipses as the framework of your drawing: Draw them in first, check that they look right, then cover them with surfaces in much the same way as modern buildings are erected with panels over a steel frame.

One of the advantages of drawing is that you can remove the construction lines once you've finished, so don't be afraid to play with the shapes you see before you. A good way to practice is to draw ordinary household objects, changing your viewpoint so that you experience for yourself how the shapes change. And remember: Draw what you see, not what you think you see!

Expert Tip

The easiest way to transfer your ellipse measurements to your paper is to plot them as four dots, then join the dots with curved lines.

Elliptical Guidelines

The basic form of this teapot is a flattened circle. But by drawing in constructional ellipses at the lid, at its widest point and at the base, the way the teapot conforms to perspective immediately becomes clear and can be used as a guide to modeling its rounded form.

Practicing Ellipses

Drawing groups of rounded objects together is an excellent way to observe how circles deform at different rates when viewed in perspective.

Obscured Ellipses

Don't hesitate to draw in partially obscured ellipses to confirm the accuracy of your perspective—after all, they are easily removed.

Drawing Heads and Faces

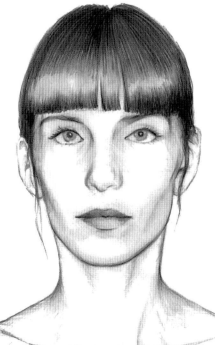

Capturing a physical likeness is one of the most satisfying of all drawing exercises—and an absolute necessity for portrait painting. Fortunately, despite their infinite variety, the proportions of human facial features fall within well-defined limits. Get to know what these are, and how they relate to each other, and you'll find that your portrait drawings soon begin to take shape.

Although we tend to think of faces as symmetrical, few really are. In this portrait slight differences are visible in the shape of the eyes, the curve of the eyebrows and even the form of the lips.

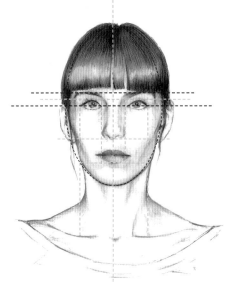

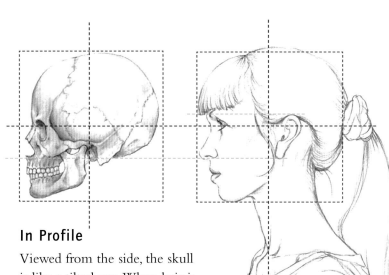

Head-On

It may come as a surprise when you first measure a face that you'll find the eyes are positioned roughly halfway down the head, with the ears just below them. The head itself is egg-shaped. The other dotted lines show the relationship between the other principal features— the brow, nose, mouth and chin.

In Profile

Viewed from the side, the skull is like a tilted egg. When hair is added, the head fits almost exactly into a square. A horizontal line halfway through this square runs through the eyeball. A vertical line halfway through the square marks the edge of the jaw. Note, too, how this line also runs directly through the collarbone. The ear is aligned with the top of the eyelid and the end of the nose.

Mapping a Face

This demonstration shows how to map the features of a face before you move on to render them in detail and hence capture a true likeness. The drawing is done on a mid-toned paper with black and white pastels, enabling you to add highlights at the end.

1 An oval shape is the starting point for a frontal head view. Divide the oval vertically with a lightly sketched-in center line (slightly curved here to reflect the very slightly off-center pose).

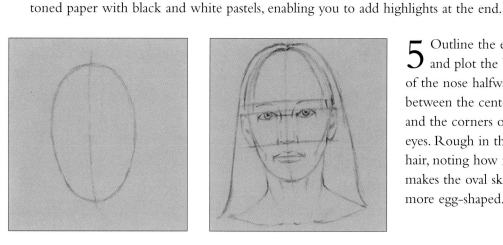

5 Outline the eyes and plot the bridge of the nose halfway between the center line and the corners of the eyes. Rough in the hair, noting how it makes the oval skull more egg-shaped.

2 Facial divisions can now be mapped. Halfway down is the eye line. In roughly thirds of the oval, position the eyebrows and the end of the nose. Halving the bottom third gives the lower lip.

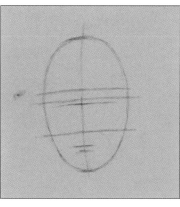

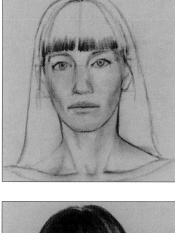

6 Erase the guides and start to establish the darker tones, which will turn the drawing from a diagram into a real face. In particular, look for the tones marking the cheekbones and the upper lip.

3 The eyes are a quarter of the width of the eye line, with an eye's width between them. Dropping vertical lines from the inside corners of the eyes gives the width of both the nose and lower lip.

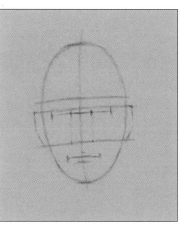

7 Adjust the contrast by deepening the darker tones, but take care not to overwork the areas where the hair thins around the fringe. Make your strokes follow the direction in which the hair grows.

4 Earlobes align with the end of the nose if the head is dead straight, with the tips of the ears falling around the top of the eyelids. Outline the top lip and add the neck and line of the collarbone.

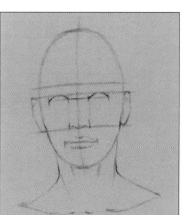

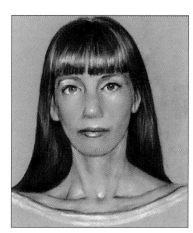

8 Add white highlights where the head catches the light, in particular the fringe, brow and lips. Notice the semicircles of lighter tone beneath the eyes and highlights on the earlobes.

Light and Shade

THE EFFECTS OF LIGHT and shade on an object are what make that object appear "real" and three-dimensional. Yet because we're so used to seeing things this way, we tend to take such effects for granted. Reproducing light and shade on a two-dimensional surface causes us to take a closer look—in particular, at where the light is coming from, whether it is natural or artificial and what kind of surface it is striking. All three factors hold some useful hints for the aspiring artist. Consider them one by one and you'll find that your drawings automatically become more lifelike, whatever the subject and whatever the lighting conditions.

Lit from the side, the tones on the partially lit surfaces are graded; those on the unlit areas are dark and cast a shadow.

Lit from the back, the tones are again graded away from the light, with the darkest reserved for the unlit surfaces.

Classnotes...

All light is not the same. Sunlight is far stronger than artificial light—especially if it is high in the sky, when it casts short, dark shadows and creates high tonal contrasts between the sunlit and shaded areas. As the sun gets lower or goes behind a cloud, these effects gradually diminish; shadows get longer and tonal contrasts become less pronounced. Even so, the "directional" pattern of the light remains. Artificial light is more diffuse, which reduces tonal contrasts and causes shadows to become weaker. It is also less directional, which means that it tends to "envelop" objects, leaving only the most unlit areas in deep shadow.

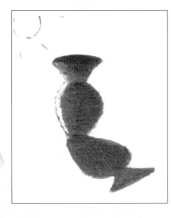

Natural Light
Tonal contrast is sharp, and shadows are dark.

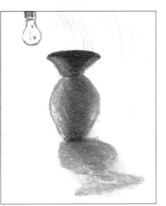

Artificial Light
Tonal contrast is weaker, and shadows are more diffuse.

Lit from the front, the tones are lighter overall but still graded away from the light. The shadow is darkest.

Surface Reflections

The way in which different surfaces reflect light gives clues about their form—flat, angular or curved—and texture. From a drawing point of view, the most informative reflections are the highlights, or lightest tones. These are also the most critical, since to a greater or lesser extent they will be represented by the whiteness of your paper. The darkest tones also need careful scrutiny, because it's all too easy to overshade a drawing and, literally, run out of tones. The secret is to "map" out the lights and darks lightly in pencil before you start shading and then work from both extremes toward the middle.

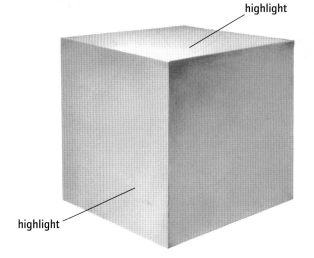

highlight

highlight

Matte Angular Surface

The highlighted areas are even but moderate in tone, which tells you that the surfaces are flat, with a smooth but matte texture. The sharp tonal boundaries between the surfaces tell us that the object is angular.

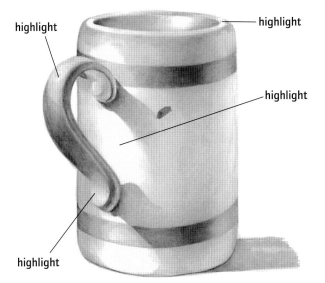

highlight

highlight

highlight

highlight

Semimatte Curved Surface

The highlighted areas are more pronounced, suggesting a surface that is more reflective. The gradation of the tones of the mug from dark to light and back again implies curvature. The same effects are evident on the handle but are more extreme because of its different angle to the light source.

Shiny Curved Surface

The highlights are most pronounced and follow the shape of the object, telling you that the surface is curved and highly reflective. Notice, too, the highlights denoting the distorted reflection of the light source itself. And because the liquid inside of the object is both visible and reflective, this also follows the same pattern of light and shade.

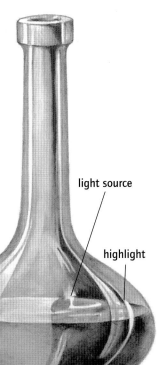

light source

highlight

highlight

Expert Tip

When drawing shadows, notice that the tones of the shadow are usually darker than the darkest tones on the object that casts it. Notice, too, that the tones on the object suddenly get lighter around the area casting the shadow—an effect caused by light reflecting back onto the object from whatever it is standing on.

Shadow Play
Drawing simple geometric shapes is a great way to practice mimicking the effects of light and shade. Don't worry about texture; just concentrate on grading tones from light to dark.

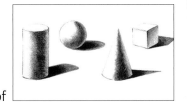

Drawing Children

HOME ARTISTS WITH young children have both the pleasure and the challenge of trying to capture them on paper. While children are a joy to draw (if you can make them stay still long enough), it's all too easy to end up with figures that look more like wooden puppets. The secret of drawing children successfully is to capture their spontaneity with quick, confident sketches and to be aware of how their proportions differ from those of adults.

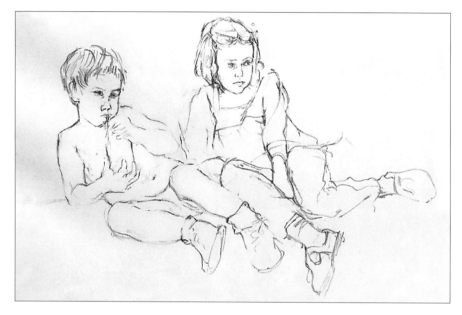

Pose and Posture

The way children sit when relaxed is markedly different from adults, making them ideal subjects for a rapid outline sketch like this one. Don't worry too much about the details: Concentrate on the position of the heads and the folds of the limbs.

Children's Proportions

At birth a child's head seems massive in relation to its body. The body slowly catches up with the head during the course of childhood until adolescence, when it reaches adult proportions—a total height of roughly 7½ "heads."

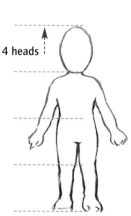

4 heads

Age 1
Head is conspicuously large in relation to body.

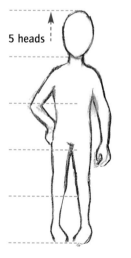

5 heads

Age 4
Toddler curves and baby fat begins to "iron out."

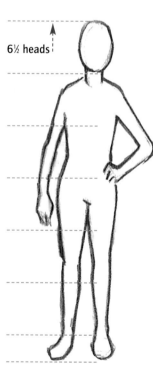

6½ heads

Age 8
Legs and torso stretch in relation to head.

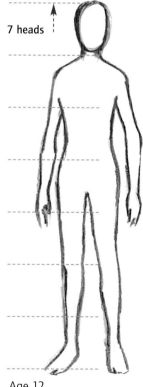

7 heads

Age 12
Head and body near adult proportions.

Sketching a Child's Figure

There's a formula for sketching children: Capture the pose in outline, check and refine the proportions, then go on to refine the facial features and model the tones to give the figure form. When asking a child to pose, let them find a position in which they feel comfortable. That way, at least there's a chance they'll stay still.

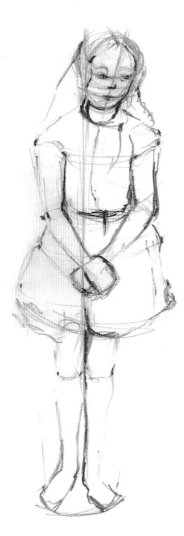

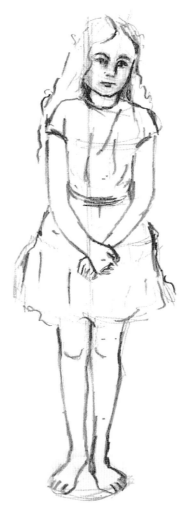

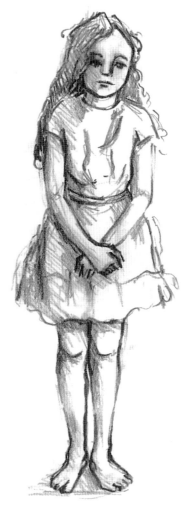

1 Start by getting the basic outline. This little girl is 7; her height is just under six times her head. Make sure the proportions are right at this stage.

2 With the facial features accurately positioned and the stance established, start working up the detail—eyes, lips, fingers and toes.

3 Finally, use shading to model the face, the hair and the figure. Work across the entire drawing to arrive at the desired level of tone and detail.

Expert Tip

Sleeping babies make delightful subjects, not least because they hold a pose! As you study a young face closely, you'll see that the features occupy a smaller area of the head than an adult's. Their faces tend to be much chubbier, with rounded features such as little ball noses and plump hamsterlike cheeks that catch the light. The skin is wonderfully soft and downy.

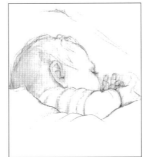

Light Shading

The softness of a baby's skin and the delicacy of the hair and features are best rendered by keeping the drawing tonally light. Use only the most delicate shading to model the tones, and blend the strokes with a putty eraser or torchon (see page 107).

Sketchbook Basics

Your sketchbook doesn't have to be as elaborate as the textured Asian ones shown here. But ideally it should be spiral-bound (to lay flat), small enough to fit in a pocket, and contain paper that suits your style.

KEEPING A SKETCHBOOK is a must for any developing artist. Use it to make visual notes, record fleeting images or simply to experiment with designs and ideas. Sketching performs another important function, too. The act of committing to paper what you observe at the moment will teach you to see like an artist. With a sketchbook under your arm, the sky is the limit, or perhaps it is just the starting point....

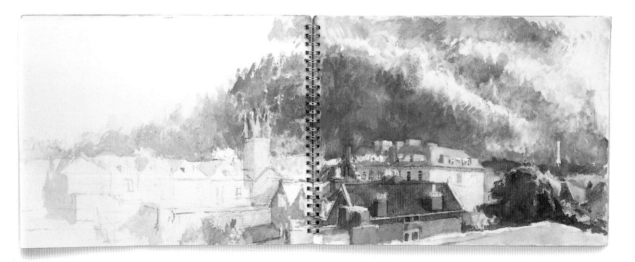

Don't Limit Yourself to Pencil!

Although pencil is the most convenient medium for sketching, it's not the only one. Here, the artist has captured the essence of a scene—dark clouds punctuated by the church tower and rooftops—with pencil and a blue wash. On the right of the picture he begins to record less critical details, such as the colors and forms of the buildings. In the end he runs out of time. Even so, the finished sketch contains more than enough information to be worked up into a painting at a later date.

Capturing a Pose

Notice in this compositional sketch how much information is recorded with a few quick lines.

For many artists, sketching is an extension of looking. It causes you to focus on whatever it is that has caught your attention—a friend's expression, the way someone folds their arms while they watch television, the creases in a pant leg. This process of looking, noting and recording will improve your drawing skills by filtering out what is unimportant and helping you to capture the essence of a scene. Nowhere is this more important than when recording poses, where you don't have time to dwell on details.

Movement

Recording movement can be tricky: You have to work fast. Often you can suggest movement by giving a strong directional feel to your marks. But you may also find it helpful to work in charcoal, pastels or watercolor rather than pencil so that you can cover the paper swiftly, without being distracted by details. As with all sketches, try to focus on what interests you rather than trying to record the whole scene. Leave that to a camera!

Creating Mood

Expert Tip

A tip that applies to all sketching but especially to sketches involving movement is to concentrate on what catches your eye. Remember, unlike a photograph, the surroundings are simply there to add context and only need to be recorded in the barest detail. You'll have another chance to filter out unwanted detail when you begin to paint, which is just as well—overdetailing can cause paintings to look flat.

Detail from Siena, John Ward, Royal Academy

Pencils, pens and chalks are all fine for sketching, but watercolor is ideal for recording the effects of light. Work fast and don't be too concerned about reproducing what you see accurately; it's all about impressions. Try laying down washes quickly and letting them run together, as in the sketch on the left. Here, the way the colors soak into the paper and bleed into each other evokes an impression of water glistening under a setting sun.

Just three color washes have been used in the sketch on the left, starting with cadmium yellow, followed by alizarin crimson and finally ultramarine blue.

Sketching Ducks

SKETCHES DON'T HAVE to be sketchy, but if you do want to get images down quickly, oil pastels are a good bet: They come in bold, bright colors and are easy to work with. Depending on how you hold them and the pressure you apply, you'll get a lively variety of marks. So pick a lively subject —such as the ducks in your local park—and get sketching!

Ups and Downs

These sketches approach the subject from different viewpoints, seeking to capture the shapes formed as the ducks huddle to look down or stretch to gaze upward.

Mood and Movement

Let the lines and shapes of your sketch mimic the essential mood of the moment—angular and elongated as a duck competes raucously for food (right); rounded and gentle as another pair squat contentedly (below).

Tail of the Unexpected

On the right the artist moves swiftly from a conventional side profile to an unexpected and heavily foreshortened front view that captures the duck's awkward tail-high waddle on dry land. Cleverly composed sketches like these capture the essence of a subject in just a few short strokes.

Mallard in Oil Pastel

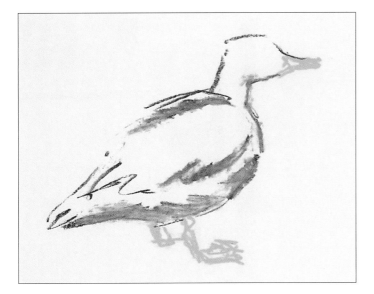

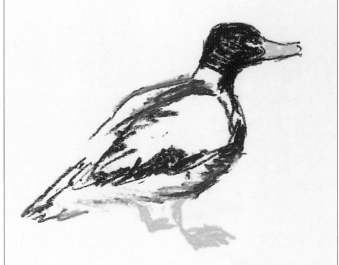

1 The trick of sketching animals from life is speed. And for speed you can't get a much better medium than oil pastels. Start with the outline. For your duck use the tip of a dark pastel and sketch the contours of its body. If you draw an oval and stretch it into a point for the tail, you won't go wrong. The head is another, much smaller, stretched oval on quite a solid, tubular neck. Add the feet and the beak using a yellow pastel.

2 The next stage is to start building up the duck's form. Use a brown oil pastel to emphasize the shape of the wing and to suggest bulk on the bird's breast. Then apply green pastel to the head, remembering to leave space for the eye. In real life the duck will probably have moved by now, but that doesn't matter. Once you've captured the initial shape of the bird, the color and details of the sketch can be taken from other ducks.

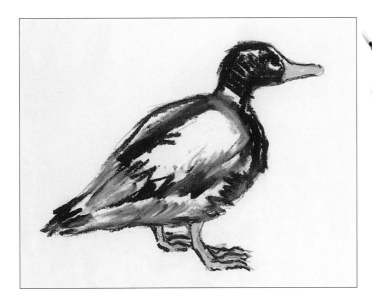

3 Line and tone come next. Reinforce the lines of the wing with a dark blue pastel. Add short strokes of gray and light blue to suggest the feathers of the back, wing and belly. With oil pastels you can mix colors a little, allowing you to obtain a mottled, feathery effect in light blue and gray. Leave the center of the wing white to suggest bulk. Finally, add details such as the eye.

Classnotes...

Use pencil sketches in tandem with your pastel sketches to record the kind of details that pastels can't easily capture— for example, the structure and texture of the bird's wing feathers and tail. Notice in the sketch below how such details are faithfully reproduced using the full repertoire of pencil marks, including lines applied with varying pressure, crosshatching and feathering.

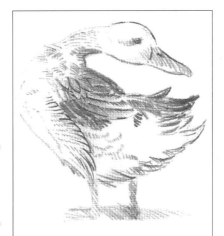

Sketching Clouds

THE SKY PRESENTS an ever-changing panorama of colors and shapes, but don't let that discourage you from tackling it. The fact that clouds are always moving can work in your favor—in a way, you can't go wrong! Sketching clouds in pencil or charcoal is a good way to become familiar with their different forms under changing lighting conditions, but to capture clouds in color, you can't beat watercolor. Fluffy white clouds are best represented by the paper itself, using a paper towel to lift off any stray paint. For stormier clouds, working rapidly wet-into-wet is likely to give better results.

Pencil

A pencil sketch (below) can capture the shapes and basic forms of individual clouds in seconds.

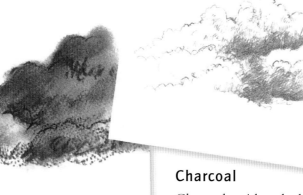

Charcoal

Charcoal—either shaded (left) or blended with an eraser (below left) is better for sketching the strong tonal contrasts of storm clouds.

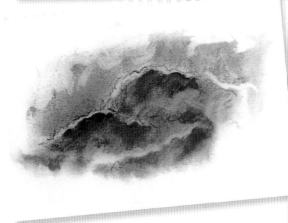

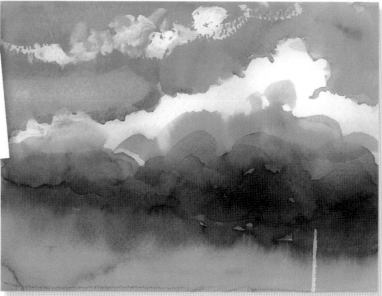

Watercolor

Using a combination of blank paper, lifting off and wet-in-wet washes (right), it's possible to execute convincing color sketches of clouds in a matter of minutes.

Sketching Clouds in Watercolor

Painting Wet-in-Wet

Working from the top down, flood in a wash of Prussian blue. Add a watery purple, letting it run into the blue, and dab it with your brush to create cloud shapes. Then quickly add some less dilute Payne's gray to create a slightly more defined layer.

Finish the left-hand corner with more blue wash, and deepen the color of the clouds in the foreground and middle ground using more Payne's gray. Work as quickly as you can before any of the paint dries; use the runs to convey the constantly shifting shapes.

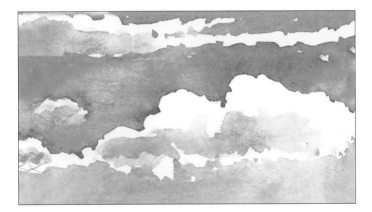

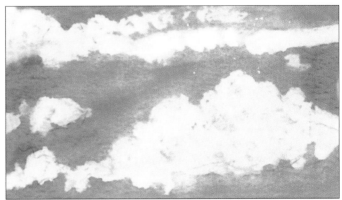

Leaving White and Lifting Off

Paint a wash of Prussian blue onto dry paper, being careful to leave areas of the paper white. Work the curved edges of the clouds quickly and spontaneously. Use a more diluted mix of the blue to add the shapes within the clouds that make them appear solid.

Next, paint a thin wash of Prussian blue over the whole picture, then use a paper towel to lift off the wet paint by dabbing at it. Redefine and adjust the shapes of the clouds as you go, giving the edges of the white areas a more blurred, nebulous look.

Expert Tip

It may seem obvious, but if you find your subjects blowing away before you manage to capture them, photograph them instead. Building up a scrapbook of cloud images will soon convince you that clouds not only come in an almost infinite variety of shapes and colors but also have a powerful effect on the atmosphere of a scene. Refer back to the scrapbook whenever you want to practice cloud painting or need a particular feel for a landscape.

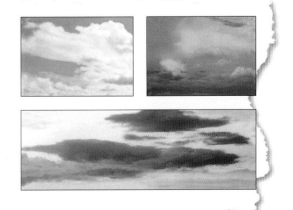

Vacation Diary

CARRYING A SKETCHBOOK pays maximum dividends when you are on vacation. While others click away, happier to record what they see than to enjoy it, you get the best of all worlds. Nothing focuses visual awareness of a scene so much as committing it to paper. And the resulting sketch can be either a study for a more substantial work to be tackled later or a finished drawing that will provide enduring memories of a time and a place.

Pencil and watercolor work perfectly together in the rapid sketch of this church (left). The pencil outline pays little attention to detail, but the washes hint at the elaborate brickwork.

Room with a View

A vacation sketchbook can record solitary observations, such as this tranquil view from a Mediterranean hotel window, or shared experiences amid the hustle and bustle of street life. In either case pencil is probably the easiest, most hassle-free medium for spontaneous sketching. Because this scene is static, there has been time to work up quite a bit of the architectural details. But the scene still seems to cry out for color, which makes the sketch an ideal study for a more elaborate studio painting back home.

Mixing Media

Just because you're on vacation, there's no need to limit yourself to pen or pencil. It's true that a pencil or charcoal is ideal for getting something down on paper quickly or for recording the effects of rapidly changing light and shade. But because vacations can be such colorful experiences, you may regret it if you can't record what you see. There's no need to take the entire contents of your studio, either; many artists relish the challenge of working with a limited range of colors and brushes because it forces them to improvise—which, after all, is what sketching is all about.

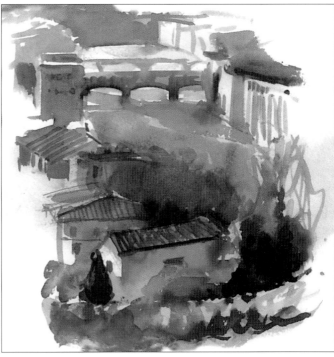

Ring the Changes

Colored pencils (left) bring zest to this sketch of a New York City skyline, while a carefully chosen palette of watercolors (above) reflects a more tranquil experience. For pure spontaneity, though, a stick of charcoal or pencil (right) is the perfect traveling companion.

Classnotes...

The size and type of sketchbook you take with you should reflect its intended use. Small is best if your preference is for spontaneous sketching and making quick visual notes. Many artists prefer hard-bound notebooks for vacation sketching because they are more robust than the spiral-bound type and you can draw right across the spine if you need to capture a panoramic view. And if you plan to sketch in watercolor, make sure the paper is heavy enough; a light-papered sketchbook will buckle under the strain of a waterlogged wash.

Changing Your Viewpoint

I F YOU'RE INSPIRED by an outdoor scene but not quite sure how to approach it, why not try sketching it from different viewpoints? Whether you use pencil or watercolor, this exercise will give you firsthand experience of what goes into making a successful composition—especially the way the subject is placed in relation to its background. Don't worry if none of the sketches make it to a full painting; at the very least, they'll provide a lasting record of an enjoyable day out.

Before you start painting a landscape, try looking at it from different viewpoints: As the pictures above show, the same subject can yield very different results.

Classnotes...

A viewfinder will help you pick out potential painting subjects from the general view. Improvise one by using your hands. Extend your thumb and fingers at right angles, then position your hands to create a viewing area. Close one eye to focus. Slide one hand behind the other to adjust the frame size (left), or rotate both hands 90 degrees to switch to a portrait view. Decide on the focal point of the composition first, then move it around the viewfinder to see how it fits in with the shapes and colors around it.

Take One Village...

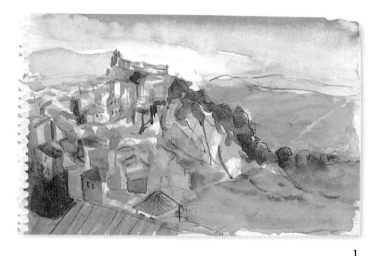
1

You can't beat pencil for quickly recording a scene and trying out compositions. But don't forget the role that color plays in sketching.

Different Viewpoints

Although elaborate as sketches go, these watercolors of an Italian hill village clearly demonstrate the benefits of trying out different viewpoints. Notice how the feelings evoked by each sketch change according to the height of the viewpoint and the position of the village within the scene: from the restfulness of (1) to the drama of (2); from the majesty of (3) to the involvement of (4).

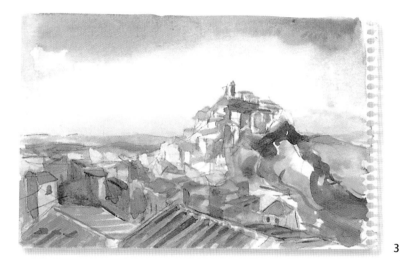
3

Left: A high horizon line helps the sense of drama conveyed by this sketch. Compare it with the one above, which adopts a more scenic viewpoint.

2

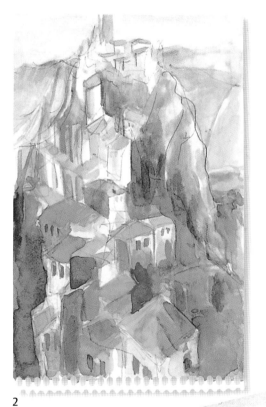
4

Panoramic sketches across the pages of a sketchbook can capture scenes no ordinary camera can. The artist's viewpoint in the picture above involves the viewer, while still managing to portray the grandeur of the scenery.

Sketching Water

WATER IS AN ENDLESSLY fascinating subject for sketching, mainly because it appears in such a variety of guises. The cool, still blue of an empty swimming pool, the sun-dappled ripples of a gently flowing stream, the murky brown depths of an urban canal, the fury of a stormy sea as it hurls itself against the shore…. The familiar media of pencil, charcoal and watercolor all have something to contribute when you set out to sketch this most atmospheric of natural phenomena.

Notice how the ripples in the sketch below are penciled in more lightly as they recede into the background.

Reflections in Water

Reflections take many forms, but they all have features in common. Where direct sunlight strikes the surface, the reflections are dazzling—which can only be conveyed by the whiteness of your paper (above). But water—even still water—is always on the move, which means that such reflections are also distorted. Convey this with stabs of line or color and by limiting yourself to fluid, irregular shapes (right).

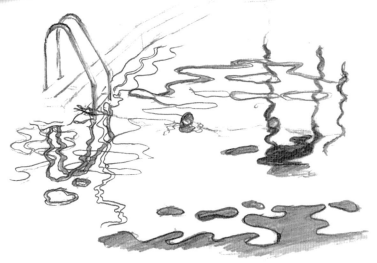

Mixing Your Media

Waves in Pencil

Pencil strokes are ideal for capturing a stormy sea with its rolling breakers and dancing whitecaps. Try to make your marks flow in the direction of the water to help create a feeling of movement.

Waves in Charcoal

The somber tones of charcoal impart an altogether darker, more threatening feel to the scene. Again, let your strokes follow the lines of the water, and pick out the cascading surf with a putty eraser.

Reflections in Watercolor

To capture the play of sunlight on still water, work quickly, wet-in-wet, so that the washes of blue and green merge. Leave strips unpainted (wider in the foreground) to denote the distorted reflection of the sun.

Ripples in Watercolor

To create ripples, apply short dabs of lighter and darker greens and blues side by side, and leave roughly equally sized patches of white paper showing through.

Classnotes...

There are several ways to create whitecaps and breakers in watercolor. One is to rub a white candle on your paper in semicircular movements to create a wax resist. This stops paint from adhering to the paper (above right). Alternatively, use the sgraffito technique, in which you carefully scrape off ribbons of dry paint with a craft knife to reveal the white paper underneath (below right).

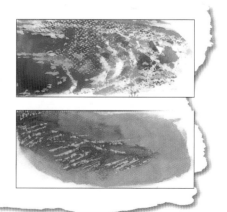

creating your picture

Think of this chapter as a mini-encyclopedia of art techniques, from choosing the right brushes and handling with a Conté crayon to laying a watercolor wash or an oil ground. Building upon the principles learned in the previous chapters will help you create a finished (and fabulous) work of art. As well as practical advice on tools and materials, there's a comprehensive introduction to each of the media covered, step-by-step instructions for specific techniques and plenty of hints and tips along the way.

Toning and Stretching

ONING AND STRETCHING are two key skills that all watercolorists need to master. Toning means giving your paper a colored background in order to unify the composition and/or paint in white highlights. Toning is best done with acrylic paint, which won't dissolve when you start painting over the top. Stretching is a more traditional technique, used to stop lighter-weight watercolor papers (less than 300 gsm—grams per square meter) from buckling when they are flooded with very dilute washes.

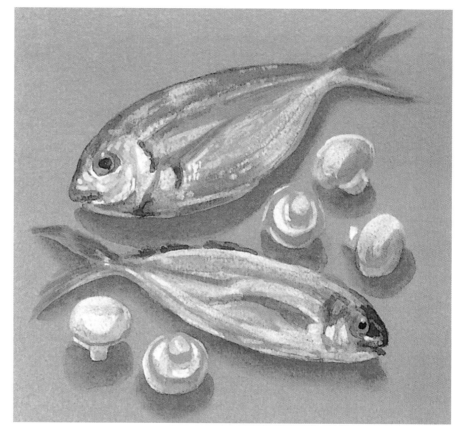

Although colored papers are available from art-supply stores, toning paper yourself is often more convenient and gives you control over the final color.

How to Tone Paper

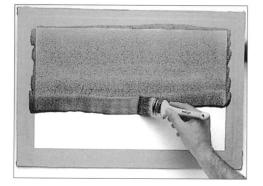

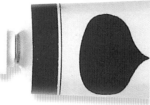

acrylic paint(s)

wash brush

1 Using heavy or prestretched paper, tape it to a board and keep the board at roughly a 30-degree angle. Mix up enough well-diluted acrylic paint to cover the sheet. Then, using a large brush, cover the paper quickly, starting at the top. Work in smooth, horizontal strokes, picking up any drips with the brush as you go.

2 Be sure to let the toned paper dry completely before you paint over it. Once dry, there is no danger of the background dissolving and you'll find that your watercolors take just as well as they would on bare paper. If you want to paint in highlights, use mixtures of white gouache.

70

How to Stretch Paper

Watercolor papers weighing less than 300 gsm are apt to buckle when you paint on them, especially if you use washes. Blocks of watercolor paper are fine because they come prestretched, but loose sheets need to be stretched and dried before you start painting.

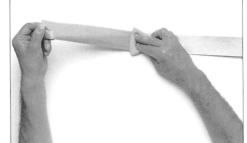

This watercolor landscape has buckled, resulting in a rippled, or cockled, surface because it has been painted on unstretched paper.

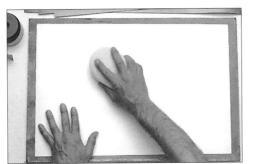

1 Place your sheet of paper on a piece of particleboard or plywood that is about 2 in. (5 cm) wider than the sheet on all sides. Then wet the paper evenly and thoroughly with clean, cold water using a sponge.

2 Once the whole sheet is damp, it will start to expand. Cut four strips of gummed paper tape to attach each edge of the paper to the board. Moisten the tape a little—if it is too wet, it will not stick—and put to one side.

sponges

3 Smooth out the damp paper starting from the middle. Sponge off any excess water. Now stick each edge of the paper firmly onto the board.

4 Let the paper dry. It will contract and become hard and flat. Keep the paper taped to the board until you have completed your painting.

gummed brown paper tape

Classnotes...

For stretching to work properly, the fibers need to expand—and later contract—at an even rate, which will happen only if the paper is uniformly damp. With some papers this may be difficult to achieve by sponging, so try submerging the entire sheet in water instead. You can use a sink, a cat litter tray, or even a bathtub if your sheet is particularly large. But make sure you remove any excess water before sticking the paper to the board.

In Tray
To stretch watercolor paper, submerge it in a water bath, then place the paper on a board and sponge off any excess water.

Brushes and Brushstrokes

THE BRUSHES YOU CHOOSE for your watercolors will have a dramatic effect on the outcome even before you put paint to paper. Some brushes are best used vigorously and expressively to give the impression of energy and immediacy; others are perfect for laying washes and blending colors to give your work a more atmospheric quality. But with all watercolor brushes, one thing is certain: The more you practice, the better the return.

Did You Know?

Brush Basics

Western artists have it easy compared with their Japanese counterparts. In Japan artists train for at least three years in the art of making brushstrokes. Only when they have achieved perfection and control are they allowed to attempt even simple images, such as a stem of bamboo.

This colorful sketch is a lesson in how to make a watercolor expressive simply through your choice of brush and strokes.

See what effects you can achieve with your brushes simply by varying the pressure as you sweep them across the paper.

Different Strokes

Flat areas
The body of the violin is executed with a flat wash brush. The light-toned base color is laid with a gentle, even pressure, then overlaid with a darker tone using the same brush at a much lighter pressure to convey the glow of the wood.

Size 6 round
A medium all-purpose brush. Sizes increase up to the vast size 24.

Defining elements
Strong lines such as the ones defining the bow are added using the tip of a size 6 round. The side of the same brush is used to lay the more detailed washes denoting shadows.

Size 3 round
Good for fine detail. Small rounds decrease in size to the tiny size 00.

Details
The fine lines denoting the inlay work around the body are brushed in last of all using a size 3 round.

Flat brush
These range in width from 0.1 in (3 mm) to 1.2 in (3 cm) plus; 0.4 in (10 mm) is a useful size.

Flat wash brush
Flat wash brushes are larger than flats. Their increased holding capacity makes them ideal for evenly covering large areas of paper.

Japanese brush
Japanese soft brushes are versatile, but only with much practice.

Shapes and Sizes

Different shapes and sizes of a brush produce different effects. Because flat brushes hold paint well and distribute it quickly and evenly, they are the best choice for laying tones and washes. Medium to large round brushes are capable of just about every stroke you'll ever need, but it takes practice to handle them consistently. Small brushes give the control you need for fine detail, but for firmer, cleaner lines over a larger area, try using the edge of a flat wash brush.

Expert Tip

Practice may make perfect, but it can also be costly. Experimenting with different brushes and brushstrokes will work wonders for your technique, but if you use expensive watercolor paper, your wallet will suffer. So until you feel more assured, start off with absorbent scrap paper, such as old newspapers.

Repeat Performance

Repetition is not only the best way to perfect your brushstrokes, it also has the added benefit of improving your fluency—a must for any would-be watercolorist. As you get more confident, you can vary the routine by interspersing the strokes with simple sketches like the ones shown left and below.

Painting Trees

Carefully placed brushstrokes characterize the Japanese-style outline sketch below.

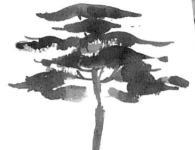

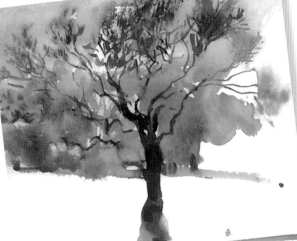

The spiky branches and twigs of this bare tree in winter are picked out against the washes of forbidding sky using a fine-point brush dipped into barely wet paint.

Flooding the paper will produce shadow effects.

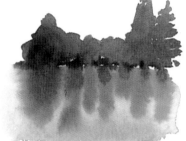

Define the basic shape in pencil.

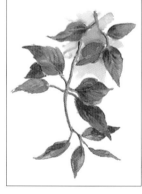

Lay in successive washes of greens wet-in-wet for the leaf mass, then pick out where the branches show through with a fine brush.

TREES ARE PERFECT for brushing up on your watercolor skills: There isn't too much color around to confuse the issue, and you can be as detailed or as sketchy as you like. Half the trick is capturing the overall shape of the leaves and branches. Trees are living, moving objects, so there's no need to be too precise.

Classnotes...

For a more detailed approach to tree painting, try copying the sprig of leaves on the right. Start with a pencil outline; then, when you're satisfied with the overall shape, mix up a range of greens. Notice how leaves always turn to show a profile; the secret is to convey this with successive layers of wash, working light to dark. Flood together Hooker's green and lemon yellow for the first wash. When this dries, use a less dilute green to paint in the shadows. Build up the tones to delineate the areas out of direct sunlight. Finally, using your finest brush, pick out the veins in dark green.

Sunny Sides

Leaves are never flat. The way they catch the light is primarily what makes them leaflike, so for the watercolorist they provide excellent practice in building tones with successive layers of wash.

Watercolor Silver Birch

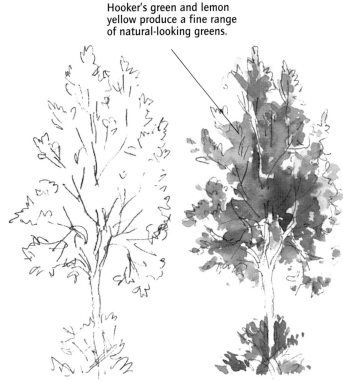

Hooker's green and lemon yellow produce a fine range of natural-looking greens.

Merged colors from Hooker's green, lemon yellow and Prussian blue create tonal contrasts.

Let the paper show through in streaks to convey the silver bark on the trunk.

1 Sketch the basic structure of the tree in pencil. Begin with the trunk and the main branches. Next, concentrate on how clusters of leaves hang. Ignoring all details, draw the outer clusters with delicate broken edges. Then start to paint the leaves and foliage using short, broken strokes. Work swiftly with a very wet brush. Let all the colors merge into one another.

2 Wait for the paint to dry, then add definition to the leaves and build up the tones using more blue/green mixtures. The color variation suggests the shimmering effect created by the gaps between the branches and by light striking leaves at different angles. Paint the trunk using mainly Prussian blue and raw sienna; use light flicks of the brush to represent the bark.

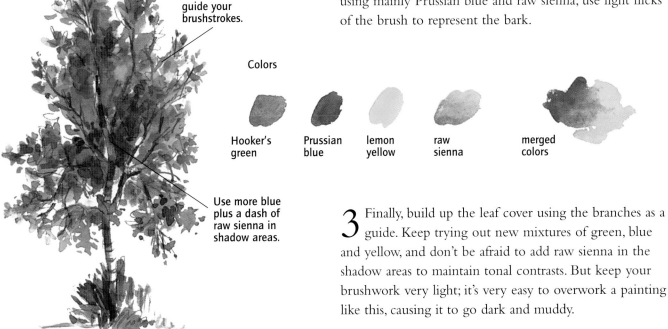

Let the branches guide your brushstrokes.

Use more blue plus a dash of raw sienna in shadow areas.

Colors

Hooker's green

Prussian blue

lemon yellow

raw sienna

merged colors

3 Finally, build up the leaf cover using the branches as a guide. Keep trying out new mixtures of green, blue and yellow, and don't be afraid to add raw sienna in the shadow areas to maintain tonal contrasts. But keep your brushwork very light; it's very easy to overwork a painting like this, causing it to go dark and muddy.

Choosing Paper

ALTHOUGH YOU'LL FIND a bewildering selection of papers in your local art-supply store, don't let it worry you; a vast range of colors, textures and materials has evolved over the years to suit the needs of individual watercolorists. As a beginner, you'll probably steer clear of expensive handmade papers that don't yellow with age; these days cheaper machine-molded paper is almost as good. Instead, concentrate on color, weight and texture. Choose white if you want to have white highlights in your paintings, opt for a heavyweight paper that doesn't buckle when soaked in water, and pick a texture that suits the subject.

Rare, more expensive papers, such as the top two Asian ones shown here, are made from plant sources. Toned paper is tinted with vegetable dye.

Left: Watercolor paper comes in different weights. Single sheets in the lighter weights tend to buckle if you apply a lot of paint. Blocks and pads are an easier option—they come in a vast range of sizes and will stay flat while you work.

Below: A variety of popular machine-made papers and their effect on a Winsor blue wash. On toned paper it gains in intensity; on the more textured papers it appears grainier. NOT refers to cold-pressed.

Right: Watercolor paper is available in loose sheets, spiral-bound pads (as here) or glued blocks.

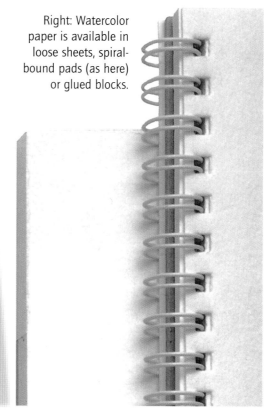

Waterford Rough

Waterford NOT

Waterford Smooth

Winsor and Newton Smooth

Winsor and Newton NOT

Bockingford White NOT

Bockingford Grey NOT

Bockingford Oatmeal NOT

The Rough and the Smooth

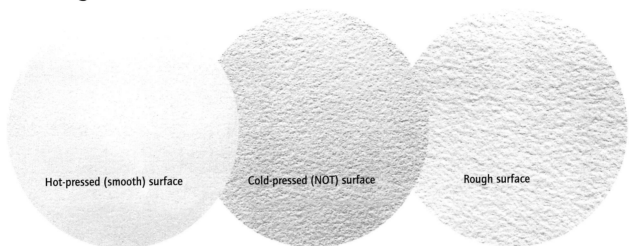

Hot-pressed (smooth) surface Cold-pressed (NOT) surface Rough surface

The most important thing to know about watercolor papers are the three standard grades of texture. Rough, as its name suggests, has the coarsest surface, and hot-pressed has the smoothest. In between is cold-pressed (or NOT), which has a fine-grained semirough texture. The type you choose will ultimately depend on what you want to paint and how. To help you decide, ask your local art-supply store for samples of all three—it's in their interest to help.

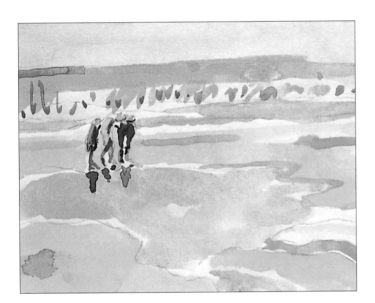

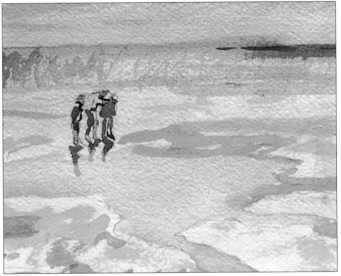

Smooth Paper

Smooth paper has a hard surface that suits a precise, detailed painting style and deep, vibrant colors. To avoid patchiness, washes on smooth paper need to be applied with even brushstrokes, working the paint over the paper in continuous movements.

Rough Paper

Rough paper is better suited for large, more impressionistic paintings and bold, vigorous brushstrokes. The texture also gives colors a more muted but "sparkling" effect—the result of the paint running into the crevices and leaving the "tooth" white.

Mixing Watercolors

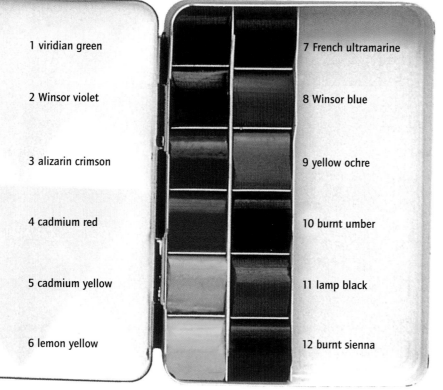

1 viridian green

2 Winsor violet

3 alizarin crimson

4 cadmium red

5 cadmium yellow

6 lemon yellow

7 French ultramarine

8 Winsor blue

9 yellow ochre

10 burnt umber

11 lamp black

12 burnt sienna

Left: A basic palette of 12 colors containing both warm and cool versions of the three primaries, plus green, violet and some earthy neutrals. From these you can mix a vast range of secondary (primary + primary) and tertiary (primary + secondary) colors.

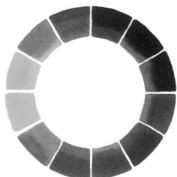

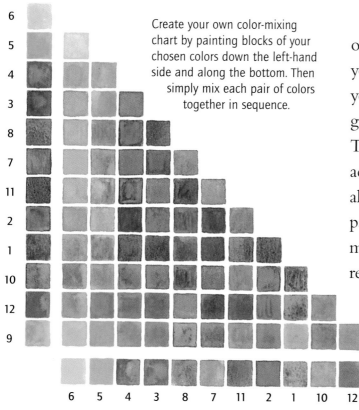

Create your own color-mixing chart by painting blocks of your chosen colors down the left-hand side and along the bottom. Then simply mix each pair of colors together in sequence.

WATERCOLORS CAN BE mixed optically on paper by laying washes of one color over another or by mixing two or more colors together on your palette. If you're fairly new to the medium, you'll probably find that mixing on the palette gives more predictable results. But remember: The final intensity of the mixed color will vary according to how much water you add, and also on the color and absorbency of your paper. That's why it's safer to build washes of mixed watercolors a layer at a time, until you reach the level of color density desired.

Mixing Primaries in Watercolor

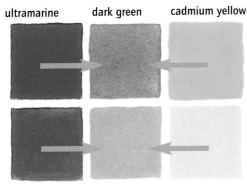

ultramarine dark green cadmium yellow

Winsor blue bright green lemon yellow

There are good reasons for having warm and cool versions of the primaries in a basic palette: When mixed together, they produce very different results. You can't assume that warm + warm = bright, or vice versa. So until you get used to the way they behave, it would be best to refer to the mixes shown here. In time you'll find you favor some colors and mixes over others, which is an indication that you are developing a personal style.

Left: Among the blues and yellows, the warm pairing of ultramarine and cadmium yellow produces the more muted green.

lemon yellow dark orange alizarin crimson

cadmium yellow bright orange cadmium red

Left: Mixing cool reds and yellows results in a more muted secondary orange than the warm pairing of cadmium yellow/cadmium red.

Expert Tip

Mix watercolors in a white ceramic or plastic container so that you see the colors as they really are. Dip your brush in clean water, touch the tip to the undiluted watercolor, and stir the color into your mix. For a wash add plenty of water, but remember that it will look much lighter when it dries. Avoid overmixing colors: It's better to wash the dish and start again if you're not getting the result you want. And when you find a color you like, keep a note of it!

Right: When it comes to reds and blues, mixing cool alizarin and warm ultramarine yields the brightest secondary violet.

cadmium red dark violet Winsor blue

alizarin crimson bright violet ultramarine

Classnotes…

Avoid using black to make grays. Instead, mix them using differing amounts of the three primary colors—red, yellow and blue. Equal amounts of all three primaries produce an all-purpose gray-brown, but when you adjust the proportions of one of them, you get a range of more subtle grays with a slight color bias. Using equal amounts of blue and red with slightly less yellow gives a soft gray with a violet tinge. Equal quantities of yellow and red with less blue gives a gray with an orange bias. And equal quantities of yellow and blue with slightly less red produces a greenish gray. These soft, muted hues are called colored neutrals. Use them in your paintings to enhance and complement the clearer, brighter colors.

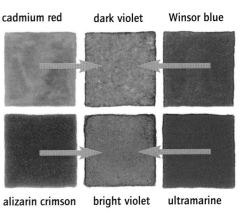

yellow + blue + red =

Laying a Flat Wash

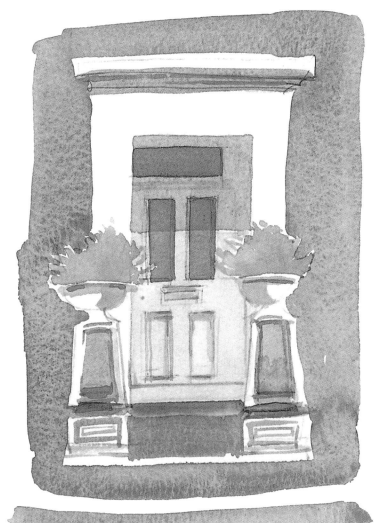

ONE OF THE BASICS of working in watercolors is laying a flat wash—that is, brushing a thin layer of color over a broad area so that you get more or less even tone. Although you can lay flat washes over previous layers of dried color, it's best to practice on (heavy) white paper so that you can monitor the consistency of the paint. You'll find that the paint flows more easily if you dampen your paper with water first. This is best done with a brush to avoid damaging the surface.

Flat washes aren't just for skies; they can be used to "lift" otherwise run-of-the mill drawings, as in the sketch on the left.

Classnotes...

To lay any kind of wash in watercolor, you need to be able to control the flow of the paint. And to do this successfully, your paper needs to be taped to a manageable piece of board—particleboard, MDF (medium-density fiberboard) or plywood will do. Tilt the board to an angle of about 30 degrees before you apply the wash so that the paint runs evenly in a single direction down the paper. Sweep your brush across the paper in broad strokes and recharge it when the color starts to fade.

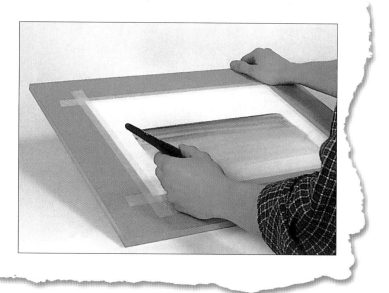

How to Lay a Flat Wash

Although flat washes are meant to be even in color, much depends on the texture of the paper. A wash may appear a little streaky on smooth paper, while on a rough paper paint tends to take on a mottled look, as in the sketch on the right.

However, if the wash doesn't look right, don't go back over it—leave it to dry and paint over it, or lift off the color with a paper towel. If the wash looks too dark, don't worry; it will dry lighter.

1 Dampen the paper, then mix the paint to a dilute consistency using a bristle brush to break down the color in the pan more readily. Switch to your soft-haired flat wash brush, load it well, and starting from the top left-hand corner, sweep across the paper from left to right with even strokes and the very gentlest pressure.

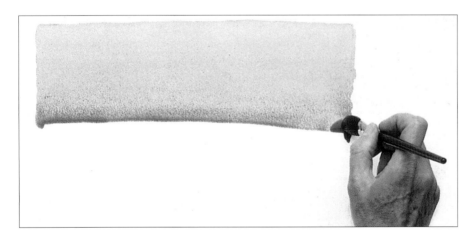

2 If the wash is even, you'll get a continuous line of wet color along the bottom edge. Pick this paint up with your brush and keep it flowing as you paint each band from left to right across the paper. Don't worry if you miss some; it will fill in as the paint runs down.

3 When the paint line runs out, recharge your brush. Sweep it lightly back onto the paper and carry on where you left off, getting the paint line going again. At the end of the wash, wipe your brush and then use it to lift off any surplus color. If you want to give the lower edge of the wash a harder edge, complete the final strokes against a piece of paper held as mask.

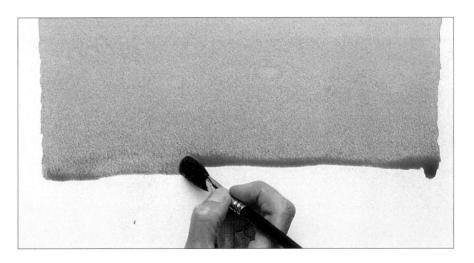

Gouache

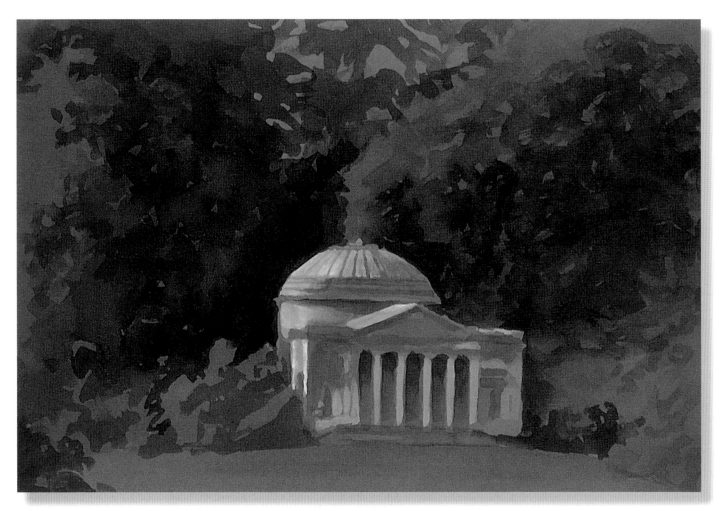

OUACHE IS SIMPLY WATERCOLOR to which gum has been added to make the paint opaque. Water soluble, it can be used as a medium in its own right or in conjunction with conventional watercolors. Opaque gouache dries to a matte, even finish that has much in common with its modern counterpart, acrylics. And like acrylics, gouache can be diluted to create transparent washes. Many artists prefer to use gouache in conjunction with watercolor. Having an opaque paint at your disposal allows you to strengthen the tonal contrasts of an otherwise "flat" image and to paint in white highlights instead of having to rely on the white of the paper showing through.

Gouache is used to pick out the dome and columns of the pavilion, allowing background washes of watercolor to be laid in first without interrupting the flow of the artist's brushstrokes.

Gouache, also known as bodycolor, is normally sold in tubes like acrylic paint.

CREATING YOUR PICTURE

Gouache Color and Effects

As a medium, gouache has the advantage of being more forgiving than transparent watercolor, drying quicker than oils and handling easier than acrylics. It is also good value for money—even a small tube goes a long way. Applied thickly, gouache can be used to add texture or to create flat, uniform areas of color that are well suited to its more brilliant pigment-saturated hues. Its matte finish when dry is not to everyone's taste, but when matched to the right subject, it can produce impressive results.

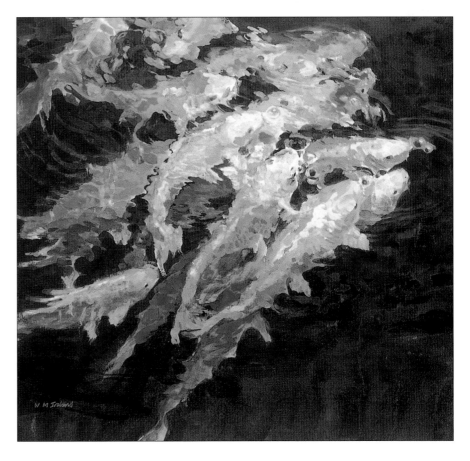

The artist has used the brilliance of gouache on a dark background to convey the shimmering quality of a shoal of tropical fish.

Classnotes...

Dilute gouache can be overlaid in washes and built up in layers in exactly the same way as watercolor. The swatches below show the difference between overlaying colors at full strength and those heavily diluted with water.

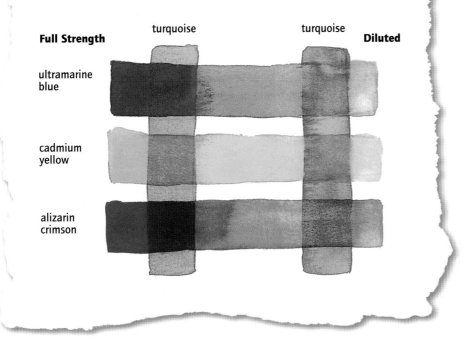

Full Strength — turquoise — turquoise — Diluted

ultramarine blue

cadmium yellow

alizarin crimson

Did You Know?

Compared with watercolors and oils, gouache is a relative newcomer to fine art. But in fact, the ancient Egyptians used a similar medium for their wall paintings (below). Gouache reached the height of its popularity in the eighteenth century, when it was commonly used by artists painting in the decorative Rococo style. Today it is more often used with watercolor.

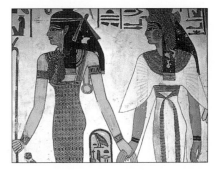

Oils

opaque and transparent primaries

earth colors and neutrals

titanium white

T HE NATURE OF OIL COLORS is such that some remain opaque when brushed undiluted onto canvas, while others take on varying degrees of transparency depending on how thinly they are applied. For a basic palette you'll need a selection of both. The colors shown here include warm and cool versions of red and yellow, but only one blue; Winsor blue is versatile enough to cover most situations, so Winsor green is included instead of another blue.

Above: There are no set rules for laying out a palette, but it makes sense to keep your white separate.

Right: A selection of 11 opaque [O] and transparent [T] colors to get you started in oils.

permanent rose (T)

cadmium red (O)

cadmium yellow pale (O)

transparent gold ochre (T)

Winsor green (T)

Winsor blue (T)

titanium white (O)

oxide of chromium (O)

yellow ochre (O)

Indian red (O)

burnt umber (T)

Expert Tip

Oil paints are expensive, so take good care of them. Each time you open a tube, use a tissue to clean away any excess paint so that the lid can be replaced firmly. This will help maintain the purity of the color, which may be spoiled if the tube is left half open.

Playing with Primaries

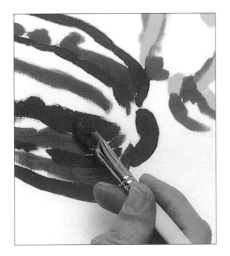

Even just two oil colors mixed together in different proportions yield a surprisingly wide range of secondaries.

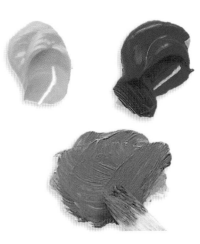

1 Get used to the way oil colors behave by trying this still-life sketch of a red and yellow pepper using just two primaries—transparent permanent rose and opaque cadmium yellow pale. Begin with just one or two different mixtures and apply them with a medium bristle brush.

2 Use the different mixtures to model the forms of the two peppers. The challenge is to keep one of them predominantly red, and the other yellow-orange. Fortunately, the opacity of the oil color makes it relatively easy to correct mistakes.

3 Finally, add dashes of pure color to represent highlights. The finished sketch shows just how much tonal variation you can achieve by physically mixing two colors. That's the beauty of oil painting—the mixing possibilities are almost infinite.

Ways to Mix Oil Colors

Small dots of primaries side by side combine visually to form a secondary.

Streaked brushstrokes of the two primaries produce a similar but more broken effect.

Overlaying blue with an opaque yellow results in a muted color with green tinges.

Notice the difference when the yellow is diluted with medium (50:50 turpentine and raw linseed oil).

Oil paints can be mixed physically on your palette using a brush or palette knife. Pick up a little of one color and put it in the center of your palette. Then pick up some of the next color and mix it thoroughly into the first. (To avoid contaminating your original colors, clean your brush or knife with turpentine before you dip it into a new color.) When mixing oils physically, bear in mind that opaque colors have a more pronounced effect on transparent ones, relative to their quantities.

Supports for Oil

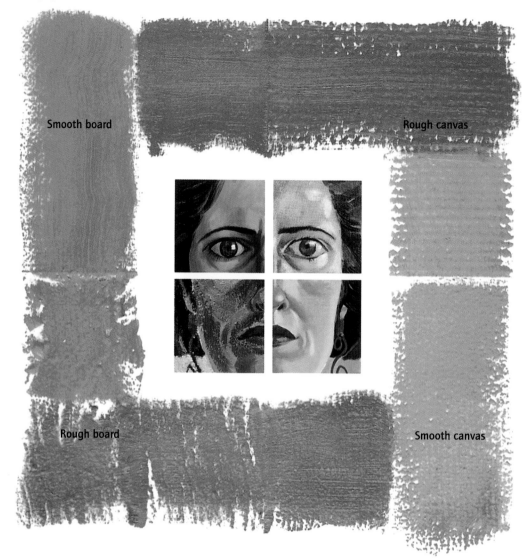

Smooth board

Rough canvas

Rough board

Smooth canvas

Most artists who paint regularly in oils opt for a canvas support or a panel of wooden board, having experimented to see which texture (left) best suits their style of painting. Of the various types of canvas available, linen is the most popular.

I N OILS, YOUR CHOICE OF SUPPORT— the material you paint on—can have a dramatic effect on the final outcome. For small paintings you might choose a rigid support such as plywood, particle board or MDF, which can be painted on the smooth side, unprimed, after a quick rubdown with alcohol. But if you want to paint on a larger scale, a flexible support such as artist's canvas is a better option. It's lighter and easier to transport, comes in a range of textures and can be cut to any length from a roll.

Expert Tip

Prepared canvas boards offer beginners the best of both worlds: They combine the rigidity of board panels with the texture of canvas. They are available from art-supply stores, come in a range of sizes and won't break the bank. Or to make life even simpler, buy a pad of acrylic-primed canvas sheets instead of boards.

Canvas boards come precoated with a primer and are perfectly adequate for small paintings.

Different Textures, Different Effects

The characteristic effects of oil paint applied to different surfaces are shown in the four studies below. In the top left panel a smooth-board support gives a hard, untextured surface on which individual brushstrokes remain clear. The uneven surface of the board in the bottom left panel breaks up the thick layers of paint for a rougher effect. The rough canvas in the top right was prepared with a single tone of one color, which remains visible between areas of paint on the face. In the lower right panel, paints have been carefully blended on a smooth canvas.

Some supports are also suited to certain techniques, such as the sgraffito (scratching) shown below and in the subject's hair.

Smooth board

Rough board

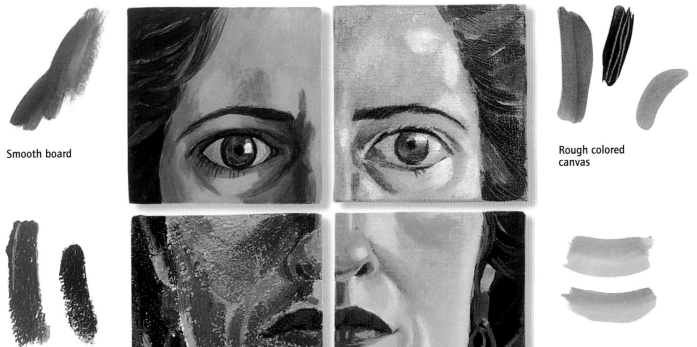

Rough colored canvas

Smooth canvas

Classnotes...

Match the surface of your support to the way you paint. A smooth surface, such as fine linen or particle board, gives great clarity and is ideal for blending and fine detailed work. Coarse surfaces break up brushstrokes to give a rougher, more impressionistic look.

Coarse linen

Fine linen

Grained cotton

Plywood*

Particleboard*

Hardboard*

MDF (Medium-density fiberboard)*

Cotton duck

*sold in home- improvement stores

Grounds for Oils

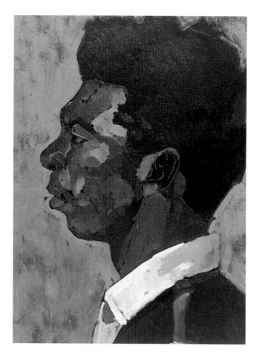

Dark to Light

For the picture on the left, the artist starts with a very dark ground (far left) so that he can make full use of mixtures incorporating opaque white to define the shirt and skin tones.

GROUND IS A TERM used by oil painters to describe the surface they paint on. Some artists prefer the white ground of a freshly primed canvas because of the way it reflects the purity of colors painted over it. But for others, preparing the canvas with a mid-toned or dark-colored ground offers the chance to paint in highlights as well as darker tones—often a great advantage in portrait painting.

Color Contrast

A single color (permanent rose) painted thickly and thinly on a white ground (above left) and a colored ground (above right). Notice how, on a colored ground, both the intensity and the luminosity of the color is reduced but also unified. Painting on a white ground generally calls for more paint.

Classnotes...

There are two main types of colored ground: toned and transparent. A toned ground is an opaque color that is either incorporated into the white primer—the base coat that prepares the surface for painting—or painted over it. A transparent ground, or imprimatura, is a thin layer of translucent color painted over the white primer. Whichever method you choose, if you opt for a toned ground, take care to paint it evenly over the entire canvas, and be sure to allow the paint to dry thoroughly before proceeding.

Uniform imprimatura
Use a wide, flat brush to apply horizontal strokes of well-diluted color. Brush over lightly once again in the same direction to provide an even tone.

Variegated imprimatura
Dilute the paint well with white spirit. Using a medium flat brush, apply it with vigorous strokes at various angles so the original white surface shows through.

CREATING YOUR PICTURE

Colored Grounds

There are good reasons for painting a portrait on a colored ground. If you use a mid-toned ground—the usual choice—it automatically positions you tonally between the extremes of light and dark in the portrait. This gives you more flexibility as you begin building up the image, using opaque mixes with white for the highlights and thin, transparent colors for the darks.

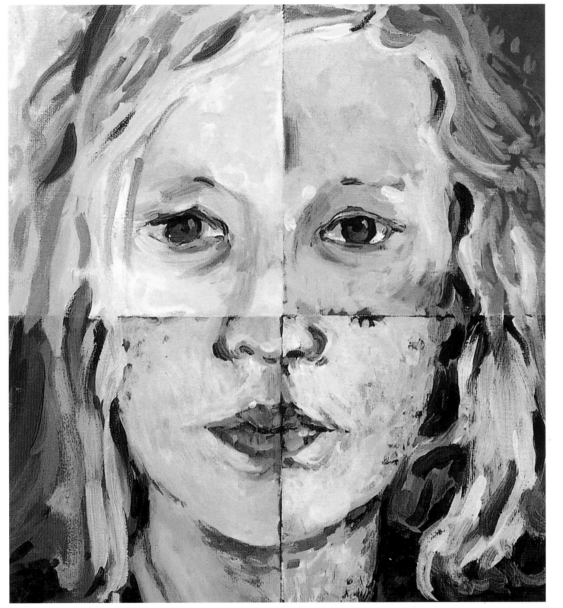

Ground Effect

See how changing the ground color affects a portrait (left). Clockwise from top left:

White ground
Illuminates color but tends to restrict opportunities to create strong tonal contrasts.

Red ground
Warms the painting and pushes the face forward, with stronger contrast between the reds and blues.

Blue ground
Has a brittle, almost mournful effect. The ghostly flesh tones can be warmed up only to a certain point.

Green ground
Subdues the color overall, but with a good interplay between the flesh tones and the background colors.

Toned Down

Opaque and transparent paints behave differently on toned and transparent grounds. The tone of a ground also greatly affects the overlaid color.

Opaque pink and transparent brown on a transparent burnt sienna ground.

Opaque pink and transparent brown on a toned yellow ochre ground.

Opaque pink and transparent brown on a transparent burnt umber ground.

Opaque pink and transparent brown on a toned green ground.

Brushes for Oils

Y OU DON'T NEED A LOT OF BRUSHES for painting in oil. Quality is more important than quantity; all artists have their favorites, but you can paint with confidence with just a handful. Oil painting brushes come in two main bristle types: stiff and soft. Bristle brushes move paint around the canvas with ease and are used for large-scale work. Soft brushes are best for more detailed work.

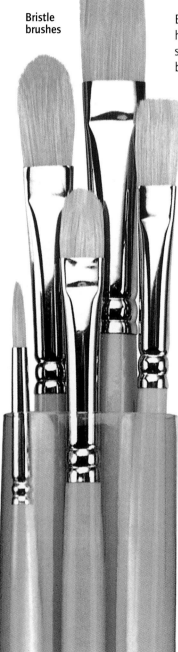

Bristle brushes

Bristle brushes are made from hog's hair. Soft brushes may be synthetic or sable; sable is better but also costlier.

Synthetic brush

Sable brush

Classnotes...

Wash your brushes every time you finish painting or they will soon be ruined. But avoid using hot water, which makes the metal ferrule expand and causes the bristles to fall out.

1. Dip the brush
Wipe the brush on a clean cloth, then dip it in turpentine to loosen the paint. If paint is trapped in the hairs, press the brush against the base of the bowl to dislodge it.

2. Wipe again
Don't leave a brush standing in turpentine or the head will become distorted. To remove any remaining paint, wipe the brush again on a piece of clean cloth.

3. Rinse
Work up a lather in your palm using hand liquid or soap. Clean the brush in the lather, then rinse it under a running cold tap. Dry the brush well and store bristle side up.

Oil Brushes and Their Marks

Three different brush shapes have evolved over the years, all of which come in both soft and bristle form. Although each of them is suited to making slightly different strokes, in many ways choosing the "right" brushes is more a matter of personal taste and experience. After a time you'll find that some brush shapes suit your style better than others; they will become "yours," wearing down to match the way you hold them and the way you paint. And remember: Even when a favorite brush has worn to the point where it doesn't perform as well as it did, you can still trim the bristles or hairs to restore their shape.

A paintbrush holder suspends brushes in turpentine for the first stage of cleaning without damaging the delicate bristles.

Size 12 round bristle brush

Size 10 round synthetic brush

Size 2 round sable brush

Round Brushes

With their smooth, pointed ends round brushes are best for long, continuous brushstrokes; the larger sizes also hold useful quantities of paint. Smaller, soft rounds can become clogged easily and are better suited to adding finer detail toward the latter stages of a painting.

Filbert Brushes

Combining the head shapes of both flat and round brushes, filberts are the most versatile type of brush for oil painting. With a little practice you'll find you can use them for just about anything, from bold, continuous strokes to short, rounded dabs.

Size 10 long filbert bristle brush

Size 6 long filbert bristle brush

Size 5 short filbert sable brush

Size 8 short, flat bristle brush

Size 10 short, flat synthetic brush

Flat Brushes

Short-haired flats are useful for dabbing on color. Longer-haired flats hold enough paint to make long, sweeping strokes, and their thin edges are good for painting clean, sharp lines.

A fan blender (right) is used to dry paint, remove visible brushstrokes and soften edges.

Size 7 long, flat sable brush

Sgraffito in Oils

IT MAY COME AS A SURPRISE to learn that you can have as much fun removing paint from a canvas as you can applying it—but that's what sgraffito is all about. Derived from the Italian word for scratching, it is a technique in which you scratch through the wet paint to reveal the dry color below, or even the white of the canvas. Some of the Masters, such as Rembrandt, used sgraffito to create very detailed work. But one of the pleasures of this technique is that you can use it to create quick, simple line drawings on a painted background.

The image of the violin below was created by scoring through a layer of blue paint (with yellow flourishes) to reveal the white of the canvas.

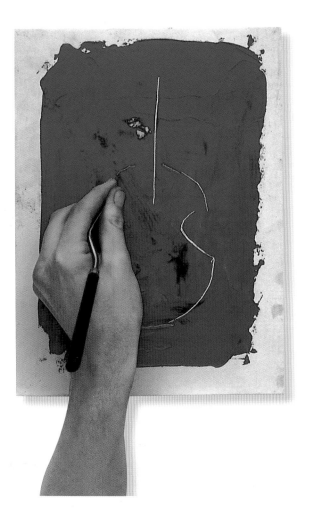

On and Off

Painting knives are not only useful for applying thick layers of paint, they also make ideal tools for sgraffito. To get a fine line, hold the blade firmly between your index finger and thumb and score the paint away using the edge (left). For a thicker line, simply angle the blade slightly so that you remove more paint. Other useful tools for sgraffito include the ends of paintbrush handles, toothpicks and nails. Or be more inventive and raid the kitchen drawer.

CREATING YOUR PICTURE

Scratching Through

Although sgraffito is often used to add texture to paintings, a fun way to practice the technique is to scratch through a dark layer of thick color to reveal colored lines of dry underpainting beneath. Vary both the thickness of the paint and the sharpness of your tools to achieve a wonderful variety of textures and details. This Van Gogh–style "room with chair" study took just minutes to create.

Materials:
- oil paints (cadmium yellow, cadmium red, any black)
- canvas sheet from a pad
- flat bristle and soft round brushes

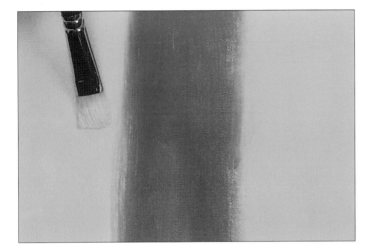

1 Using a flat bristle brush, paint either side of your canvas sheet with broad stripes of yellow. Clean the brush, then paint a strip of red between them. There's no need to be too precise; this is just an underpainting.

Expert Tip

Score dry or thick paint with a sharp implement, such as a painting knife, to get a very fine, crisp line. On wet paint it's easier to use blunter tools to scratch your lines—and if you make a mistake, simply paint over it and start again.

Parallel Lines
A hair pick is a great tool for scoring parallel, wavy or crosshatched lines to suggest texture.

2 When the underpainting is dry, paint a thick layer of black over the top. Then, while the paint is still wet, use the handle of a soft round brush to scratch out the shape of a chair across the underlying layers.

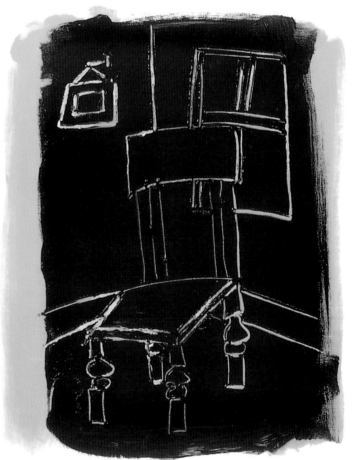

3 Complete the study by locating the chair within an imaginary room. Score some paint away to suggest the corner of a wall, the window and the small painting. Then draw in the floor, complete with skirting board.

Glazing in Oils

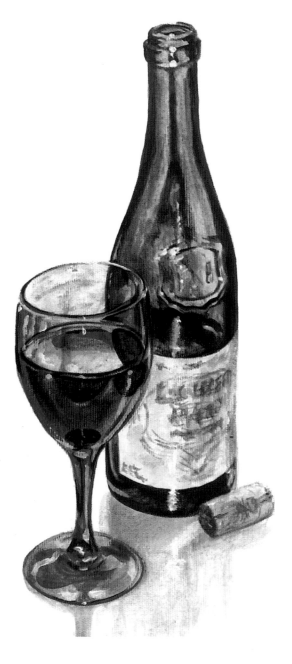

A GLAZE IS A TRANSPARENT LAYER of oil paint that is applied over one or more layers of dry color so that the underlying layers shine through. Most of the great artists of the past built up their oil paintings this way, painstakingly laying one glaze over another to create great depth and richness of color. But you don't need to be Rembrandt to paint effective glazes, you just need time—a lot of it, since each glaze can take several weeks to dry. Glazing works because light passes through the glaze and is reflected back through it in a slightly modified form. Some oil colors are naturally more transparent than others, but this can be achieved by diluting them with a suitable oil painting medium. The trick is to make sure that the layer you are glazing is completely dry before you paint on top.

Double Glazing

The still life above began as an underpainting in blue (right). First a yellow glaze was applied to create the green in the bottle, followed by a crimson glaze to signify the wine and some purple highlights to add depth. The glazes were then repeated, refining the forms, with the highlights picked out in opaque white.

Glazing Demonstration

Brush up your glazing by trying this still–life study. Start with an underpainting of yellow ochre and burnt sienna thinned with turpentine. Brush it on loosely to convey the impression of texture and let it dry completely. For each successive glaze, add a drop or two more of medium (see *Classnotes*) to make it slightly more flexible and translucent than the one before. As the glaze dries, lightly dust it with a soft brush or shaving brush to smooth out any brushmarks.

Materials:
- oil paints (yellow ochre, burnt sienna, phthalo green-yellow, dioxazine purple, cadmium yellow, alizarin crimson, white) and oil painting medium
- size 10 flat bristle and size 8 soft round brushes
- canvas sheet from a pad; soft brush or shaving brush

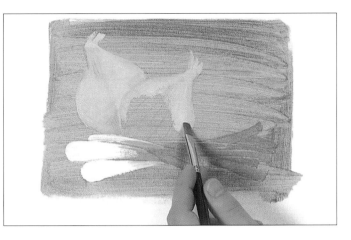

1 When the underpainting is dry, block in the back onion (white, phthalo green–yellow, cadmium yellow), the spring onions (white body, green/yellow leaves) and the red onion (white, dioxazine purple). Let the colors dry.

2 Next, define the forms. Paint the hoops on the red onion in purple and those on the back onion in burnt sienna. Moving to the spring onions, mix some darker and lighter greens for the stem shapes. Let it dry for a couple of days.

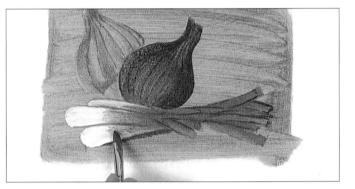

3 Apply a mix of purple with a little crimson and oil painting medium to glaze the red onion, and burnt sienna straight from the tube (it's very translucent) for the brown one. Then add more green to the onion stems and leave to dry.

Classnotes...

Oil painting medium for creating glazes traditionally consists of a 50:50 mixture of turpentine and boiled (stand) linseed oil. You need to add only a drop or two to your mixtures to make them more malleable, although you should increase the proportion of medium slightly with each successive layer of glaze. Art-supply stores also sell rapid-drying mediums with additives that make glazes dry faster—a boon if you can't wait to see the results of your efforts.

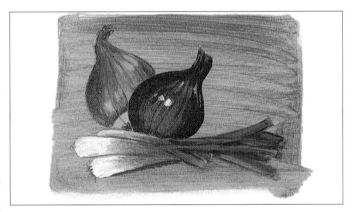

4 After about a week apply another layer, but with darker mixes of color. Leave to dry. Then apply a white glaze (white plus oil painting medium) over both onions to create the translucent skin. Finally, dab on some white highlights.

Acrylics

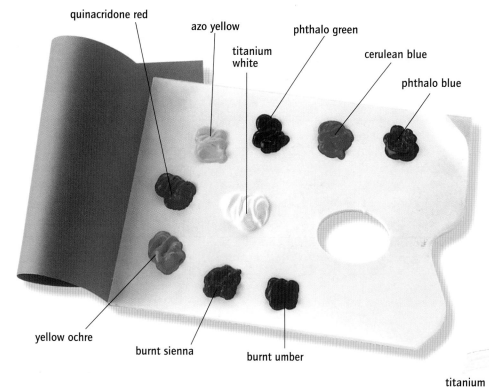

quinacridone red
azo yellow
titanium white
phthalo green
cerulean blue
phthalo blue
yellow ochre
burnt sienna
burnt umber

Color Choice

A basic palette of acrylic colors, laid out in much the same way as for oils, on a disposable paper palette. As well as white, there is a warm red, a warm yellow and both warm and cool blues. Three hard-to-mix earthy neutrals are also included, corresponding to light, mid- and dark tones.

A CRYLICS ARE ABOUT as versatile as you can get. When applied thinly, they take on the transparency of watercolor; when applied more thickly, they assume the opacity and texture of oils; and they are thinned with water, which is less messy than turpentine. More or less, the only drawback to acrylics is the speed at which they dry—and even this can work to your advantage.

titanium white

cadmium yellow

quinacridone red

phthalo blue

Restricting Your Palette

Acrylics are more about technique than color selection, so start by keeping to a few basic colors and concentrate on getting the most out of them. The picture above uses just four colors. But by combining thin background washes with brighter stabs of opaque color for the petals and vase, the artist creates a far more complex painting.

Expert Tip

Because acrylic paints dry quickly when exposed to air, you need to be prepared. If you are mixing a color that you will need more of later, make up a large batch and store some in an airtight screw-top jar or an old makeup container. It will keep this way for weeks.

Making the Most of Acrylics

Because acrylic paint is so versatile, you can achieve many different effects with the same colors. A good starting point is to play with colors that are opposite each other (complementary) or next to each other (adjacent) on the color wheel. Try painting them as pure colors, see what happens when you mix one with the other, and then try combining a thin wash—that is, a color diluted with plenty of water in a mixing dish—with opaque brushstrokes of another color. One of the strengths of acrylics is the way you can switch seamlessly from transparent to opaque and back again.

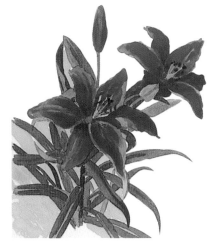

A striking example of what can be achieved by pairing two complementary colors (red and green) opaquely, at full strength.

Toned Down

The same pairing, this time with thin washes of one color laid over the other. Notice how the overall effect is much more muted.

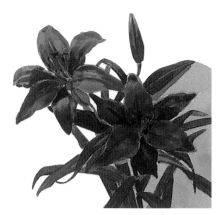

Wheel of Color

Use the color wheel as a reference when trying out acrylic paints. Colors that are opposite each other (complementaries) can either make the other more prominent or tone each other down depending on how you use them. Colors next to each other (adjacents) can be used to build tones of a flat color.

Seeing the Light

The color wheel on the left also shows how acrylic colors can be diluted with water to achieve a range of effects from opaque, through translucent, to virtually transparent.

Building Tones

Tones of cool red (left) are built up with successive washes of the same color, with shadows added using a wash of adjacent violet.

Delicate washes of adjacent blue and violet (right) are blended smoothly together.

Combining yellow with adjacent green and adjacent orange (above) allows for a high degree of tonal variation.

Masking Out

To make an object stand out, or to get a clean edge without disrupting the flow of your brushstrokes, try the technique known as masking out. This involves protecting part of the support—or a previously painted area—while you paint over it. When the mask is removed, you are left with a hard-edged shape or line against a unified background.

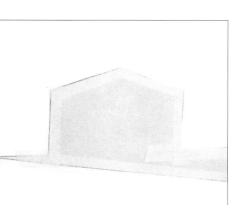

The painting on the left began as a paper mask (above), which was cut to the shape of the building and wall and secured with masking tape. After painting in the broad, sweeping strokes denoting the sky, the mask was removed to leave the white ground of the canvas in sharp relief.

Scissors

Scalpel or craft knife

Masking tape

Wash brush

PLUS: a sheet of card or stiff paper

Expert Tip

Paint has a tendency to seep under the edges of masking tape, particularly when it is heavily diluted to create a wash. To stop this from happening, run your thumbnail or a knife handle hard along the edge that's doing the masking. Another tip is to make sure you use fresh tape—old rolls tend to bubble and blister and their adhesive coating becomes uneven.

Hard-pressed
If you use multiple lengths of tape as a mask, make sure that both edges are pressed down (below).

CREATING YOUR PICTURE

Taping Shapes

Masking out is less about technique and more about planning: You need to train yourself to "see" shapes that offer potential for masking at the composition stage. Even so, it does no harm to practice, so why not try this simple demonstration?

Materials:
- masking equipment
- flat wash and size 3 round brushes
- canvas board
- acrylic paints (cobalt blue, cadmium yellow, dioxazine purple, pthalo green, burnt umber, titanium white)

1 After planning the composition and the shape to be masked, use a pencil—and if necessary, a ruler—to draw the shape on a piece of card. Cut around the outline.

2 Position the mask on the support and tape down the edges. Remember, it is the tape rather than the mask itself that defines the shape; if necessary, trim the edges with a scalpel.

3 Lay in the sky wash over the mask in pure cobalt blue. The paint should be undiluted enough to emphasize the strength and direction of your brushstrokes.

4 Use the same technique to brush in the foreground wash of cadmium yellow. Make sure you paint up to and over the edge of the mask.

5 When the paint is dry, gently peel back the mask. Paint the wall (right) and the shadow areas of the building using dioxazine purple toned down with a little white, and touch in the windows in blue. If desired, paint in the palm trees with your round brush using pthalo green and burnt umber.

Brushes for Acrylics

BECAUSE ACRYLIC PAINT is so versatile, your choice of brushes is more likely to be influenced by the way you paint than by anything else. If your style tends toward oils—that is, thickly applied opaque paint combined with expressive brush work—then you'll find that a traditional combination of short- and long-haired bristle brushes will cover you for most situations. If you prefer to work with more dilute paint, whether in the form of flat washes or fine, detailed brushwork, your brush jar is more likely to include a selection of flat and round soft-haired brushes.

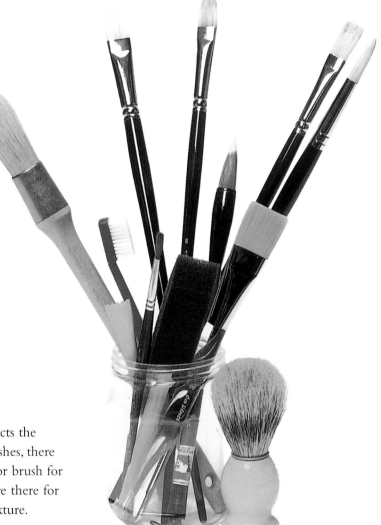

The eclectic nature of this acrylic artist's brush collection reflects the versatility of the medium. As well as round and flat bristle brushes, there are round and flat soft-haired brushes and a Chinese watercolor brush for applying more dilute paint. A shaving brush and toothbrush are there for creating dry brush effects, and there are scrapers for adding texture.

Expert Tip

Good brush care is vital when you paint in acrylics; not only do acrylic paints dry very quickly, they also become water-resistant when dry. This means that if you leave paint on a brush for more than just a couple of minutes, you may find it difficult or impossible to remove. So get into the habit of following the routine shown on the right, and give your brushes a chance to show what they can do for you.

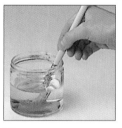

Rinse
Immediately after using a brush, rinse it in cold water. Hot water hardens the paint and can damage the brush.

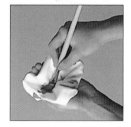

Wipe
Use a clean cloth to wipe off excess paint. If any paint remains, rinse the brush in the cold water a second time.

Clean
At the end of a session, rub the brush on some soap. Work up a lather in your hand. Then rinse again in cold water before storing.

Choosing Brushes

Small round sable
The "spring" in the pointed tip of sable brushes is what makes them so good for painting details fluently.

Size 8 round soft synthetic
The paint-carrying capacity of a brush this size makes it ideal for bolder, more expressive strokes.

Size 8 flat soft synthetic
Useful for laying flat washes, but you can also paint long, thin strokes with the brush held edge-on.

Size 5 filbert hogs-hair bristle
Combining the qualities of both round and flat brushes, this is a versatile choice for all-purpose work.

Size 5 round hogs-hair bristle
The ideal choice for thicker, more expressive brushwork because it can carry a lot of paint.

Size 5 flat hogs-hair bristle
Bristle flats produce similar strokes to soft flats but can carry much more paint.

1-inch synthetic wash brush
A special-purpose brush for laying flat washes of dilute paint over a large area.

Large round synthetic
Useful only if you like to paint on a broad canvas. The paint-carrying capacity of these brushes makes them difficult to clean.

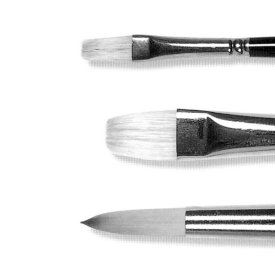

Choosing a "Starter" Set

It's all too easy to be intimidated by the vast array of brushes on display in art–supply stores. But don't be; they are mainly there to entice you. Resist the temptation to build up a huge collection of brushes until you've evolved your own painting style. In the meantime, improvise. Small household paintbrushes make good substitutes for flat wash brushes; toothbrushes are great for dry, textured strokes; and if you've already dabbled in watercolor or oils, the same brushes can be used for painting in acrylics. A medium–sized filbert (around size 5) is certainly a good investment, because of the broad range of strokes it can make. When it comes to bristle type, it's worth remembering that acrylics is quite a robust medium. Natural hogs–hair bristle and sable soft-haired brushes undoubtedly produce better results if you're really practiced at what you're doing. Until then, synthetic versions should do fine.

Pencils

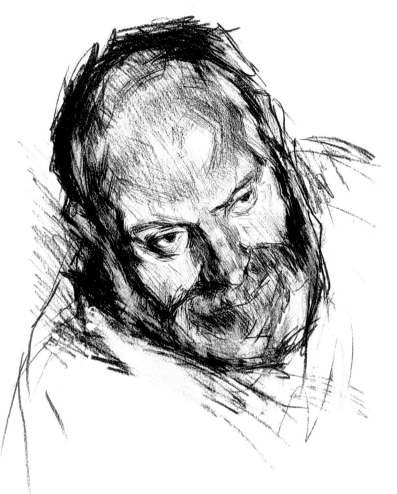

PENCIL MAY BE THE SIMPLEST and most immediate drawing medium, but that doesn't lessen the importance of good technique. First and foremost, you need to experience for yourself how the different kinds of pencil—and the marks they make—can be used to bring variety of texture, tone and expression to your drawings and sketches. Although pencils come in a variety of grades from hard to soft, artists tend to avoid the harder grades because they allow little scope for tonal shading, pressure variation or expression.

Expert Tip

Pencil erasers are not just for erasing, but are tools in their own right—for lifting, smudging, blending tones and countless other uses. Putty erasers are generally more useful to artists than the more common plastic kind because they can be molded to whatever shape you want, offering greater control.

Versatile Putty

A putty eraser (right) is the best option if you are working in pencil or charcoal.

Shading is the obvious way to create tone and texture in pencil drawings, but crosshatching can be just as effective. Try out marks of different thickness, angle and density to see what effects suggest themselves.

Making Your Mark

Most artists find that just three grades of regular graphite pencils—an HB for line work and a 2B and a 4B for hatching and shading—are sufficient for sketches, with one or two softer grades added for finished drawings. But there are no hard and fast rules: Some people appreciate the capacity of harder pencils to be sharpened to a fine point; others take advantage of hard pencils' tendency to "dig in" by using a soft, spongy paper to add physical texture to their drawings.

In art-supply stores you will also come across graphite sticks and water-soluble pencils. Graphite sticks are lead-only and are graded in the same way as ordinary pencils. They are ideal for shading on a large scale. Water-soluble pencils produce deep, rich, very black marks that can be used to good effect in their own right. But the principal attraction of water-soluble pencil marks is that they can be diluted with water to blend areas of tone or to form a transparent wash, both of which greatly extend the scope of the medium.

Expert Tip

Always use fixative to seal the surface of finished drawings. Fixative consists of resin sealant in a volatile solvent spray. As the droplets of spray hit the paper, the solvent dries to leave an invisible but smudge-resistant protective layer.

Can or Bottle
Fixative comes in handy spray cans or in liquid form with a mouth atomizer (right).

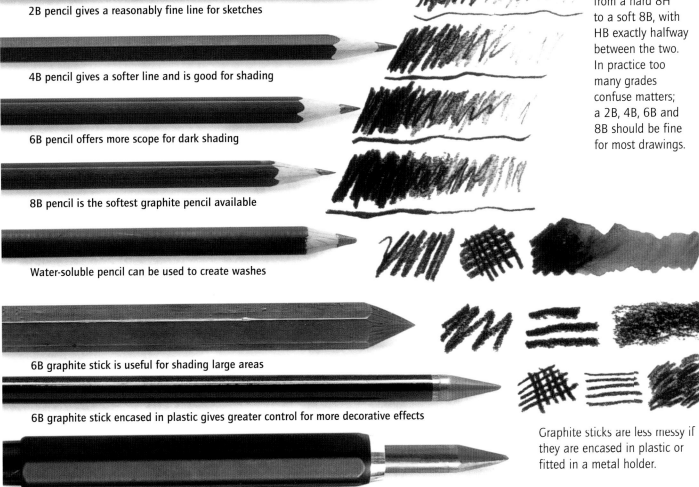

2B pencil gives a reasonably fine line for sketches

4B pencil gives a softer line and is good for shading

6B pencil offers more scope for dark shading

8B pencil is the softest graphite pencil available

Water-soluble pencil can be used to create washes

6B graphite stick is useful for shading large areas

6B graphite stick encased in plastic gives greater control for more decorative effects

6B graphite stick in a holder keeps fingers and hands smudge-free

Graphite pencils range in texture from a hard 8H to a soft 8B, with HB exactly halfway between the two. In practice too many grades confuse matters; a 2B, 4B, 6B and 8B should be fine for most drawings.

Graphite sticks are less messy if they are encased in plastic or fitted in a metal holder.

Colored Pencils

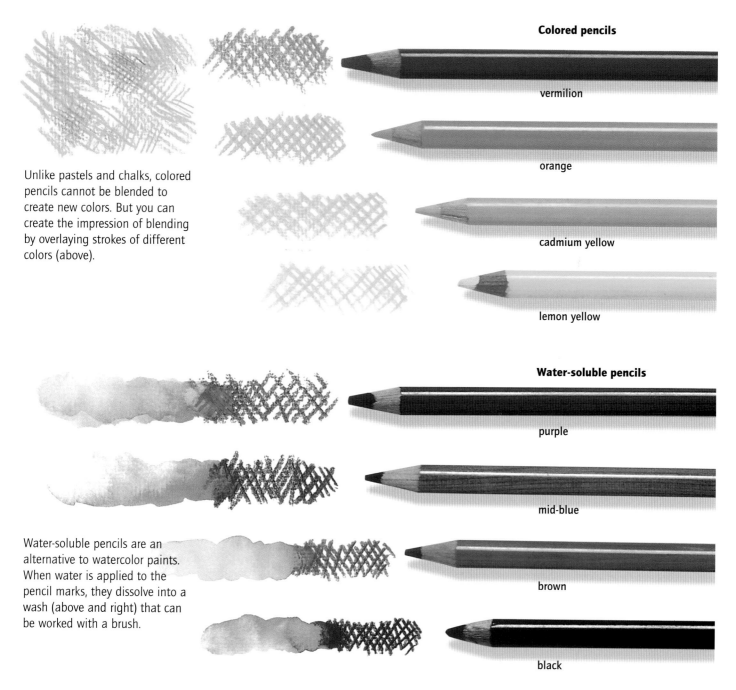

Colored pencils

vermilion

orange

cadmium yellow

lemon yellow

Unlike pastels and chalks, colored pencils cannot be blended to create new colors. But you can create the impression of blending by overlaying strokes of different colors (above).

Water-soluble pencils

purple

mid-blue

brown

black

Water-soluble pencils are an alternative to watercolor paints. When water is applied to the pencil marks, they dissolve into a wash (above and right) that can be worked with a brush.

Colored pencils aren't just for children; they are a versatile, convenient and inexpensive medium in their own right, with the potential to make wonderful drawings. Although colored pencil pigments can't be physically blended, they can be mixed optically on paper by feathering—laying roughly parallel strokes of different colors side by side—or by hatching and crosshatching, as shown above. You can achieve an even wider range of effects by varying the line width according to how much pressure you apply and which part of the sharpened point you use. And then, of course, there are water-soluble pencils. These can be blended to achieve wash effects very similar to watercolor.

Optical Mixing

The two sketches shown here illustrate just how wide a range of effects you can get with colored pencils simply by laying one color over another in different ways. The apparently solid brick-red color of the walls is, in fact, made up of feathered layers of red, orange, yellow and brown, the brown being employed mainly to convey variations in texture. Conversely, on the curtain the artist has used the very faintest strokes of a single color to give form to the white of the paper.

These sketches of an Asian window show the versatility of colored pencil depending on how you choose to optically blend different colors.

Layering colors has a tendency to darken the tones of whatever you are working on, so make sure you work from light to dark or you may find that you run out of tonal values, causing the picture to go flat. Notice in these sketches how the tonal values are clear-cut—from the dark-toned walls and interior to the mid-toned shutters and light-toned decorative surround. As a beginner, you'll find it helpful to select subjects with similarly strong tonal values.

Expert Tip

A putty eraser is an indispensable tool for the colored pencil artist—and not just for rubbing things out. Use the eraser to lift color, for example, out of a blue sky to make clouds, or out of a window to suggest reflections on a pane of glass. You may also discover that when you put pencil to paper, the colors aren't as bright as you expected because the pigment fails to reach all the indentations in the surface. In this case, rub gently with an eraser to diffuse the pigment and increase the color density.

Shading and Blending

The two classic ways to build tone in pencil are directional shading (in which strokes are laid side by side) and crosshatching (in which parallel lines are applied at right angles to each other). In both cases the softer the pencil, the harder the pressure; and the closer the lines, the darker the tone. Directional shading tends to give a sketchier feel, which is preferable for backgrounds and large areas, while crosshatching—which offers more control—is better suited to modeling three-dimensional forms. But for a really lifelike, finished look, both types of shading can be vastly improved by smudging and blending the pigment so that the lines merge, and by lifting off pigment to create highlights.

Deep, blended crosshatching with a 1B pencil defines the form of the figure above against a more sketchily shaded background. On the left, vigorous directional shading with a 2B graphite stick creates a different atmosphere.

2B graphite stick: dark and dramatic

1B sketching pencil: great variety of line

Soft Blended Study

The artist wanted to do a white-on-white still life, so he selected garlic and a white chopping board. He added the knife for contrast and to practice making reflections. His drawing materials were a 1B pencil, a putty eraser and a torchon (see below), plus a very smooth paper to make the blending easier.

1 Lightly sketch the main shapes of the composition in pencil. Take time adjusting, erasing and refining the lines until you feel that everything is placed correctly.

2 Locate the darkest areas and shade them in firmly. Between the darkest tones that the pencil can create and the white of the paper lies the range of tones available to you.

3 Next, the darker mid-tones. Ease off the pressure slightly and shade from the darkest areas to the lighter mid-tones. Reserve areas of white for the reflections of the garlic on the knife.

4 Soften and blend with a torchon or putty eraser, being careful not to rub outside the area you're working on. Pick out highlights with the eraser and clean away any unwanted smudges.

Expert Tip

The torchon (tortillon) is an invaluable tool for blending when you need to exercise close control within a small area. A torchon is simply a piece of paper rolled up tight to the thickness of a pencil, although sizes vary (right). Its pointed end allows you to smudge and blend with great accuracy, making it ideal for creating highlights in pencil drawings.

5 Continue refining with the pencil and eraser until you're satisfied with the tonal balance. As a finishing touch, create highlights on the knife by carefully lifting off more pigment.

Hatching and Feathering

The colors, textures and tones of this scarf have been created almost entirely by hatching, crosshatching and feathering, using only the five colored pencils pictured below.

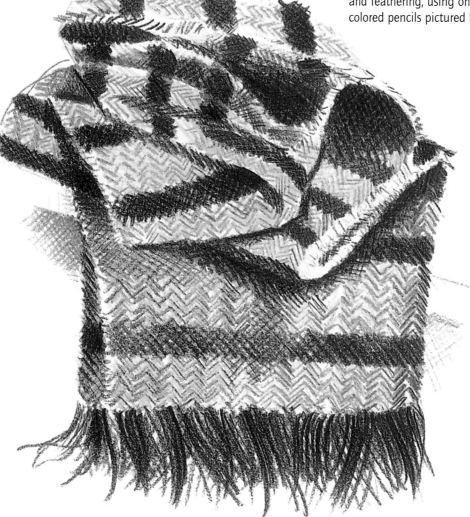

Hatching

Groups of parallel marks that do not intersect.

Crosshatching

Groups of parallel marks that intersect each other at right angles.

Feathering

Series of tiny, curved flicks that may or may not intersect. Tends to give a softer effect than hatching.

Hatching and feathering are two of the most important and widely used techniques in pencil drawing. When used to model the tones of an object to suggest its three-dimensional quality, they offer more control than simply flat-shading with the pencil on its side. When used to indicate texture, they offer almost limitless possibilities, depending on how hard you press and how closely the lines are spaced. But perhaps the most fascinating application of hatching and feathering is when they are used in conjunction with colored pencils to mix colors optically on the page. So if you like pencil drawing, get practicing; you could find yourself doing away with outlines altogether!

CREATING YOUR PICTURE

Hatch and Feather Demonstration

The soft, velvety texture of this festive hat with its fake-fur trimming lends itself perfectly to being rendered in soft, gentle strokes of hatching and feathering. All those little flicked, feathered marks of colored pencils work together to create the illusion of fur, while hatching and crosshatching greens against mauves suggest the highlights and shadows of the velvet.

Materials:
- colored pencils (light green, dark green, midnight blue, light blue, mauve)
- medium drawing paper
- putty eraser

1 Outline the hat with short, feathered strokes in mauve, and feather in a few key creases and shadows. These will be worked up at a later stage.

Expert Tip

For optical mixing of colors, feathering (below) tends to produce purer results than hatching or crosshatching. But beware of overdoing the overlapping strokes. It's generally better to leave some of the white paper showing through to illuminate the colors; otherwise, they may start to look muddy.

2 Build up the creases and shadows, adding directional feathering in midnight blue. Then use light blue to establish the form of the fur.

3 Bring form to the hat by feathering in light green and dark green, then stop and review the balance of the tones.

4 Continue working on the green part of the hat to darken the tones overall. For the very darkest folds and shadows, keep adding layer after layer of feathering so that short, flicked strokes of one color crisscross and fill in the strokes of another.

Conté Crayons

CLEANER THAN PASTELS and brighter than colored pencils, Conté crayons combine the best of both worlds. They are similar in makeup to pastels, but harder and therefore better suited to drawing rather than painting techniques. Because of their square format, you can use the flats for broad sweeps of color or the edges for drawing fine, delicate lines.

Conté crayons were traditionally available only in earth colors such as black, sepia (a mid-brown hue), white and sanguine—the distinctive red-brown color beloved of Renaissance artists for drawing figures. Modern Conté crayons (below) come in a much wider range of hues and are often sold by art-supply stores in sets of landscape or portrait colors. Unless you really fall in love with the medium, though, it's wiser to buy single crayons and gradually build up your own palette of colors.

Black Conté crayons offer an interesting—and cleaner—alternative to charcoal, as this study of the sunlit hallway of a Tuscan villa shows. The finer lines were drawn by sharpening the sticks to a chisel point, the dark tones by rubbing broken pieces of crayon into the paper. The sensitive shading of the mid-tones was achieved by laying the crayons flat against the paper and rubbing with broad, light strokes.

Conté Crayon Demonstration

On paper, Conté crayons behave in a similar way to hard pastels. In fact, there isn't a great deal of difference between the two, and some artists use them interchangeably. Traditionally, Conté crayons were preferred for figure drawing and soft landscapes, usually on a warm, mid-toned ground that complemented their earthy hues. Today the wider color choice means that you can use them for sketching just about anything. Try this colorful still life as a first exercise—or use hard pastels if you prefer.

Materials:
- Conté crayons (black, sanguine, sepia, white, mid-green, violet, light blue, dark blue, yellow, red)
- colored pastel paper
- craft knife

1 Arrange the boots into a pleasing composition. Next, using the corner of a sanguine crayon, lightly sketch in the outline of the boots. Add some shadows underneath and draw in the lacing.

2 Block in the rich red and green colors of the boots using the sides of Conté crayons, leaving gaps for the highlights. Next snap your violet, light blue and yellow crayons in half; drawing with these broken ends releases more pigment and produces stronger, richer colors. First, add violet to the open ends of the red boots and blue to the soles. Continuing with broken crayon, add yellow to the tops and soles of the green boots. Then sharpen the blue crayon to a point with a knife and draw in the laces of the green boots in more detail.

3 Now it's time to build up the tones. Using the tips of a sepia crayon and then a black one, gently darken the tones on the backs and sides of the green boots. Blend the colors with a finger. Use the black crayon again to emphasize their outlines, then apply short strokes of the same crayon to deepen the shadows beneath the boots. Similarly, use the tip of a dark blue crayon to create the shadows inside and on the soles of the red boots. Finally, use the tip of a white crayon to draw in the highlights on the red boots and blend these with a finger. Use white again for the metal eyes on the green boots.

Pens

PEN AND INK is a thoroughly modern medium. Forget about scratchy pen nibs and tiresome blobs of ink: rollerballs, felt-tips, ballpoints and technical drawing pens are today's stock in trade, and you probably already have at least some of them at home. Using different kinds of pen will bring variety of texture and tone to your drawings. Everyone has their favorite, but some pens are better suited to certain line styles than others, and it's quite common to use two or more types of pen in the same drawing. So try them all, and see what they—and you—can do.

Writing materials are not just for writing. And where pen and ink is concerned, a picture can be worth a thousand words.

These sketches show what can be achieved with a technical pen. The pen's clean lines make it ideal for quick contour studies, where the emphasis is mainly on outline and shape.

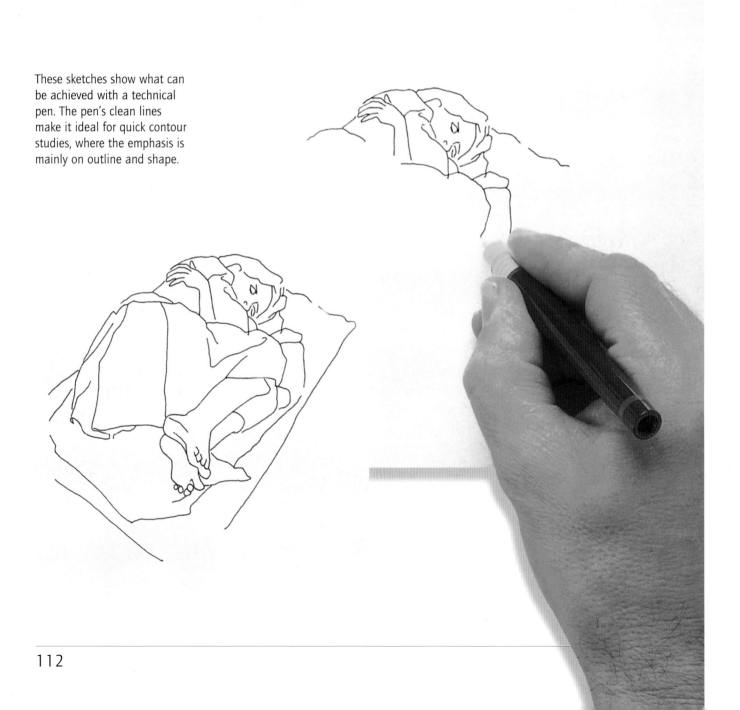

Making Your Mark

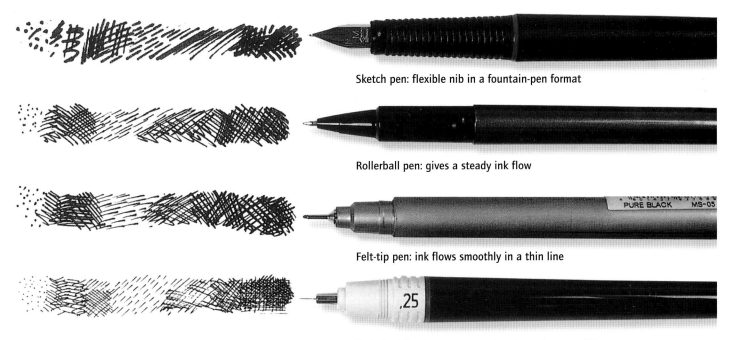

Sketch pen: flexible nib in a fountain-pen format

Rollerball pen: gives a steady ink flow

Felt-tip pen: ink flows smoothly in a thin line

Technical drawing pen: control and consistency of line

The great subtlety of a line obtained with traditional quills and dip pens may be hard to match, but working with a modern rollerball, felt-tip or technical pen makes drawing in pen and ink so much easier. The best thing about these pens is the constant flow of ink, which allows for rapid work and smooth, even lines. The drawback is that it can be hard to vary the line width. Increasing the pressure does give some degree of control if you are working in felt-tip, but at the risk of damaging the tip.

To get more variation of line, try making multiple strokes—for example, by overlapping short lines or laying them next to each other—and experiment with nonlinear strokes such as dots and squiggles. Alternatively, do what many artists do and mix pens—for example, by applying shading with a rollerball to a sketch drawn in felt-tip.

Expert Tip

Technical pens and graphic designer's felt-tips come in a range of nib sizes, some of which are very fine. But most artists find that medium nibs offer the greatest range of marks for drawing purposes.

Sketching in Pen

The speed of modern pen and ink makes it ideal for capturing fleeting gestures and movements that would otherwise be gone in a flash. The fact that you can't rub lines out or get "lost" in shading causes you to concentrate on the lines that convey the essence of the subject. The two sketches here were made while the artist was on vacation in India; notice how much information they convey with just a few lines.

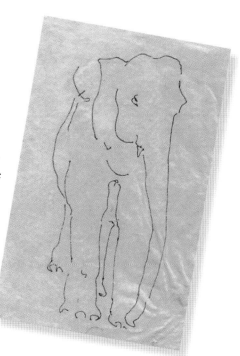

Contour Drawing

Different kinds of pen produce different marks. Each works best with its own drawing style.

Fine Felt-Tip

Creates consistently fine lines. To modify the appearance, rework your subject in loose, repeated strokes.

Coarser Felt-Tip

Best used with the technique known as "lost and found," in which interrupted lines help to give an illusion of three dimensions.

Sketch Pen

Has a versatile and responsive nib. The line it produces varies in thickness according to the pressure you apply.

Contour drawing means drawing with line alone rather than with line and tonal shading. At its most basic, the technique creates simple outlines. But by varying the nature of the line, you can make contour drawings that appear remarkably three-dimensional. If you are using a pencil or a sketch pen, alter the pressure you use so that the line is at times thin and at times thick. With drawing tools that generate a consistent mark, vary the type of line rather than the pressure you apply. Try a "lost and found" approach in which the line starts and disappears, or go over the line a few times in a more fluid style of drawing.

Fine felt-tip: produces a consistently fine line that calls for a sketchier approach.

Sketch pen: line width varies according to pressure, allowing for more precise outlines.

Felt-Tip Pen Demonstration

Felt-tip pens come in a range of nib types, some as fine and as precise as those on technical pens, others as broad and dramatic as highlighters. The finest ones produce a clear, consistent line. The broadest, as in marker pens and highlighters, are generally too crude to draw with. For making sketches, you want a nib between these two extremes. Ideally, choose a finely chiseled nib that will allow you to vary your lines depending on which edge you use.

Materials:
- pencil and felt-tip pen
- smooth sketching paper

1 Pineapples are deceptive in their complexity, so start with a pencil sketch. Draw in the fruit's segments one by one and outline the main leaves.

2 Go over the pencil sketch with your fine felt-tip. Add detail to the geometric design and the leaves. Then erase the pencil lines.

3 Finish drawing the leaves, putting in the curled ends. Try to vary the width of the lines, using thicker ones for the areas that are in shadow.

Expert Tip

Sketches made in felt-tip pen are easy to modify with the appropriate solvent: water (for most felt-tips) or turpentine (for oil-based inks). If you brush over an area of your drawing with clean solvent, you can dissolve some of the ink to create subtle areas of tone. The apples on the right were first drawn with a water-based felt-tip. Then a wet, soft round brush was used to transform the original outlines into various shades of gray.

4 Finally, add more detail. Draw in the gnarled bits of skin on each of the diamond-shaped segments to imply a rough, spiky texture and lightly insert the occasional crease mark to make the fruit appear more convincingly solid.

Oil Pastels

As their name suggests, oil pastels differ in character and consistency from their soft pastel cousins because they are held together by an oil—rather than gum—binder. The pigments are the same, which makes oil pastel colors just as rich. But because the binder can be diluted, carrying the pigment with it, oil pastels can be blended on the support, or thinned to create vibrant, luminous washes. Oil pastels come into their own for color sketching, thanks to their handiness and the ease with which they can be moved around the pad. One word of warning, though: The consistency of oil pastels varies. They become softer when warm, and even the warmth of your hands can alter the way they perform.

Expert Tip

Oil pastels are thinned and blended on the paper using white spirit. Among the materials you'll find useful for doing this are cotton wool pads (for large areas), bristle brushes (for creating washes) and cotton buds, for blending details.

Like soft pastels, oil pastels can be optically blended on the support by laying one (preferably transparent) color over another...

...but to some extent they can also be blended physically (left), even without white spirit, to extend the range of color possibilities.

Oil pastels are sold in 80 or so colors—a smaller range than soft pastels. But the fact that oil pastels can be blended makes extra color variations possible.

Oil Pastel Techniques

Oil pastels have their own techniques, many of which are more closely related to oil painting than to soft pastels. Impasto is the art of building up thick, intense layers of color simply by applying more pressure. Stippling is a technique for blending colors optically using short, stabbing strokes. Fine blending can be done with a cotton swab soaked in white spirit to soften edges and details. Another oil-related technique is sgraffito, in which you use a penknife to scratch lines through thickly applied layers of color to reveal the underlying layers or the color of the support.

Stippling

A technique in which oil pastels are applied in broken patterns of short, stabbing strokes (above). This causes colors to mix optically rather than physically.

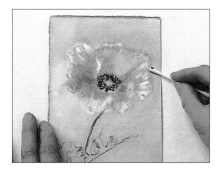

Fine Blending

Use a cotton swab soaked in white spirit to blur the edges of areas of contrasting color (left) for a softer, gentler effect.

Impasto

The slightly stiffer consistency of oil pastels makes them ideal for impasto—the dense application of paint, in which individual marks remain visible.

Classnotes...

Oil pastel washes can be done in one of two ways, depending on whether you want a gentle wash or a more luminous effect. Either way, be sure to work on a canvas board or pad; even heavy watercolor paper buckles under the strain of soaking in white spirit. Protect your hands, too.

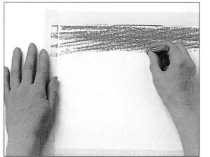

For a gentle effect like this sky, lay down the strokes of color as evenly as possible. Then sweep across the surface with a cotton ball soaked in white spirit, lifting off color as you go.

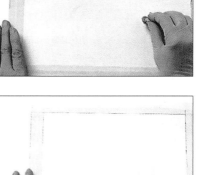

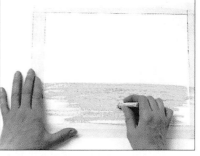

For a more luminous wash, apply the color in broad, sweeping strokes. Then brush the area with white spirit to disperse the pigment without actually removing it.

Soft Pastels

SOFT PASTEL is the original and most popular form of pastel medium. Its soft, fine-grained nature makes it easy to apply and gives you the chance to employ a broad range of painting techniques—from watercolor-style flat-toned washes to the kind of rich, bold layers of color more reminiscent of oils. By their nature, soft pastels are likely to

create a fine powder as you work with them. But this is more than outweighed by their extraordinary brilliance of hue: Pastels contain just enough binder to hold the pigment in stick form, which helps to retain the pigment's original purity.

The raw constituents of soft pastel sticks: chalk (filler), gum (binder), pigment and water.

Did You Know?

The term pastel reflects the way pastels are made. The word comes from the Italian *pastello*, which derives from pasta, meaning paste. Pastels are made from dry pigments, chalk and vegetable gum, which acts as a binder. The pigment and a weak solution of the gum are mixed into a stiff paste—traditionally with a mortar and pestle. Chalk is then added to the pigment in increasing proportion to create the various tints of colors. Finally, the paste is shaped into sticks and left to dry.

Soft pastels are fragile and need to be stored carefully. The foam-filled trays in large boxed sets offer the best protection, as well as ensuring that one color is not contaminated by the powdery residue of another.

Shapes and Sizes

Half Pastels
Less prone to break than regular pastels; sold in boxed sets of up to 60.

Large Pastels
Sold in a wide range of colors, but available only from larger art suppliers or by mail order.

Of all the pastel types—soft, hard, water-soluble, oil pastel, pastel pencil and so on—soft pastels come in the most extensive range of colors. Sticks are sold individually or in boxed sets of varying size and box quality. Some manufacturers produce more than 300 different colors, but you will find that the very large sets have equally sizable price tags.

The three types of stick—half, large and square—are broadly similar in consistency and in the way you use them. But each type is suited to particular kinds of mark, so it pays to have a selection of all three in your set.

Soft Options
Different shapes of pastel produce different effects.

Although they are relatively expensive, large soft pastels are ideal for blocking in areas of color. So if you plan to work on a large scale, with broad, flat areas of tone, you'll probably find that these chunky sticks pay their way. On the other hand, if your style tends toward the decorative or delicate, you'll find that the sharp edges of square soft pastels give you sharper lines and more control than their conventional round equivalents.

Square Pastels
Good for fine lines but only available in a limited color range.

Expert Tip

Keeping your pastels as good as new is the secret of getting clearer lines and truer colors; heavily used sticks become increasingly powdery, and you need to be very careful not to let them contaminate each other. No matter how you choose to store your pastels, it's good practice to keep a box of tissues beside you as you work and to wipe sticks clean at regular intervals. But when you've finished for the day and you're tired, resist the temptatation to throw the sticks together into a tin or box. If your budget won't allow you to buy a special pastel box with individual foam-filled compartments, try laying the sticks in dry rice instead. As long as all the sticks are kept separated in the box, they'll stay clean.

Cleaning with Rice
You can use dry rice to clean pastel sticks. Put the stick in a jarful of rice and shake gently for a few seconds. Any stray powder will stick to the grains.

Supports for Soft Pastels

For the soft-pastel artist, choosing a suitable support (surface) to work on is especially important. Because of the nature of the medium, both the texture and color of the support can have a significant—and sometimes dramatic—effect on the finished painting. What all pastel supports have in common is a noticeably textured surface, or tooth, which rubs away the pastel and retains the particles of pigment dust within its fibers. Generally speaking, the sharper the tooth, the greater its holding power and the better suited it is to thick applications of color.

A simple flower sketch made on high-quality NOT watercolor paper. Notice the subtle muting effect of the paper's color and texture on the pastel colors.

NOT Watercolor paper
Even textured, making it more suitable for controlled blending than rougher textured papers.

Ingres Paper
A marked texture of parallel lines; one of the most popular papers, available in a wide range of colors.

Canson paper
A stippled (dotted) texture on one side that gives a less directional look than Ingres; also made in a wide range of colors.

Flocked (velour) pastel board
Has a texture created by spraying fine particles of cloth onto the surface of art board; ideal for subtle blending.

Glass paper
Coated with a fine layer of grit to give an exceptionally sharp tooth; ideal for thick applications.

Rough watercolor paper
Another support with a sharp tooth, making it ideal for heavy applications of color (impasto).

Colored Papers

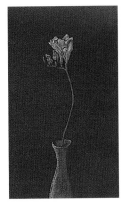

Olive green

This delicately colored flower and vase are thrown into sharp relief by the dark tones of the paper. The colors take on a luminous quality against the drab, receding background.

Color Contrasts

With so many colors available (above), your choice of support color can have a dramatic effect on the final outcome (left).

There is a vast range of colored papers available, but it's always worth paying more for artist-quality paper. Unlike ordinary wood pulp paper, which contains bleaching agents that cause it to become brittle and yellow with age, artist-quality paper is made from cotton rag and retains its purity. Speciality pastel papers come in pads, sheets, rolls and on boards. For the beginner, pads are a good starting point; as well as being handy, they generally include a selection of warm and cool colors and are relatively inexpensive.

If you opt to buy individual sheets, the choice of colors can be overwhelming: Should you go for a subtle tint or a bold, solid color? Until you get used to the way pastels behave on different backgrounds and develop a sense of personal style, there is really no knowing. As an exercise, try repeating a simple subject on scraps of different colored papers (as on the left) and see which ones work for you.

Vermillion

By contrast, the strident nature of this background dominates the painting. Even so, the fact that red and green are complementary stops the flower from getting lost.

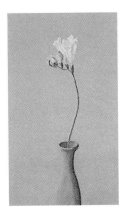

Peach

What this lacks in drama it more than makes up for in subtle charm. The vase works well against the background, and the paper is just dark enough in tone to carry the flower head.

Middle Ground

The tone of your support can be just as critical as the color, as these sketches on a neutral colored paper show. Capturing feline movements means working rapidly, with little time to plan for highlights. By using a mid-toned support, the artist gives herself the chance to paint in both lights and darks as she goes along.

Mauve

This color harmonizes with the vase and is dark enough in tone to draw attention to the flower head, especially since mauve and yellow, too, are complementary colors.

Blending Pastels

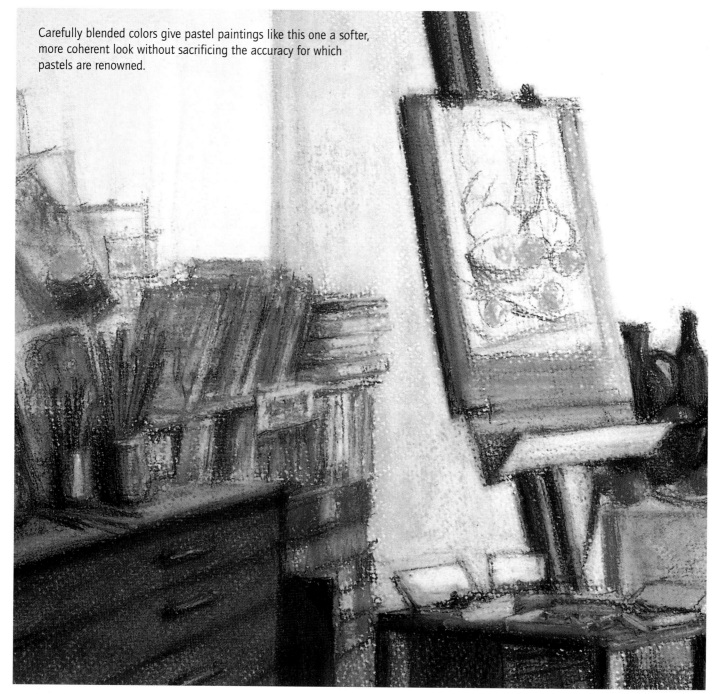

Carefully blended colors give pastel paintings like this one a softer, more coherent look without sacrificing the accuracy for which pastels are renowned.

Pastel colors can't be mixed in the way that oil paints and watercolors can, which is partly what gives pastel paintings their unique vividness. But because pastel dust, once applied, consists of pure pigment, it's possible to blend colors together on the paper to create a broader range of hues and tones. At its simplest, the blending can be done with your fingers or, for larger areas, with the side of your hand. Even so, you'll find that the special blending tools described here give you more control and offer a wider range of effects. All of them are inexpensive and readily available—and, in a pinch, most can easily be improvised using everyday items from around the house.

Tools for Blending

Because pastel pigment dust grips the paper loosely, it's easy to spread or blend colors. The special blending tools shown here will help you achieve a wider range of effects, but you can easily improvise with paintbrushes and rolls of paper.

Using an Eraser

Roll it across colors using only the slightest pressure for a fine blend, or shape it to a point and draw it across a pigment more firmly to add texture. For lifting pigment off to create highlights (right), use a short, stabbing motion.

Putty eraser
Can be shaped to a point for blending details and for streaking or crosshatching to suggest texture; also useful for lifting off color to create white highlights.

Using a Fan Brush

Gently dust a fan brush over the surface of the paper to produce more subtle gradations of tone and color once you've established the main tonal variations of the painting. On the left, a fan brush is used to soften the areas of shadow around the pear without disturbing the outline of the fruit itself.

Fan brush
Normally used to brush away loose pigment from the finished painting, softening the tones in the process; also useful for dispersing pigment dust over large areas.

Using Torchons

Also called tortillons, these are for detailed blending. Sold in various sizes, they don't lift off color to the same extent as a putty eraser. As a rule, make short strokes in one direction, as though you were crosshatching with a pencil. Depending on the pressure, you'll either lift off pigment (right) or blend it.

Torchon (tortillon)
A tight roll of paper shaped like a wax crayon to blend fine details; when dirty, the top layer of paper can be unwound from the tip and discarded.

Using a Cloth

For larger areas of color, like the background to this flower (left), using a cloth to blend will give you more consistency of tone at the expense of fine control. To compensate, try to work backward into areas of blank paper.

Soft cloth
For blending large areas of flat color, make sure the cloth is lint-free, or flecks of material will contaminate the pigment.

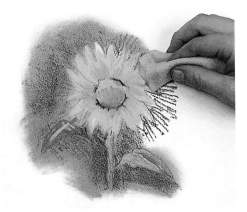

Drawing with Hard Pastels

HARD PASTELS, as their name suggests, contain a greater ratio of binder to pigment than their soft-pastel cousins. Hence, they behave more like chalky pencils and are usually classed as a drawing medium. The sticks are also square with sharp edges, which means that depending on how you hold them, you can draw very fine, precise lines as well as blocking in broader areas of color.

Hard pastels can be physically blended, too, which offers you the chance to combine crisp, clean line work with the color vibrancy for which all pastels are renowned. Hard pastels don't come in quite so many colors as the softer type, but even just a few will still enable you to produce colorful eye-catching drawings.

Hard Pastel Study on a Blue Ground

The picture above is a good example of how even the most everyday objects can be brought colorfully to life by drawing with just nine colors (right) on a rich blue support. The blue ground adds depth to the various blues and greens laid on top, while the fine lines of the mop handle and the outline of the bucket show just how crisp hard pastels can be. At the same time, the ease with which hard pastels can be physically blended on the support is apparent in the mop head and the sides of the bucket, where the artist's fingers have smudged color over color to build up depth of texture and variety of tone.

light blue

light olive green

blue-green

yellow ochre

ultramarine

terra-cotta red

cerulean blue

black

white

CREATING YOUR PICTURE

Hard Pastel Demonstration

This study demonstrates the ability of hard pastels to produce fine, crisp lines, as well as the more standard techniques of blocking-in and blending pigment dust directly on the support. Hard-pastel drawings tend to work better on a colored ground, which allows you to add both darker tones and highlights. In this example, the artist chose yellow ochre to complement the dark blues of the subject. Note that the texture of the support need not be as pronounced as for soft pastels, so you can feel free to use inexpensive craft paper.

Materials:
- hard pastels (8): yellow ochre, terra-cotta red, light blue, ultramarine, blue-green, dark brown, black, white
- sheet of yellow ochre craft paper; kitchen paper

1 Make the initial sketch in yellow ochre, which will barely show against the ground. Start with lines only, using the edge of the stick, then block in color using the side. Redraw over the yellow ochre with terra-cotta and block in shadows using the same color.

2 With a paper towel, gently smudge areas of your drawing. Add ultramarine over the terra-cotta lines using the point of the pastel. Next, block in the dustpan and the darker parts of the shadow using the side of the same pastel, but retain flecks of terra-cotta for sparkle.

3 Add the other two blues and the black in small amounts, working with the edges of the sticks. Confine the lighter blue to the brush handle and the black to the darkest areas of shadow. Gradually the blues will begin to obscure the colors below but leave some of the terra-cotta red and yellow shining through to lift the drawing.

Fill in the darker areas with dark brown and a little green. If necessary, tone down the light blue of the brush handle by smudging with a paper towel. Finally, add delicate strokes of light blue and white for the highlights on the brush handle, bristles and rim of the pan, and a little terra-cotta red to the cast shadow on the right.

the projects

If you're ever short on inspiration, this is the place to come. Employing a range of the media already covered, twenty talented artists have each created a project that takes a more in-depth look at a specific technique. The detailed instructions and first-person tips from each artist offer skills that can be practiced and then applied to your own work. There's even a Try It For Yourself suggestion at the end of each project that focuses on a specific element within a book by one of the great masters.

Lake View in Two Colors

Artist: Ray Leaning

In this study I used a large flat brush to lay in broad washes of color, and a paper towel for lifting out some of the paint to convey the impression of white clouds.

cadmium lemon

Winsor blue

Size 12 flat

Size 7 round

Size 1 round

PLUS: paper towel or tissue paper; watercolor paper

THIS PAINTING WILL GIVE YOU PRACTICE in painting wet-in-wet—blending washes of color while they are still wet to give a characteristic watery feel to the picture. To keep things simple, I used just two colors: Winsor blue and cadmium lemon. Applied in different combinations and dilutions, these tints are capable of a vast range of hues, from the pale blue of the sky to the greens of the trees and the dark shadows in the foliage. Although I worked from a photograph, I didn't try to duplicate it, nor did I bother to draw the scene first. Instead, I wanted to see what effects I could achieve just by washing in my chosen colors.

Getting Started

Old photographs can be a treasure trove for artists. The chances are that if you liked a scene enough to photograph it, you will also like it enough to paint it. I came across this picture I had taken of a Scottish lake and decided to try my hand at painting it.

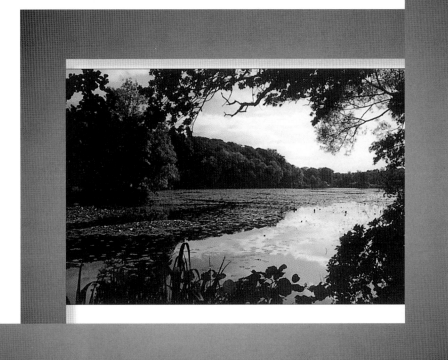

Watercolor paper comes in standard sizes and formats. My photograph was a little too wide, so I decided to crop it. As well as making my job easier, the slightly tighter view made for a more dynamic picture.

1 Tape a sheet of watercolor paper onto a board. Applying washes can be tricky, so make sure you can maneuver your board easily. Begin by brushing or sponging clean water over the area where the sky will be, starting a little below the top of the sheet.

2 Mix a thin wash of Winsor blue. With a large flat brush, sweep the paint across the page, starting at the top edge. Allow the color to seep downward. Next, mix a slightly darker wash and repeat the process so that you have a graded sky that fades gently toward the horizon line.

Heading Up

3 For the clouds, scrunch some tissue paper or paper towel into a cloudlike shape. Now gently press the paper onto the wet sky. When you remove it, you will see that an area of color has come off. This is known as lifting off. You can alter the shape of your clouds by either dabbing or dragging your paper over the moist blue paint.

4 To paint the lake and treeline, lay a pale blue wash with your large flat brush, starting in the center of the paper. If you want to lighten any area, use paper towel to lift off color as you did for the clouds. After this wash has dried, mix a thin wash of cadmium lemon and carefully rough in the tree shapes along the horizon using the medium-sized brush.

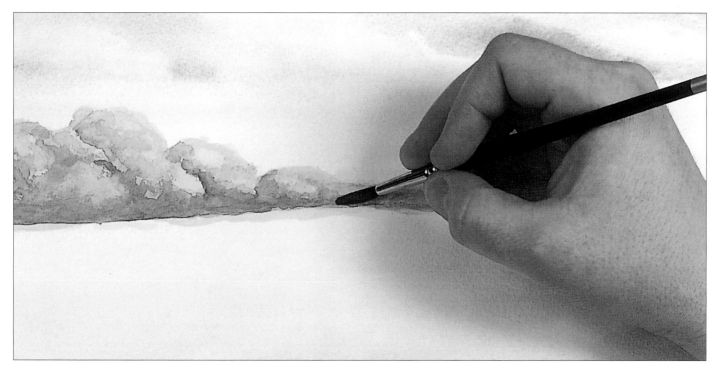

5 Establish where the light source is; here, the sun is out of frame to the right, so shadows are cast to the left. Mix a thin wash of Winsor blue and lay in rough shadows of the trees leaving areas of sunlit highlights. Note how the blue transforms the yellow into green. Working wet-into-wet, add small amounts of darker wash into these shadow areas and allow them to spread. The idea is to give the general impression of trees rather than painting each one individually.

An Impression of Distance

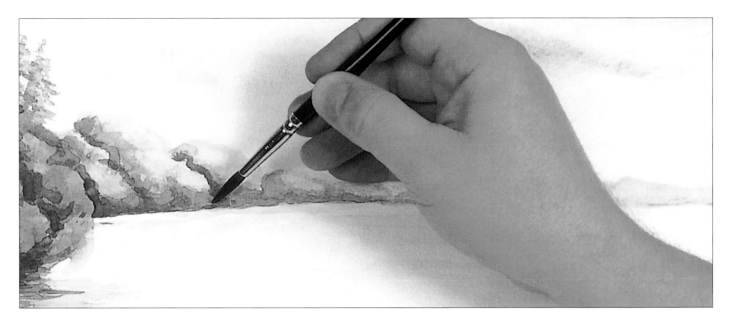

6 The farther away the objects are, the paler they appear, while nearer objects seem stronger and more vibrant. To create this effect, use a strong mixture of Winsor blue to wash in the trees in the left and right foreground. Once the paint has dried, carefully describe the dark shadows beneath and behind the trees. Notice how far away the distant trees now seem by comparison.

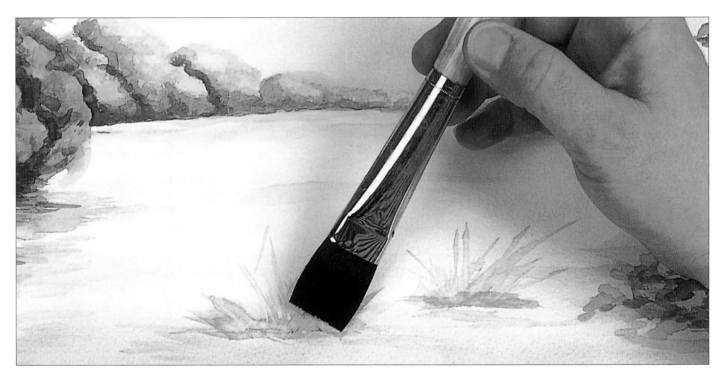

7 With a large brush, add touches of Winsor blue for the foreground details. Dab and drag the brush across the paper to simulate different textures, such as the spikiness of the reeds, the leaves blowing in the breeze, the ripples in the water. Drag the brush semidry to create the impression of reeds; use a more watery mix and a smaller brush to suggest the clumps of leaves on the right. After these have dried, add extra touches of blue and yellow as needed.

Keep all the ripples horizontal; otherwise, the water will appear to be running uphill.

Dabbing paint on with a medium-sized brush creates looser, more impressionistic effects.

Use the tip of a fine brush to draw in details, such as delicate branches and blades of grass.

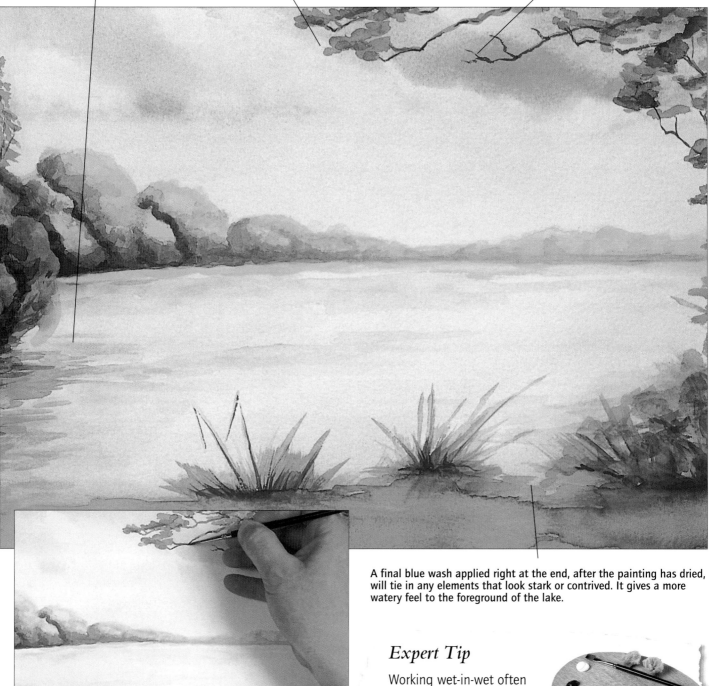

A final blue wash applied right at the end, after the painting has dried, will tie in any elements that look stark or contrived. It gives a more watery feel to the foreground of the lake.

8 Using your smallest brush, carefully pick out the details on the trees nearest you—for example, the branches on the right of the picture. Finish off the painting by using the smallest hints of cadmium lemon to add a sense of the sun's sparkle on the water and to the leaves and grass in the foreground.

Expert Tip

Working wet-in-wet often blurs details and can cause colors to run into each other. If you want to avoid this and keep colors clean or edges sharp, try giving your painting a blast from a hair dryer. This will dry the paper quickly and allow you to apply fresh washes or sharp details safely. Many professional watercolorists use this technique so that they can work more quickly and accurately.

Learn from the Master: J. M. W. Turner
Stonehenge

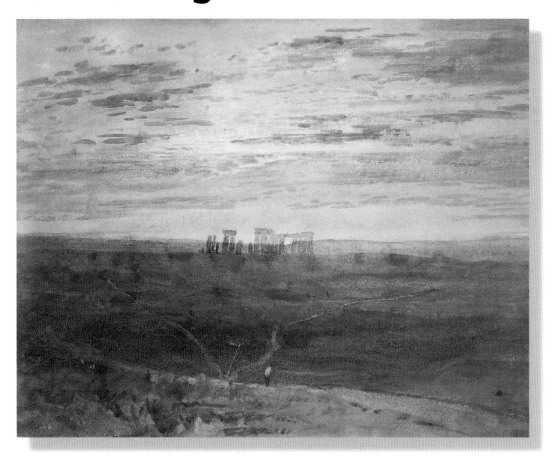

I N HIS LATER YEARS the nineteenth-century English artist
Joseph Mallard William Turner gave up his earlier
method of laying washes over drawings and began to
draw with color alone. Instead of detail, he became interested
in the way that light defines the atmosphere and scale of a
scene, as exemplified by this watercolor view of Stonehenge
at sunset. Turner begins with the light itself by laying a warm
red wash over the upper half of the picture. At the horizon
line, defined by distant hills, this wash is left almost
untouched. Above it, streaks of blue grow steadily in density
and intensity to suggest the onset of evening. In the
foreground the undulations of the somber landscape are
defined by darkening the tones of areas in which sunlight has
ceased to fall. The figure, the sketchy pathways, and the
almost casually rendered silhouette of Stonehenge itself create
a sense of scale and perspective with just a few brushstrokes.

Try It for Yourself

Take a leaf out of Turner's book
and see what effects you can get
by drawing with color using a
subject silhouetted against the
sky. Limit your palette to just two
colors; start with the lightest
washes and work back toward the
dark tones. You may be surprised
what can be achieved with just a
few brushstrokes.

Fruit Still Life

The secret of working with a limited palette is to create variations in tone and intensity by building up the paint one layer at a time.

Artist: Ray Leaning

THIS HIGH-KEY STILL LIFE IS AN EXERCISE in re-creating a lifelike image using just three colors. It shows just how versatile watercolors can be, gives you valuable practice at mixing colors and demonstrates the art of creating tonal variation simply by building up layer upon layer. In fact, all the colors here are derived from just six simple washes mixed from three high-key primaries. So, one brush, three colors, and off you go!

You will need...

permanent rose

cadmium lemon

Winsor blue

B pencil

Size 2 round (preferably sable)

PLUS: heavy watercolor paper; eraser; blotting paper

Getting Started

One of the benefits of a still-life study is that it doesn't move; you can set it up, leave it, and come back to it. You are in control of the positioning. If you can also control the lighting, by using good artificial light rather than daylight, then you are in total control of your subject.

Take advantage of this by trying out the light source in different positions until you are completely happy with the effect.

Arrange the composition: Use a pair of L-shaped pieces of cardboard to crop in the subject.

Expert Tip

A rule of thumb when working from life: Use the "sight size" technique to accurately measure your subject height and width and then transfer those measurements to paper.

Measure Up

Close one eye. Hold your pencil vertically in an outstretched arm with elbow locked. Align the point of the pencil with the top of the composition. Now slide your thumb down to align with the bottom of the arrangement.

Transfer Your Measurements

Decide how big your final picture will be. If you want to work to sight size, transfer the measurements directly onto your paper. In this example, the artist is working 2 x sight size, so he doubles all his measurements.

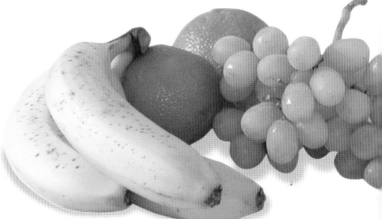

Keep it simple: There are many color variations to identify in these three fruits alone, so arrange them on a plain background to help simplify the subject.

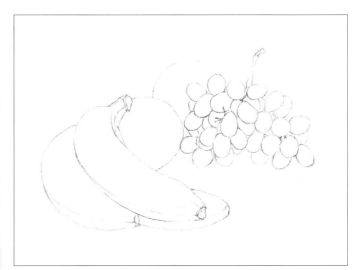

1 Working with a soft pencil on watercolor paper, lightly sketch the outlines of the fruit. (Using a smooth, relatively heavy watercolor paper will stop the paper from buckling when you start painting.) Keep the lines quite faint and don't be tempted to shade in the darker areas— these will be defined using built-up layers of paint. Use an eraser to adjust any lines and to correct mistakes.

Underpainting

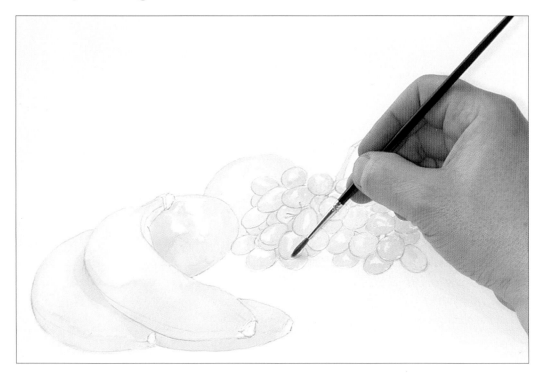

2 Once you're happy with the sketch, start painting. All of the chosen fruits have a yellow base, so apply a thin yellow wash over all of them—except for the white highlights on the grapes and oranges. Paint each piece of fruit separately. (Do this throughout the project to prevent blurring and to keep the edges crisp.) Apply more yellow wash to the darker areas of the subject. Allow a few minutes to dry.

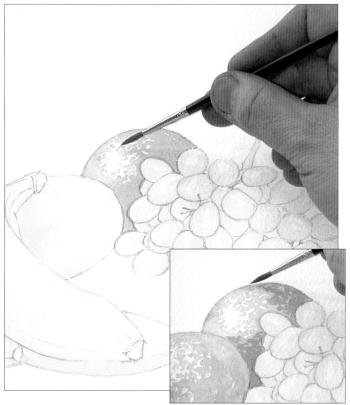

3 Mix permanent rose and cadmium lemon with plenty of water for the orange. Work from dark to light, adding more water as you go, and use the end of your brush to create a dimpled texture. Leave some white paper and yellow to show through for the highlights. Add a second wash to build up the color.

Two Tonal Washes

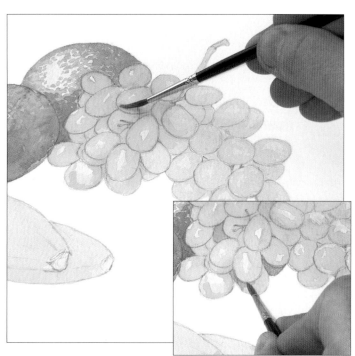

4 Mix cadmium lemon with a small touch of Winsor blue to make pale green. Wash over each grape individually, leaving white and yellow highlights. For the second wash, mix in a fraction more blue and work on the darkest grapes first—those in shadow. Soften any unwanted hard edges by brushing with clear water.

Dark Wash Details

5 With green still on your brush, don't forget to look for little bits of green on the bananas. Next, using a clean brush, mix cadmium lemon and permanent rose with touches of Winsor blue to make a brownish-yellow. Soften this with water to create different strengths of color for your bananas. Add a touch more blue to make a darker brown for the brown shadows, flecks and banana tips.

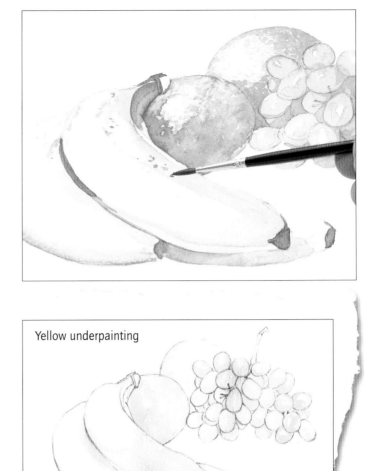

Classnotes...

Constantly ask yourself as you paint: Which area is lighter and which is darker—the area behind or in front? Remember, because watercolor is translucent, variations of color density can be created by building up several layers of the same color, or by laying another color over the top. Layers can be applied either when the previous ones have dried for a sharp edge, or when they are still slightly damp for a soft edge. If done immediately, the colors will run.

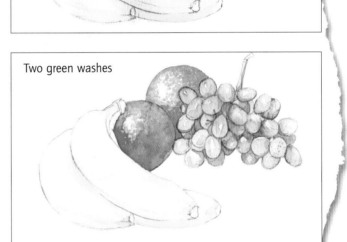

Yellow underpainting

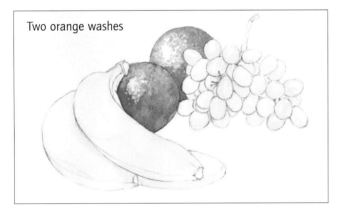

Two orange washes

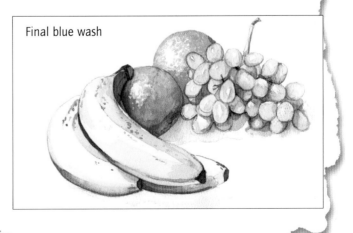

Two green washes

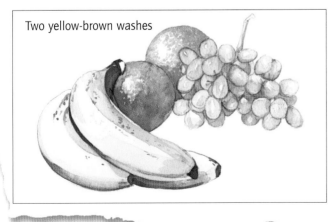

Two yellow-brown washes

Final blue wash

Highlights are created by leaving areas of the white paper unpainted. The pale yellow underpainting also shows through in some places, enhancing the effect.

Stippling and dabbing the orange wash with very small brushstrokes gives the impression of dimpled orange skin.

A final thin wash of Winsor blue creates shadows beneath the fruit and is also used lightly on the grapes, oranges and bananas to model the darkest areas.

Dabs and flecks of the darker brown wash add detail to the banana skin.

Hints of green color can be seen at the ends of the banana.

Casting Shadows

6 Paint shadow areas beneath the fruit with clear water first. Then dab in Winsor blue and let it run into the wet areas. Also use this thin blue wash to pick out the darkest shadows and extra details on the grapes, oranges and banana tips.

Learn from the Master: Paul Cézanne
Still Life of Peaches and Figs

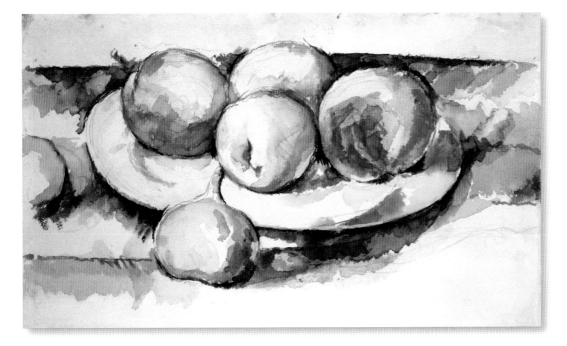

THE FRENCH IMPRESSIONIST Paul Cézanne (1839–1906) is an acknowledged master of still-life subjects. He was attracted to them because he could compose and light them exactly as he wished and then study them— sometimes for hours—until their forms and colors began to take on a life of their own. At this point Cézanne would start painting, often with a limited palette and always with

simple, expressive brushstrokes. Yet behind the apparent simplicity of his work lay a greater complexity: Rather than just imitating nature, Cézanne was more concerned with painting what he felt. In this watercolor on paper, it is the soft, plump forms of the slightly overripe fruit that immediately catch the eye. While the outlines are clearly defined, the forms are built by patiently laying layers of intense color upon one another (detail above), with little or no attempt at blending. The result is rich and expressive—a triumph, in fact, of emotion over reason.

Try It for Yourself

Surprising as it may seem, painting loosely is often harder than keeping a tight control over your brush-strokes—but the effects can be magical. See if you can paint a peach or similar rounded fruit in the style of Cézanne.

Start with a simple pencil outline, then take a medium-sized brush and gradually build up the layers of color. Let your brushstrokes follow the form. Make your paint mixtures intense, but still transparent enough to allow the layers beneath to show through. Allow each layer to dry before you apply the next.

Pots and Plants

Artist: Carolyne Moran

spectrum red

alizarin crimson

spectrum yellow

French ultramarine

indigo

raw umber

lamp black

I CHOSE GOUACHE PAINTS for this still life because they have a more rugged quality to them than traditional watercolors, which I think suits the subject well. Gouache is simply watercolor with gum and chalk added to make it opaque. This means that it can be used thickly and applied light over dark, a bit like oils and acrylics, so you don't have to plan your washes in advance. On the other hand, you have to be very precise with your mixes and keep your water and brushes clean or you'll end up with mud.

You will need...

Size 3 round brush

Size 5 round brush

PLUS: zinc white; heavy watercolor paper

Getting Started

This jumble of gardening paraphernalia has a pleasing slice-of-life quality. When setting up a still life, aim to create a natural grouping that has an air of spontaneity; a setup that's too carefully arranged can look contrived and dull. When it comes to choosing what to paint, I usually find that a still-life group that has a theme works better than a collection of disparate objects because it has a story to tell. But the most important thing is to choose objects that you really like. If you are inspired by your subject matter, it will come through in your painting.

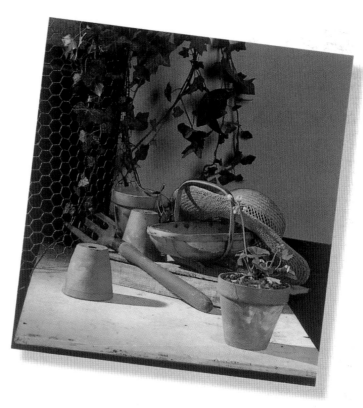

Lighting always plays an important role in a composition; arranging for the light to come from the left casts strong shadows that help to describe the rounded forms.

Cropping the Picture

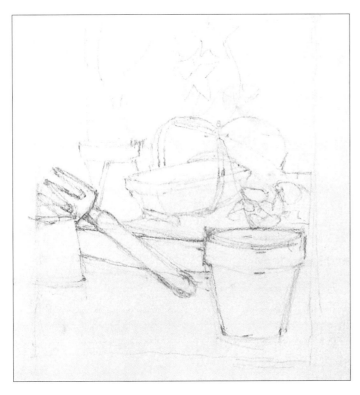

1 After exploring possible compositions through my viewfinder, I decide where the edges of the picture should be; notice that I have cropped out the empty areas all around the group. Then, using a soft pencil, I start to sketch in the outlines. I try to view the group as a whole, rather than completing objects one at a time.

Blocking In

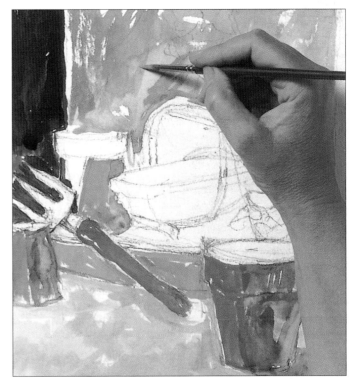

2 I quickly block in dilute areas of color. For the fork handle, I mix equal amounts of spectrum red and yellow. I use the same mix for the flower pot, with raw umber on the right. For the tabletop, I start with spectrum yellow plus a touch of red. Then I block in the cool gray of the wall with zinc white and just a little French ultramarine.

Establishing Colors and Modeling Tones

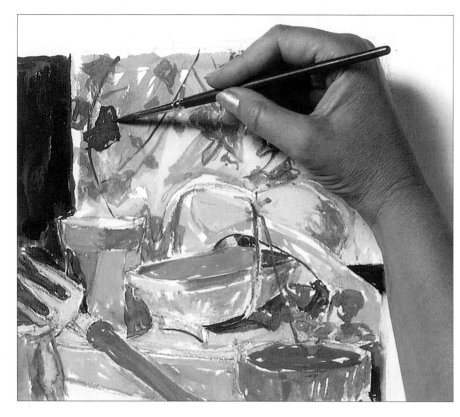

3 When I mix a color for one part of a picture, I look to see where else I can use it. I find that moving around the picture this way gives a more harmonious and unified result. The garden basket and straw hat are painted with various tones of white, spectrum red, spectrum yellow and raw umber. For the trailing ivy, I mix French ultramarine and spectrum yellow, lightened with white or darkened with raw umber for the darker shades of the leaves.

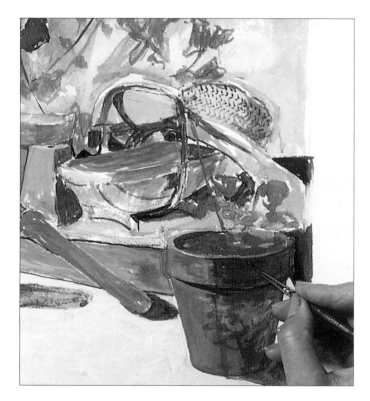

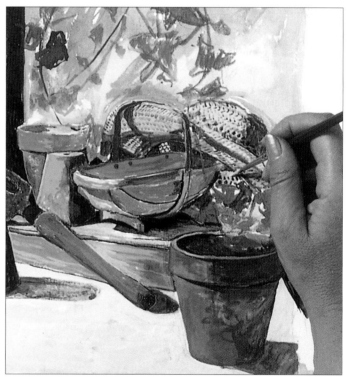

4 Now I start to model the dark areas and cast shadows that describe the forms of the pots using a dilute mix of raw umber darkened with a little indigo. I find indigo is much better for darkening than pure black, which tends to make everything flat.

5 With all the main colors and tones in place, I switch to a smaller, size 3 round brush and start work on the details and textures. Here, I am using the very tip of the brush to suggest the woven texture of the straw hat with tiny strokes of indigo and raw umber.

Creating the Illusion of Depth

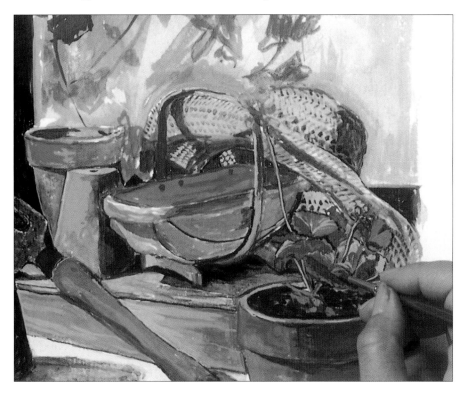

6 I decide to add more color and detail to the potted geranium. This has the effect of pulling the foreground nearer and pushing the background farther away, accentuating the impression of space and depth in the composition. The pink geranium bud is modeled with light and dark tones of zinc white and alizarin crimson.

Finishing Touches

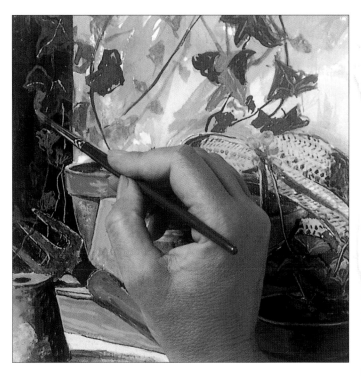

7 When the painting is almost complete, I take a short break. On my return I tend to see things with fresh eyes, and any changes or modifications that are needed usually become immediately obvious. Next, I add a few more ivy leaves in the background to unify the colors.

Expert Tip

While gouache paint has a characteristic matte finish, it doesn't have to. You can use gum arabic to make it shinier, either in a localized area of your painting or over the whole of it. If, for example, you want to create a highlight, simply mix a little gum arabic into your pigment to make it glow. Alternatively, for a more lustrous finish, paint a dilute wash of gum arabic over your finished image once all the paint has dried.

Gum arabic
A little of this mixed in with your paint will make it shine.

The greens of the ivy work well against the complementary terra-cotta reds of the pots and help to tie the picture together.

The straw hat echoes the curving forms of the plant pots, while its woven surface adds a welcome note of textural contrast.

Don't forget the fairly sharply defined shadow areas on the hat and the handle of the basket.

Highlights and dark tones are softly blended into the mid-toned base color of the pots to model their rounded forms.

The light tones of the tabletop and sharply cast shadows imply that the objects are bathed in sunlight rather than lit artificially.

The size and level of detailing on the foreground flower pot relative to the pot in the background helps to give the composition a sense of depth.

Learn from the Master: Lisa Graa Jensen
Our Backyard

SNAPSHOTS OF EVERYDAY LIFE are what interest artist Lisa Graa Jensen: For her, the colors and textures that come into play help to lift such scenes out of the ordinary, as well as provide some interesting possibilities for mixing media. In this garden view, Jensen combines the subtlety of watercolor with the depth of gouache on paper to create a treasure-trove of colors and textures, from the weathered terra-cotta pots and mildewed shed to the brilliant flowers and sparkling white sheets and window frames. The artist's technique is to begin with an underpainting of watercolor and to let the luminous, transparent quality of the medium shine through where appropriate—for example, on the geranium leaves, the lawn and the shed window. Then, to create textural variation and depth of color, Jensen applies successive layers of gouache over the top. Once dry, the matte finish of the more muted colors perfectly captures the earthiness of the pots and shed, while the opacity of the brilliant reds, blues and white leap off the page in what amounts to a far from ordinary painting.

Try It for Yourself

The way the side of the shed is painted, you can almost sense the dampness of the wood and the slipperiness of the mildew. Try painting a plank of wood in gouache to see if you can evoke similar sensations. Start with an underpainting of dark green, loosely mixed from blue, yellow and a touch of raw umber so that the constituent colors show through. Let this dry, then draw very fine brushstrokes of yellow and white across it to suggest the opening of the grain.

African Violets

With no colors to worry about, a monochromatic study like this offers the chance to really focus on tonal values.

Artist: Sharon Finmark

DRAMATIC PICTURES don't necessarily call for an entire palette of colors. I decided to paint this still life in just two colors to explore my subject purely in terms of its tonal values—in other words, the relationship between the light areas and the dark areas and how they create the illusion of three-dimensional form. A painting like this is known as a monochromatic (one-color) study. As well as offering the challenge of working with a limited palette, it gives you hands-on experience of building up the paint in layers to create increasingly darker tones.

You will need...

indigo

Payne's gray

Size 8 round brush

PLUS: watercolor paper; blotting paper; soft pencil; eraser; size 3 brush (optional)

Getting Started

One of the benefits of a still-life study is that you have total control over the lighting and positioning. In a monochromatic study, the tonal values created by the lighting are particularly important. Artificial light is preferable to daylight, as it is constant. So take advantage of this and move your light source around until you are completely happy with the effect.

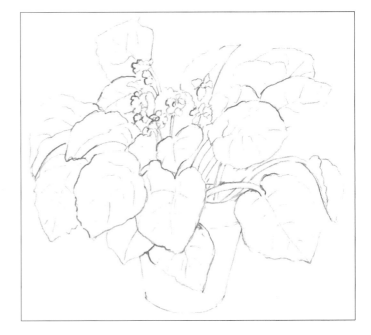

A potted plant makes a perfect subject for a tonal study because of the way the leaves bounce the light around.

Expert Tip

If you're not used to seeing objects purely in terms of tonal values, try squinting at your subject. The image will blur slightly, and the colors will become less distinct—but magically, you'll be able to make out the tonal differences much more clearly. The effect works because when your vision is impaired—as it is by squinting—the brain prioritizes the information it needs to keep track of the image. Hence, out go the colors and in come the tones!

Paper Trick

Another good trick to help you see tones is to crumple up a sheet of white paper, set it on a white background and stare at it for a while. Gradually the tonal differences created by the play of light over the different surfaces will become more apparent.

1 Working with a soft pencil on watercolor paper, I lightly sketch the outlines of the plant. A smooth, relatively heavy paper will let the pencil glide over it and won't buckle when you start painting. Avoid the temptation to start shading in areas. Where parts of the leaves are in shadow, the outlines will appear darker. Don't worry if you make mistakes at this stage; they can easily be erased with a putty eraser.

First Washes

2 Once you're happy with the sketch, you can start painting. I apply the palest washes first, using a very dilute mixture of indigo. Then I start filling in larger areas, such as the foreground leaves and the pot. Throughout this stage I frequently look at the subject and take note of where the highlights are. These areas will be left white.

3 Look hard at the plant so that you see it in terms of tones rather than colors. As soon as you register an area of darker tone, translate what you see to paper by adding one or more fresh layers of paint—but don't forget to let each new layer dry completely before you start applying the next layer.

Adding Details

4 With the basic tones established, I start on the details. You may prefer to use your finer, size 3 brush for the central area, with its intricate arrangement of foliage.

Darkening Shadows

5 Next, I build up the shadows with yet more washes. Here's where it pays to keep some blotting paper or paper towel handy in case the color starts to run—in a precise study like this, the last thing you want is a wet-in-wet look.

Fine Detailing

6 As you progress, you'll notice that the indigo gets considerably lighter as it dries. For this reason, to define the very darkest tones, you may need to cheat a little by mixing in some Payne's gray. This darker mix is perfect for tracing the veins on the leaves and defining the parts that are in shadow.

The flowers are among the lightest areas of tone in this study. But notice how the fine outline of the petals serves to throw them into sharper relief.

The sense of roundness and solidity of the earthenware pot is created by the gradual darkening of tone from left to right.

If you look closely at this leaf, you can almost count the layers of paint that have been applied. It is the contrast between these very dark areas and the lighter ones that give the plant study its three-dimensionality.

Classnotes...

By its very nature, watercolor paint tends to run. On a precise study like this, work with your easel horizontal and use blotting paper or paper towel to deal with unexpected runs. The blotting paper can be used as a tool, too, to lighten areas of wash by applying it to the surface and lifting out some of the paint. You may wish to practice this before you start.

THE PROJECTS

Learn from the Master: Sue Sareen
Cat with Kitchen Sunshine

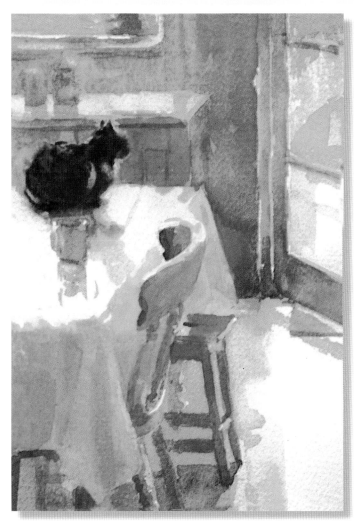

MONOCHROMATIC STUDIES don't have to be dark—in fact, the way sunlight bleaches out colors while creating sharply defined areas of tone can be used to good effect to produce remarkably atmospheric pictures like this watercolor. This artist chose raw sienna to convey the sleepy warmth of afternoon light streaming into a kitchen. The highlighted areas around the window and door are created with just one or two layers of very dilute sienna wash, allowing some of the more shaded areas, such as the walls and sides of the tablecloth, to be modeled by building up successive layers of more intense color. Touches of Prussian blue are mixed in with the washes to cool down the shadows on the furniture and to hint at the grass outside, and black is used for the cat and the deep shadow area under the table. Yet despite these apparent "cheats," the painting is primarily an exercise in one-color painting—and is all the better for it.

Try It for Yourself

A chair and tablecloth provide a good subject for a study in painting warm sunlight. The one on the right uses just two colors: raw and burnt sienna. Start with a very light wash of raw sienna, using it to distinguish the areas of mid- and dark tone so that you can see which parts to leave white for the highlights. Add one or two more layers of the same color to define the tablecloth, then float over a dilute wash of burnt sienna for the areas in shadow. Use a stronger burnt sienna mix to model the chair, then pick out the dark shadows.

Cliff-Top Lighthouse

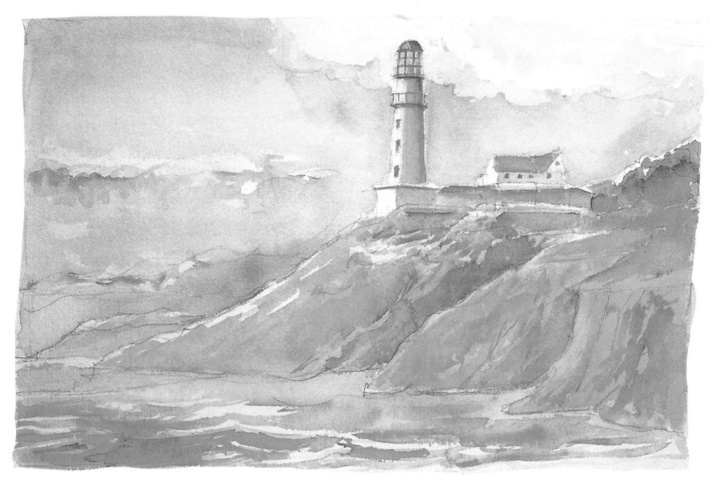

Artist: Sharon Finmark

P ART OF THE FUN OF WATERCOLOR is watching the effect of each layer of transparent color as it is laid on the one(s) before. Some people prefer to do this with the paint still wet and let the colors bleed into one another. But for this painting of a lighthouse standing defiant against the onset of a summer squall, my aim was to let each wash dry completely before overlaying the next so that the colors would build in vibrancy and richness. Of course, watching paint dry takes time and patience. If you're short of either, a few quick blasts with a cool hair dryer after you've laid each wash should help to move things along.

You will need...

alizarin crimson Prussian blue cobalt blue

raw sienna indigo Payne's gray

Size 8 sable/synthetic brush

Size 12 synthetic brush

PLUS: 4B pencil; heavy white watercolor paper with a smooth texture; kitchen roll; hair dryer

Getting Started

This picture comes partly from sketches and mostly from my imagination, so I start with a pencil sketch to ensure that I get the composition right.

I use very white paper, since I prefer to let the whiteness show through to convey the dramatic wave crests and also the blustery sky.

1 Using a soft pencil, I lightly sketch in the outlines of the buildings and the jagged lines of the various headlands. I also add a few lines to indicate the areas in the sea and sky that I'm going to leave white. Be sure to keep your pencil marks light, and resist the temptation to shade—the colors will take care of that later on.

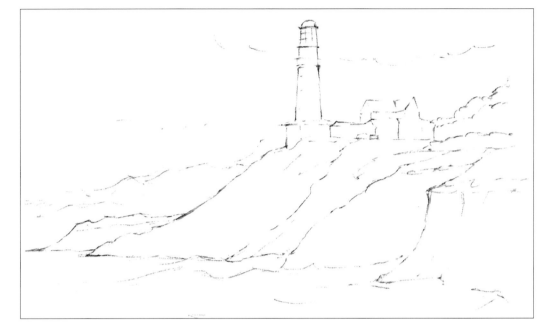

Expert Tip

When I'm working from color notes, as here, I find it helpful to create swatches of various mixtures in various strengths on a separate piece of the paper. That way, you can see how the mixtures will behave optically and gauge how much water to add.

Swatch it!
Swatches of the various mixtures used in this watercolor project.

Underpainting

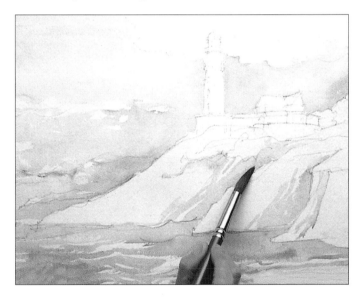

2 My base wash is diluted cobalt blue with a bit of Payne's gray. With a size 12 brush I fill in the sky, sea and shadowed parts of the cliff face, leaving the clouds, cliff edges and other highlights white. When the wash is dry, I add more of the same mixture to darken the foreground waves and shaded headlands. Where I think I've added too much color, I wash some off with a clean, wet brush and blot with a paper towel.

Base Washes and Main Colors

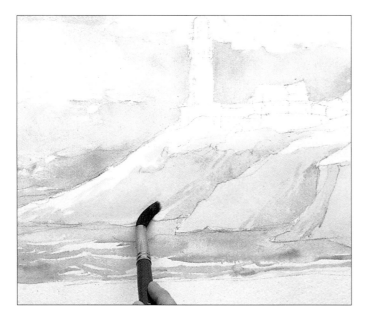

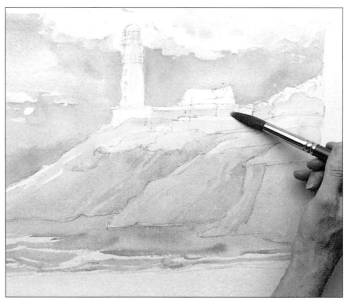

3 My sketches included color notes to remind me of the glistening blues of the sea, the mottled greens of the grassland and the warm, sandy hues of the cliffs. While the blue washes are drying, I play around with these mixtures both on my palette and on paper before finally opting for a wash of alizarin with a touch of raw sienna as a base for the cliff face.

4 Sticking with the size 12 brush, I paint in a wash of pure raw sienna as the basis for the shadow areas of the lighthouse, the vegetation and the sandier areas of the cliffs. Notice how I use water to vary the intensity of the wash: I use the purest color to define the outlines, which is where I want the wash to show through, and let it fade over the rest of the area.

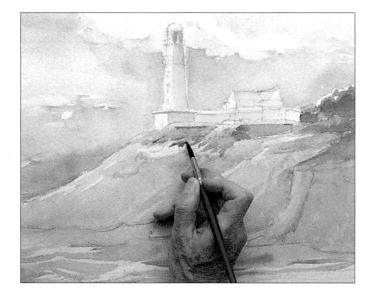

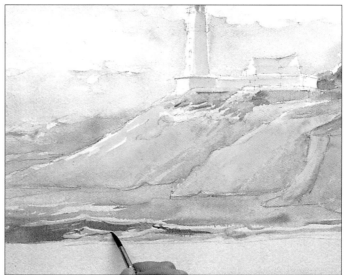

5 Switching to a size 8 brush, I add a layer of Prussian blue to define the trees and grass. The resulting green varies in warmth and intensity according to how much of the raw sienna base shows through, so I start with a very dilute color wash, let this dry partially, then add flecks of purer blue to build up the darker, bluish green tones that stop the vegetation from looking flat.

6 Still using the smaller brush, I mix a strong wash of Prussian blue and indigo with just a dash of water. This gives me the color I need to convey the swirling of the waves, which I paint in with short, curved flecks using the full body of the brush. This mixture will appear brighter when wet, so you may have to deepen it with one or more layers once it dries.

Lighthouse Details

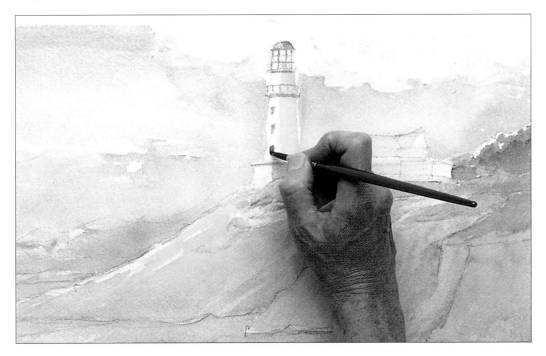

7 Pure Prussian blue is dark enough for the details on the lighthouse, which appear hazy because they're bathed in light. Don't overdo them or they will look contrived. I also define the buildings a little more, including the rooftops, the windows and the line of the wall, using more of my alizarin mixture toned down with a dash of raw sienna.

Casting Shadows

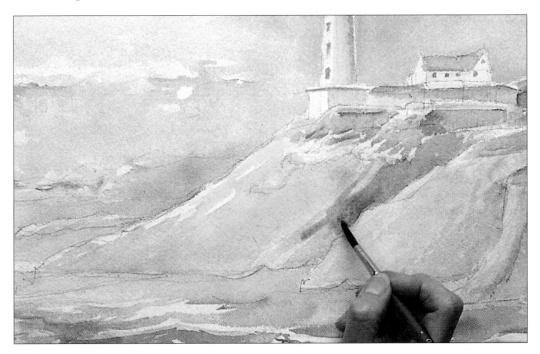

8 For the shadow areas on the headlands, I mix alizarin crimson with Payne's gray. I start by painting in the shadows using a strong wash of this mixture. Then, to soften the contrast, I add a more dilute wash to the areas immediately to the left of the shadows.

The clouds are formed by the white of the paper. Some areas are simply left unpainted, while in others some of the blue base wash is lifted off using a damp paper towel.

Those parts of the buildings in direct sunlight are similarly left unpainted.

Letting the base wash of raw sienna shine through the overlying layers of Prussian blue breaks up the vegetation.

Dashes of alizarin wash echo the shadows on the headland to denote the gathering storm.

More distant headlands are hinted at using washes of raw sienna and Payne's gray with a touch of alizarin crimson.

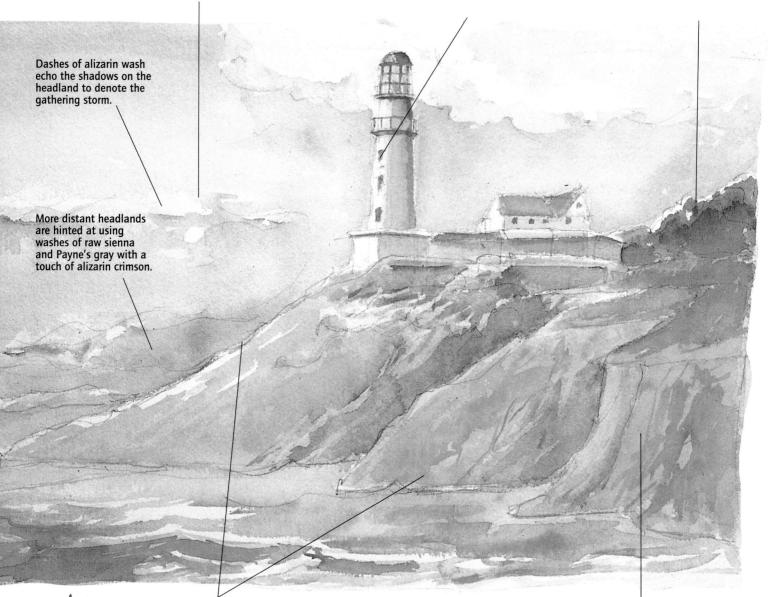

The vibrancy of this painting owes much to the way in which complementary colors (see below), such as blue/orange and purple/yellow, are pitched against one another.

Washes on smooth paper tend to streak. Use this to your advantage to hint at the tonal variations in the sea and the cliffs.

Classnotes...

Complementary colors—which are opposite each other on the color wheel—can really lift a picture, as exemplified by the two landscapes on the right. Although they are essentially the same, the inclusion of red—the complementary of green—in the foreground, middle ground and background of the painting on the bottom creates a much richer impression.

Landscape in blues and greens

Landscape overlaid with red

Learn from the Master: J. S. Cotman
Fort St. Marcouf

THIS DAZZLING EARLY NINETEENTH-CENTURY watercolor by John Sell Cotman uses the medium to its fullest to portray a coastal fort amid the calm before the storm. The stillness of the scene is immediately conveyed by the reflections of the building in the water (detail below), which have been carefully planned and painted in advance of the streaked blue washes laid over them. The

impending storm is skillfully suggested by juxtaposing a dark background sky. This also conveniently throws the profile of the fort into sharp relief against a pattern of light and shade on the building's walls that could only be cast with the sun high in the sky. The tension between the lighting conditions echoes the tension in the weather. Although it pervades the whole painting, it is achieved almost entirely through the artist's use of tonal contrast—his palette is limited purely to blues and ochres.

Try It for Yourself

Lake scenes and seascapes come alive when you show reflections in the water. To create this effect, focus on a simple shape such as a lighthouse. Block it in on land, and paint a rippled version of it below in exactly the same color. When this has dried, mix up a pale blue wash and sweep it across the top of the water over the reflection. Do the same with a darker wash below the first one, and the same again with one a bit darker.

One-Brush Flower Study

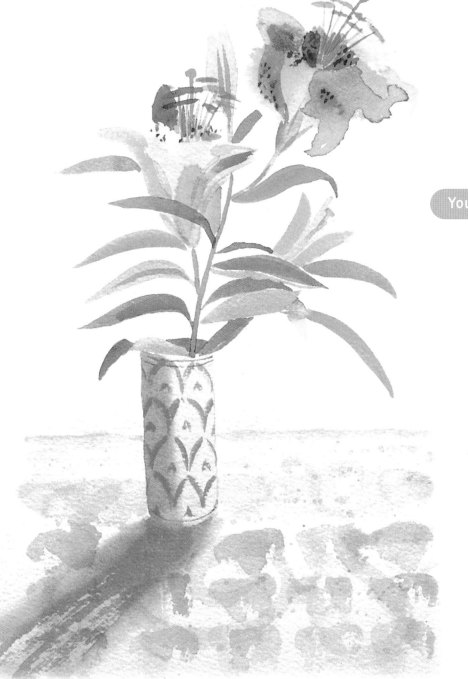

You will need...

rose madder

yellow ochre

sap green

viridian

Winsor blue

ultramarine

B pencil

Size 9 round (preferably sable)

PLUS: heavy watercolor paper;
putty eraser; blotting paper

Artist: Jane Telford

THIS WATERCOLOR PAINTING was something of an experiment: I wanted to see if I could paint an effective picture using just one brush—a medium round—although I did stack the odds in my favor by choosing sable. Asian artists make brilliant paintings using a single brush, so I thought I'd give it a try.

See What Your Brush Can Do

Imagine asking 10 of your friends to write your name, all using an identical pen. You would see 10 versions of the same word, all vastly different. Some might be small, others might have flourishes, and so on. If you can get so many variations from a single pen nib, just think what can be done with a flexible brush!

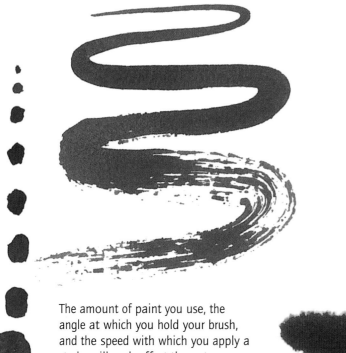

I rolled a fully loaded brush on its side here to get the intensified color along one edge.

The amount of paint you use, the angle at which you hold your brush, and the speed with which you apply a stroke will each affect the outcome.

I sponged water on the paper before pressing the brush firmly into the dampened area.

Try using the tip of the brush to paint dots and outlines.

Getting Started

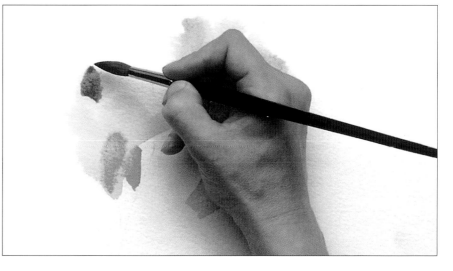

1 I always start with a pencil sketch. That way, I can see immediately if my composition works. Here I used a soft pencil and a smooth, relatively heavy watercolor paper that won't curl when wet.

2 To get going on the painting, I mix a watery wash of rose madder with just a touch of ultramarine to enrich the color. I use the body of the brush to wash in the broad shapes of the petals; they don't have to be perfect—petals rarely are. Then, with the tip of the brush, I apply dots of less dilute rose madder to build up the tones of the petals.

Building the Lilies

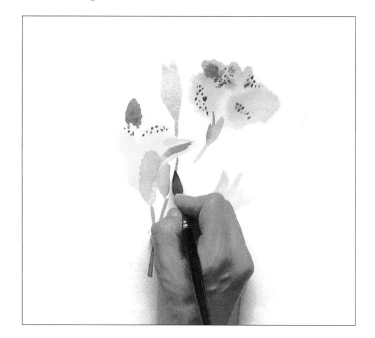

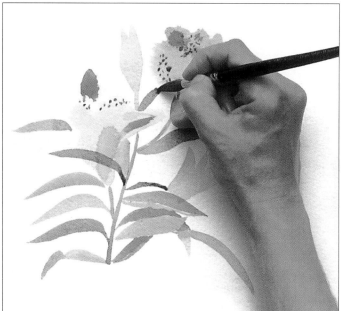

3 For the green of the stems, I used a mixture of sap green, viridian, yellow ochre and Winsor blue, with a touch of rose madder. There's no need to try to match this color exactly; just keep experimenting with your paints until you get a green that you like. The important thing is to make sure you mix up enough initially so that you don't run out.

4 This is where brush control really comes into play. I paint the length of the stem and the stamens of the flowers with the tip of the brush, using minimal pressure; the trick is to do it lightly but smoothly, with confidence. The leaves involve a different technique: I paint each one with a single brushstroke, pressing down harder where the body of the leaf is fullest.

Single Brushstrokes

5 The vase has a simple shape, but to convey its roundness you have to gradually change the tones of your washes—in this case, getting darker toward the left, since the light is coming from the right. I start by blocking in the cylindrical form of the vase with a flat pale blue wash of ultramarine, using the body of the brush. Once this dries, I add a stronger wash of ultramarine along the left of the vase. I also make a mental note to add a shadow on the tablecloth when I am nearer completion.

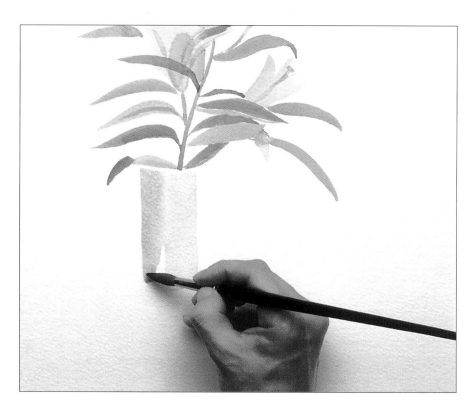

160

Vase Details and Tablecloth

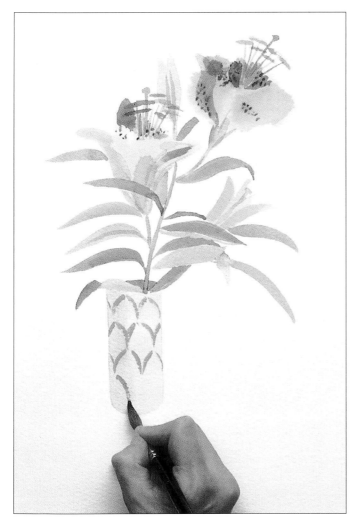

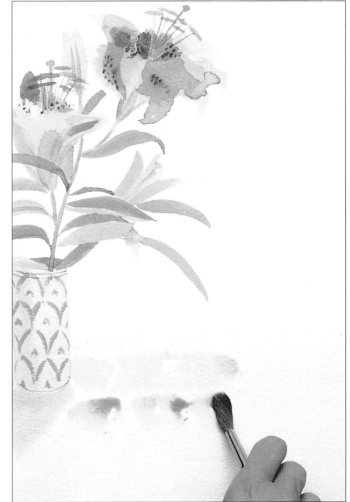

6 Next, I turn to the pattern on the vase. I like this stage: With just a few strokes I can transform my vase into a realistic three-dimensional object. Again, I rely on the tip of the brush for this, using light but confident strokes.

7 For different brushstroke effects I use the tablecloth as a testing ground. I start by washing in the blue, using broad, watery sweeps. Then, with more blue, I roll a fully loaded brush from left to right along the paper.

Expert Tip

The beauty of watercolor has much to do with the purity of the colors combined with their delicate transparency. But obvious as this may seem, it is only possible if you keep your brushes scrupulously clean. For this reason it's a good idea to work where you have access to water. But if you can't, make sure you have several jars of clean water before you start on a painting. Your paints will soon become muddied if you mix pigments with the same water in which you clean your brushes.

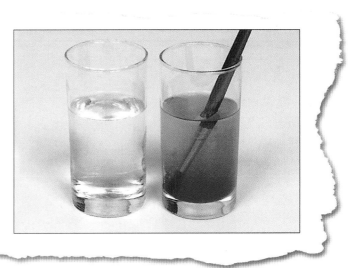

Painting the flower stamens requires the most control; practice first.

After I've finished painting the flowers, vase and tablecloth, I use broad strokes of very dilute yellow ochre to fill in some of the white space in the background.

Notice how the forms of the flowers are created convincingly by applying just a few strokes of stronger color over the base wash.

I painted the fine decorative lines on the vase using just a touch of paint on the longest hairs of the brush.

For the shadows around the vase, I tried applying the paint both wet and relatively dry, using the full body of the brush.

I dipped my brush into a relatively concentrated mix of ultramarine and Winsor blue and rolled it repeatedly on its side to achieve this patterned surface.

THE PROJECTS

Learn from the Master: Joan Thewsey
Poppies

SOMETIMES EVEN SIMPLE STILL–LIFE subjects take on an exciting new dimension when you take a slightly closer look. Contemporary watercolor artist Joan Thewsey does just that by focusing on the spectacular changes of tone revealed within the petals of a simple pair of poppies. She begins by mapping out the shapes the petals will form across the paper page, not worrying about creating precise outlines. Just as important to her are the negative shapes formed by the background sky; the relationship between the two sets of shapes gives the composition its power. The modeling of the petals is more conventional, using successive layers of wash to deepen and intensify the tones. But notice the role played by the blue background washes in building up the color of the flowers. Although these washes give the poppies a bluish cast that would be absent in nature, they provide the unity of color that such a bold, simple statement needs.

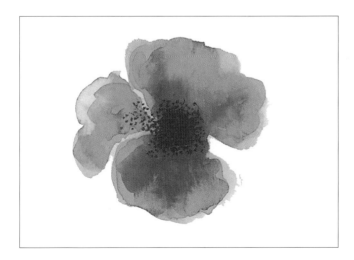

Try It for Yourself

Painting the tones in flower petals is one of the most effective—not to mention rewarding—ways to practice building up layers of wash. With a medium round brush paint the shapes of the petals with clear water. Then flood in some dilute cadmium red and allow to dry. Next comes the tricky part: Apply a dilute wash of cadmium red and alizarin crimson over the top so that the lines and runs begin to define the form of the petals. When the second wash is completely dry, use a fine brush and some India ink to dot in the pollen clusters in the center.

A Vacation Remembered

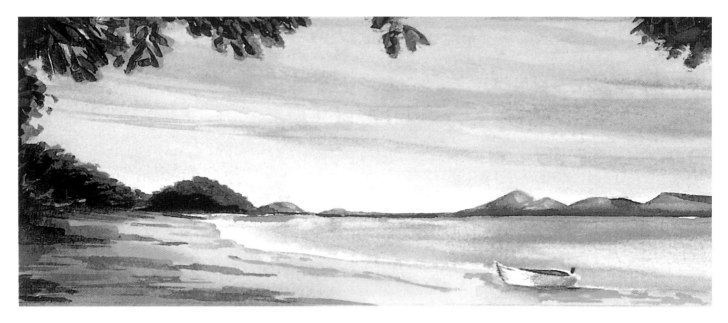

Artist: Rob Bennett

I OFTEN PAINT FROM PHOTOS, so I always have a camera at the ready, just in case. I know some artists consider it cheating, but personally I think that interpreting a photograph can be just as challenging as painting from life. The inspiration for this beach scene was a magical spot I visited along the shores of Lake Malawi in southern Africa. There was no one around, just a solitary fisherman's boat moored on this endless expanse of sand. I didn't have to do anything to get an interesting composition except pick the right time of day. In hot countries the midday sun accentuates the camera's tendency to bleach everything out, so morning or afternoon light is better.

You will need...

cobalt blue · Prussian blue · sap green · alizarin crimson

cadmium yellow · yellow ochre · burnt sienna · cadmium red

Large, flat synthetic

Size 8 round (preferably sable)

PLUS: opaque white gouache; medium-heavy watercolor paper; paper towel

THE PROJECTS

Getting Started

Vacation snaphots are great for reliving memories, but when it comes to painting, don't be limited by them. My photo shows the distant hills as silhouettes only; in my painting I give them far more color.

It's all about artistic license. When painting from a photograph, don't be afraid to play around with the image. My shot captured the glorious view along a deserted beach, but I had another photo of a more dramatic sky, suffused with lilacs, pinks and golds. I decided to marry the two to create a more colorful, vibrant painting.

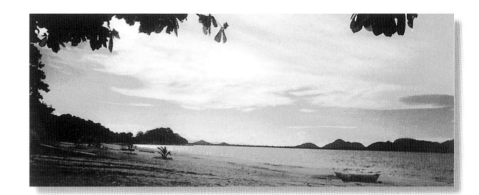

1 A pencil outline of the landscape is the first step. I sketch in only the most basic shapes: the hills punctuating the horizon, the shoreline and the fringe of leaves in the foreground.

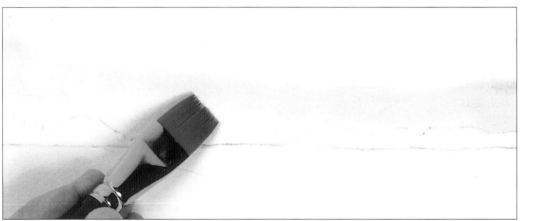

2 Using a large, flat brush, I moisten the sky area with water. Then I paint in a thin wash of cobalt blue with a dash of alizarin crimson and let it bleed into the dampened paper.

3 I leave some areas unpainted to suggest distant white clouds. As the wash drifts down toward the horizon line, I use a paper towel to lift off any spills and to blur the edges.

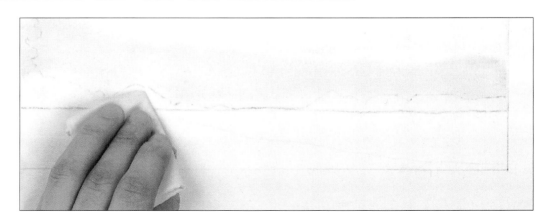

Colorful Sky and Sea

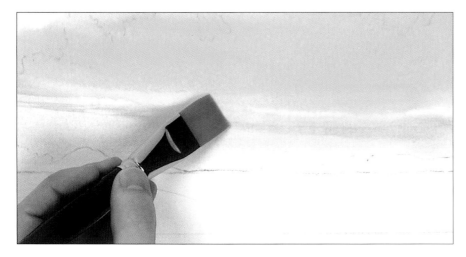

4 For the pink trails of clouds, I mix up a watery wash of cadmium yellow and cadmium red. The paper is still very damp as I paint the color into it, wet-in-wet, with long, broad brushstrokes. Then I add slightly stronger mixes of yellow and red to create patches of darker tone within the clouds.

5 To enliven the sky, I add a little bit of alizarin crimson to the mix and add touches of this new color. I like the way the bands of color bleed into each other, but if you feel your washes are out of control, use a paper towel!

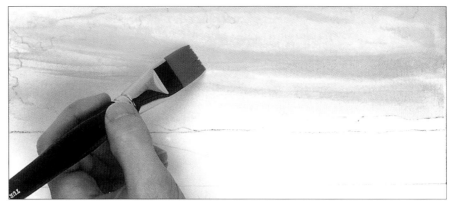

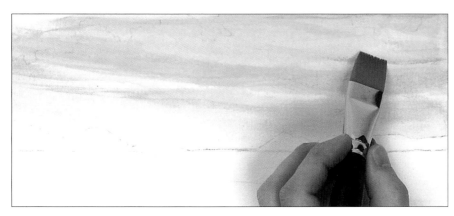

6 I want still more suffused color, so I clean my brush and change the water. (Do this often or things will get muddy.) Then I use cobalt blue and alizarin crimson to make a mauve wash, which I use to add touches to the clouds.

7 Now the sea. First I dampen the paper with a wet brush. Then I apply horizontal strokes of mauve and Prussian blue washes in varying strengths. I sweep a paper towel over them to lift off some color, then darken the horizon with the edge of my brush.

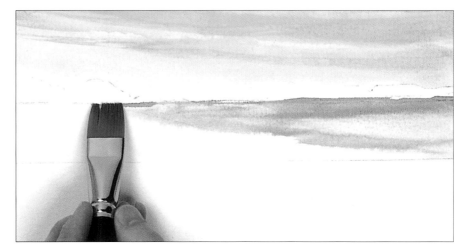

THE PROJECTS

Modeling the Land

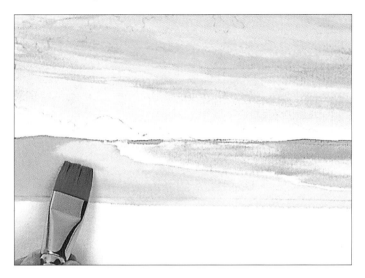

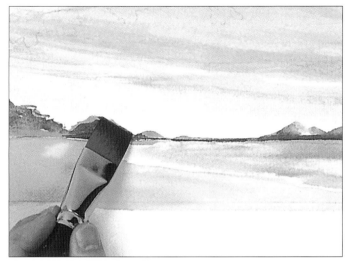

8 With a clean brush and water I dampen the beach area. I use a light wash of yellow ochre and burnt sienna to brush in the sand with long strokes, then add a little burnt sienna to create the more shaded areas.

9 For the distant hills I need dense color, so I use the edge of the brush. I dab in washes of Prussian blue and mauve mixture and allow the colors to bleed from light to dark to create the shadowy tones of the hillsides.

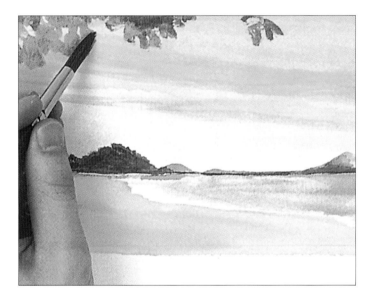

Taking to the Shade

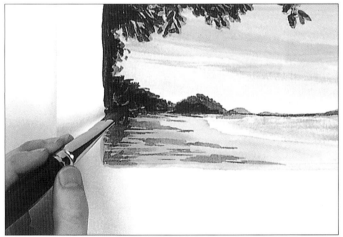

10 Using a soft, round brush and a wash of sap green with a little cobalt blue, I touch in the leaves and the treeline on the left. I also add some of this green to the hills on the left, then leave the painting to dry.

11 I dilute more of the same wash and use my flat brush to define the more shaded areas of the beach, which also adds texture and tone. I use touches of the same color on the hills. Then, using a fresh mixture of Prussian blue, yellow ochre and cadmium red, I add more details to the green areas with the corner of the brush.

Finishing Touches

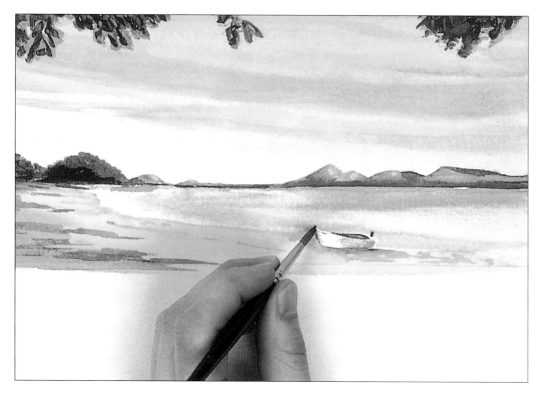

12 Finally, I paint in the boat using white, with blue-grays for tone. I use a touch of cadmium yellow to suggest sunlight on the leaves at the top of the picture and on the distant hills. I use my mauve mixture, this time lightened with a little white, to add highlights on the mountain range in the distance.

The overhang of dark green vegetation acts as a natural frame for the sunlit beach.

Creating suffused color effects like this means working fast, while the washes are still wet.

The cool green of the shadows on the beach ties in nicely with the green of the overhanging vegetation.

I choose to paint the boat in opaque white, at the end of the picture, so as not to interrupt the flow of the horizontal brushstrokes behind. If you prefer, you could mask out the shape with a piece of cardboard.

The colors on the hillsides are accentuated to reinforce the impression of a bright, sunlit landscape.

THE PROJECTS

Learn from the Master: Julia Rowntree
Spring Morning, Barham

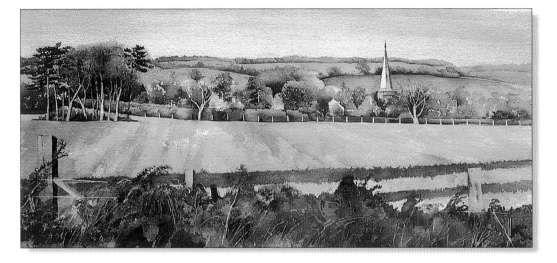

A STAUNCH ENTHUSIAST OF PAINTING from photographs, English contemporary artist Julia Rowntree is rarely without her camera. This scene caught her attention as she was driving. With no time to sit and sketch, she stopped briefly and took a couple of snapshots that she hoped would capture the bright sunlight and sharp tonal contrasts of that particular morning. For her watercolor painting on paper, she settled on this view, with the church spire slightly off center and a blaze of pink blossoms to its left. Although the picture is awash with the kind of fine detail that working from photographs allows, its most striking compositional feature is

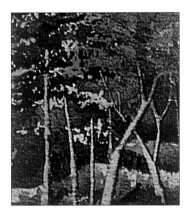

the way it works in broad bands of contrasting color and tone.

From the foreground verge of ferns and grasses, the eye is led across the meadow of freshly mown grass, through the tree-studded village and up the sloping fields to the hazy purple hills in the far distance. The fringes of the fields, dotted with tiny trees, reinforce the sense of perspective and distance. And above it all is a delicately laid-in sky wash of the clearest blue—the crowning glory of this bright spring morning in the countryside.

Try It for Yourself

It is well known that warm colors—reds and yellows—appear to advance, while cool colors—blues and purples—appear to recede, but it's not always easy to put the theory into action. A good way to practice is by painting horizontal bands of color and letting these alone impart a sense of receding into the distance (below).

First, wet your paper with a flat brush and paint a broad wash of sap green over the bottom half. Now lay a band of yellow over the lower third of the green and watch how this area appears to advance toward you. Add a band of mauve over the upper third of the green. Then, using the edge of the brush and less dilute mauve, suggest a fringe of trees on the horizon. Finally, add a pale wash of blue for the sky.

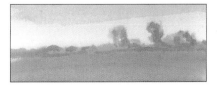

Cat Portrait

Speed is of the essence when painting an animal portrait because your model is unlikely to remain still for very long.

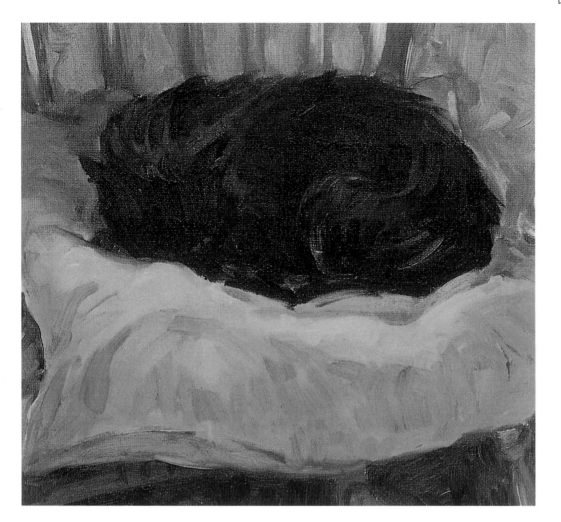

Artist: Sue Sareen

burnt sienna

yellow ochre

cadmium orange

cadmium yellow deep

cerulean blue

ivory black

C ATS TEND NOT TO KEEP STILL when you want them to—mine certainly doesn't. So when I set out to capture Sola in oils, I knew I had to work as quickly as possible and, ideally, in one sitting. This type of painting, which means working while the paint is still wet, is called *alla prima,* or direct painting. Some people think it's difficult, but I actually enjoy it: It forces me to get the essence of a subject down quickly without worrying about fine details. A much bigger question in my mind was whether Sola would suddenly wake up, decide she was hungry and stalk off in search of food!

You will need...

Size 2 round (preferably sable)

Size 1 round bristle

Size 5 long-bristled filbert

PLUS: titanium white; small canvas board; clean cloth; turpentine

First Sketches

I share my house with many cats, so I make a habit of sketching them as they sit, stretch, sleep.... It means that if I'm midway through an oil painting and my subject decides to saunter off, I can generally refer to earlier sketches to complete it.

For my sketches I use pencil when I want to capture a particular pose and watercolor when there's time to record details of textures and markings.

Before committing paint to canvas, I establish the composition. The focus is my cat Sola, but I have to decide what else to show. The orange cushion makes an interesting contrast, both in terms of its color and form. Although the chair is a strong shape, too, I feel that to show all the arms and legs would be overly distracting.

Quick Brush Drawing

1 When painting *alla prima,* I always use a small support so that I can cover the canvas as quickly as possible. First I outline the shape of the cat in ivory black thinned with plenty of turpentine, using my round bristle brush. I work very quickly, concentrating on the outline and the folds of the head, limbs and tail. If you make a mistake at this stage, just wipe off the paint with a piece of a cloth dipped in turpentine.

Blocking in the Fur

2 I outline the chair and cushion in relation to Sola using a mix of cadmium yellow and yellow ochre, in case she stirs. Then I study the fur and the way the light strikes it. I next mix varying amounts of ivory black and cerulean blue with a little titanium white to produce several tones of black. I flick the paint on lightly to give the impression of the fur.

Orange Cushion

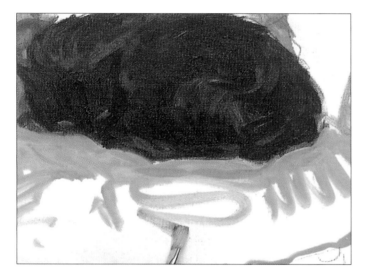

3 For the cushion I start with a base mixture of cadmium yellow and orange. I apply this with the filbert brush, using quick, loose strokes. Then I add a little titanium white to the mixture to paint in the lighter tones denoting the folds of the cushion.

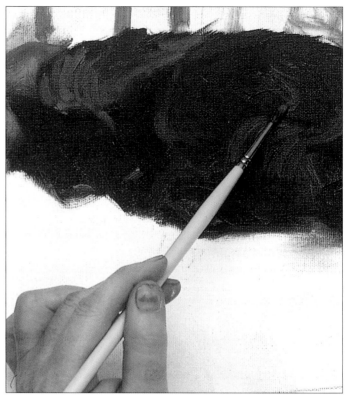

Background

4 For the background behind the chair, I mix together burnt sienna and titanium white with a hint of cerulean blue. I vary the proportions to obtain a mottled effect, washing my filbert brush in turpentine after each alteration to stop the mixture from turning muddy. I work the color right up to the chair and cat, making sure not to overlap. Then I redefine the shape of the chair using more of the cadmium yellow and yellow ochre mixture.

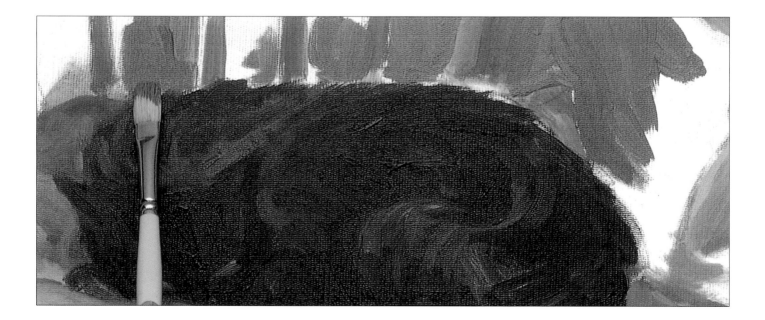

Filling in the Gaps with Color

5 I use the small bristle brush to fill in any areas of the canvas that remain unpainted. I use more of the yellow/orange mix to adjust the tones of the cushion. But for the gaps in the cat's fur, I lightly stroke in some pure cerulean blue to emphasize the fur's wispy texture.

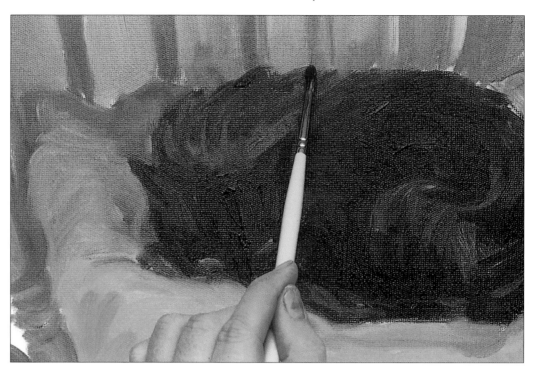

Final Modeling and Details

6 Once I'm happy with the cat, I finish the rest of the picture. Using the filbert brush, with light pressure I deepen the folds and shadows of the cushion with more cadmium yellow and orange. Finally, cleaning my brush in between, I use several separate applications of yellow ochre and burnt sienna to add definition to the tones of the wooden chair.

Deepen the Shadows

7 To deepen the shadows on the cat, I mix together a small amount of cerulean blue with some ivory black. I apply this with a small sable brush using minimal pressure. This makes it possible to lay fresh color over the still wet paint without mixing the two—a good tip when painting *alla prima*.

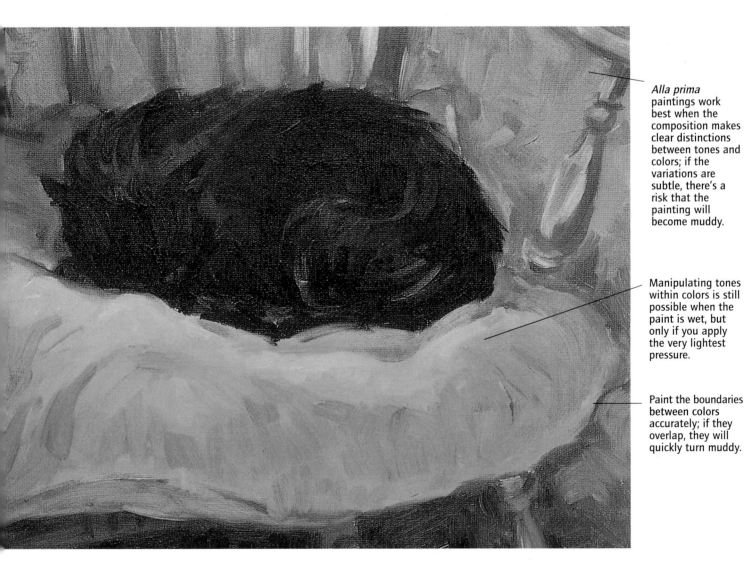

Alla prima paintings work best when the composition makes clear distinctions between tones and colors; if the variations are subtle, there's a risk that the painting will become muddy.

Manipulating tones within colors is still possible when the paint is wet, but only if you apply the very lightest pressure.

Paint the boundaries between colors accurately; if they overlap, they will quickly turn muddy.

Learn from the Master: Mabel Hastings
Terrier

THIS LATE NINETEENTH-CENTURY PAINTING of a much loved family pet is a fine example of the art of painting fur. Not content with simply rendering her terrier's shaggy coat, Mabel Hastings places the dog on an even shaggier rug and sets herself the challenge of bringing out their contrasting textures. Both parts of the oil on canvas painting employ a technique known as dry brush, in which the paint is applied undiluted in tiny amounts using the very tip of a medium bristle brush. Each bristle

fiber leaves its mark (detail left), giving the impression of hundreds of individually painted hairs. The brushstrokes on the rug are longer and gentler, the splay of fibers in different directions suggesting its softness. Those on the dog are shorter and more directional, implying a spikier, coarser texture. Of course, in oils such effects take time: Far from completing the painting in one sitting—*alla prima*—the artist is more likely to have taken several weeks.

Try It for Yourself

Unlike a person's hair, an animal's fur may contain dozens of distinct colors. Look at the dog's coat and see how many shades are involved in what seems to be white. Paint the darker layers first—dry strokes of Prussian blue. Let these dry and add some strokes of yellow ochre and burnt umber. Paint downward, in the direction of the fur. Finally mix some yellow ochre and white and flick this lighter hue on top.

Three-Color Composition

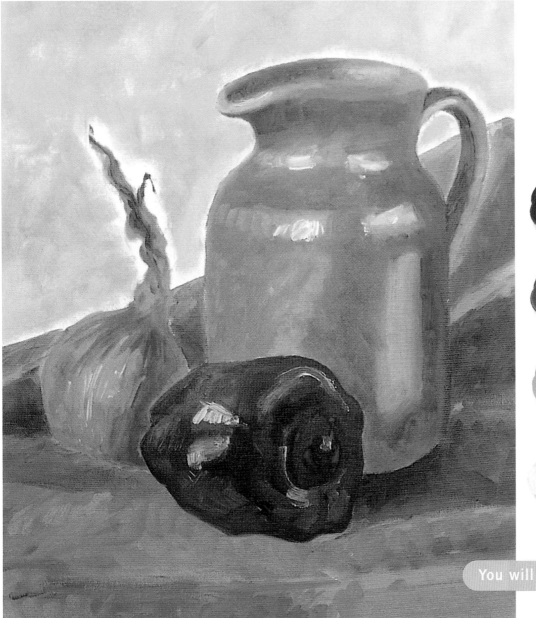

Artist: Sharon Finmark

Winsor blue

cadmium red

cadmium yellow pale

titanium white

You will need...

Size 4 round (preferably sable)

Long, flat bristle brush

Size 5 filbert bristle brush

PLUS: primed canvas or board; stick of charcoal; charcoal paper (optional); turpentine; palette

I ENJOY MIXING COLORS: It's all part of the buzz of painting in oils. Here, I set myself the challenge of using just three colors, plus white, to re-create the fresh green tones of the pepper, the transparent blue of the cloth and the natural orangey brown of the onion. As is customary in oils, I achieved such a wide range of colors and tones in two ways—on the canvas, by laying one color over another, and on the palette, by physically mixing colors together.

Getting Started

Composition is the key to a good still life, so as usual, I spent time playing with the elements and the lighting until I found the ideal arrangement. With such a limited palette, I was concerned with obtaining the correct tonal values. So I did what a lot of oil painters do—made a quick preliminary sketch in charcoal (right). Tonal sketches like this are a great help when you begin to start mixing colors, because they force you to study the relationships between light and shade first. And because oils take so much longer than other painting mediums, a charcoal sketch can help you capture a scene before the light changes—or is changed for you!

If you don't want to go to the trouble of making a charcoal sketch, half-close your eyes so that you see the tones more clearly and map them out in pencil. A black-and-white Polaroid photograph will also give you a reasonable tonal reference to paint from.

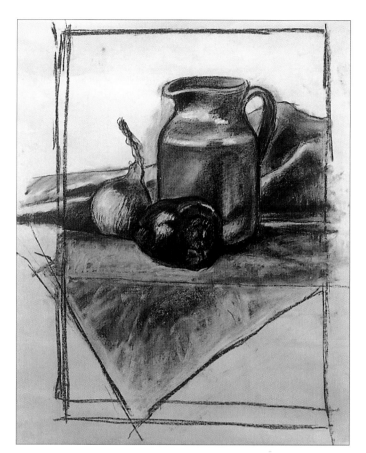

Getting the Shapes

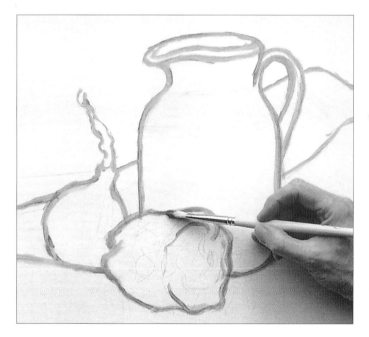

1 After some thought I decide to crop in on the original sketch. Taking a small piece of primed white canvas board, I lightly sketch in the main elements in charcoal. I use charcoal for several reasons: It goes on easily and quickly; it can be erased or changed using a putty eraser; and it vanishes when you paint over it in oils. So when I feel I've got the shapes positioned correctly, I use a small round to paint over the outlines in yellow.

Expert Tip

There is no magic formula for mixing oil colors—experimentation is the key. Working on your palette, pick up just enough paint to cover the tip of the brush, and clean the bristles before you apply each new color. To make green (below), for example, I start with a dab of blue. Then I add yellow in steadily increasing amounts, working from the top downward, to make a range of dark and light greens. Remember, too, that although most mixing is done on the palette, you have a second chance to adjust tones and colors on the canvas.

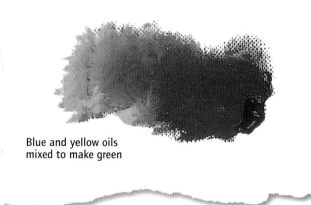

Blue and yellow oils mixed to make green

First Color Blocks

2 Switching to a flat bristle brush, I block in the pepper with pure Winsor blue. Then the fun begins. I mix up a darker blue by adding a little red to the blue and use it to build tone on the pepper. But I need more colors. The cadmiums work well together, so I combine cadmium red and cadmium yellow to block in the orange tones of the onion. Then I add some white to the orange mixture to create the more opaque orange base of the jug. Notice what a powerful effect it has.

Modeling the Pepper

3 At this stage I block in the cloth with a thin mix of Winsor blue diluted with turpentine. Next it's time to start modeling the tones and rounding out the shapes. To get the lighter tones of the pepper, I lay a few short strokes of cadmium yellow over the blue.

4 Then I work the yellow over the rest of the pepper. Although small flecks of blue will show through the yellow, the overall effect will be green. And thanks to the areas of darker blue I added earlier, the tonal values of the pepper will be held despite the color change.

Modeling the Onion and Jug

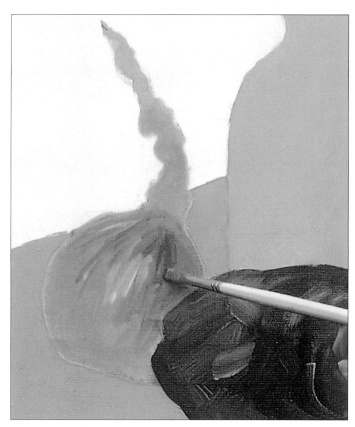

5 Using the small round, I paint streaks of yellow and red down the onion. Then I model the tones on the jug by overlaying the base color of the jug with touches of white and a brown mixed by adding blue to the orange mix. Switching to the cloth, I use diluted Winsor blue mixed with either white or a bit of red to model the lights and darks of the folds.

Lights and Darks

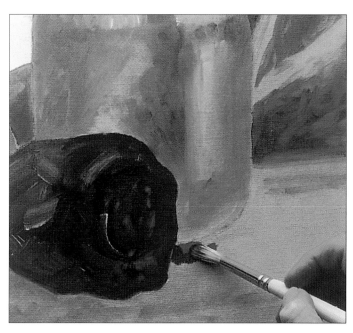

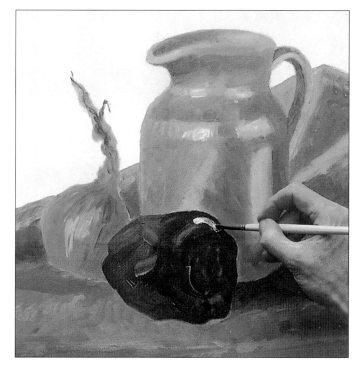

6 I add another layer of Winsor blue mixed with a dash of red for the shadows around the jug base, which I paint in with a small filbert brush. In the same way, I make adjustments to the tones in the folds of the cloth.

7 I pick out the highlights in white mixed with tiny amounts of yellow. I let my brushstrokes follow the grain of the onion skin and the curves of the pepper and tone down the color by blending it into the paint layers below.

Brushstrokes of pure red and yellow simulate the texture of the onion skin.

Block in the background with a thin mixture of pale orange, laid using a flat brush.

Light and dark tones reinforce the rounded form of the jug. Use dabs of white for the highlights and a light brown mixed from orange and blue for the darker areas.

Flecks of white and yellow are used to pick out the highlights. Blend them into the paint below to keep them from looking too stark.

Strokes of Winsor blue mixed with a little red overlay the blocked-in blue of the cloth to create the shadows around the jug and pepper.

THE PROJECTS

Learn from the Master: Philip Sutton
El Greco Flowers

FOR AN ENTIRELY DIFFERENT TAKE on a still life using a limited palette, consider this oil-on-canvas painting by the contemporary British artist Philip Sutton. His title pays homage to the sixteenth-century Spanish artist El Greco, whose innovative use of dark tones, geometric forms and flat areas of color is echoed by Sutton with an abstract twist. The most notable feature of this painting is the way that tones—the play of light and shade on the subject—are conveyed with flat color only, with almost no attempt at blending. This is much harder to do than it seems: The secret is to half-close your eyes to see the tones more clearly and then to transform what you see into shapes of tone in your mind's eye. Not that the job ends there—the next task is to pick colors whose tonal values match the different shapes. If you get this far, you'll know what to do next; if not, don't worry—it takes practice!

Try It For Yourself

To paint a jug like this one, mix together Winsor blue, cadmium red and titanium white. Start with blue and a little white and then gradually add the red, since this has a tendency to overpower the other colors. Block in the main body of the vase first. Then work the lights and darks to be tonally consistent with your base color.

Fish Still Life

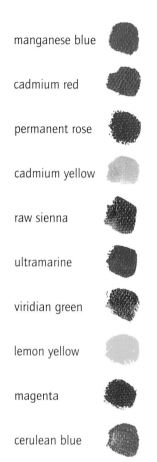

manganese blue

cadmium red

permanent rose

cadmium yellow

raw sienna

ultramarine

viridian green

lemon yellow

magenta

cerulean blue

Artist: Jane Telford

I LOVE WORKING WITH PURE, BRIGHT COLORS—they always seem to lift my spirits. Saturated "high-key" colors also bring even a simple composition to life in the most exuberant way. In this still life study of two parrotfish on a plate, I've tried to capture the dazzling light reflected from the brilliantly colored fish, the lemon and the tablecloth. Some people still assume that oil paintings have to be subdued or even somber, but that's the province of low-key colors, with their tendency toward browns and grays. Banish gray, I say! It's time to have some fun with bright high-key primaries.

You will need...

Size 1 round hogs-hair brush

Size 6 long filbert hogs-hair brush

Size 8 long filbert hogshair brush

PLUS: titanium white; 4B pencil (preferably sepia); white canvas sheet

Getting Started

Still lifes are all about lighting and composition, so I play around with both until the elements start to jell. I want the painting to be really vibrant, so I find a tablecloth that picks up the colors of the fish. The cool blue plate acts as a perfect foil, while the lemon and the spring onions give me an excuse to add dashes of fresh yellow and green. A white support will ensure that the tones dry to a bright, luminous finish. Oils take a while to dry, and I will be mixing quite a few colors, but a little patience usually goes a long way!

1 First I make a preliminary sketch using a sepia-colored pencil. I start with the basic outlines of the fish and the plate, add the lemon and spring onions, then move on to the folds of the tablecloth.

Blocking in the Colors

2 This sketch acts as a guide for blocking in the main areas of color, which I do with the larger of my filbert brushes. For brightness I add white to the basic colors— cerulean blue for the plate, cadmium yellow for the lower fish, manganese blue for the upper fish, viridian green for the spring onions, lemon yellow for the lemon and cadmium red for the cloth. When this layer is dry, I go on to define some of the tones using purer versions of the same colors. By this time the painting is well on its way, but there's still plenty to do.

White = Bright
Mixing white with bright primaries is a tried-and-tested way of adding vibrancy to oils. The white mixtures effectively establish the mid-tones of the picture, enabling you to paint in the darks with stabs of pure color rather than relying on darker, muddier mixtures.

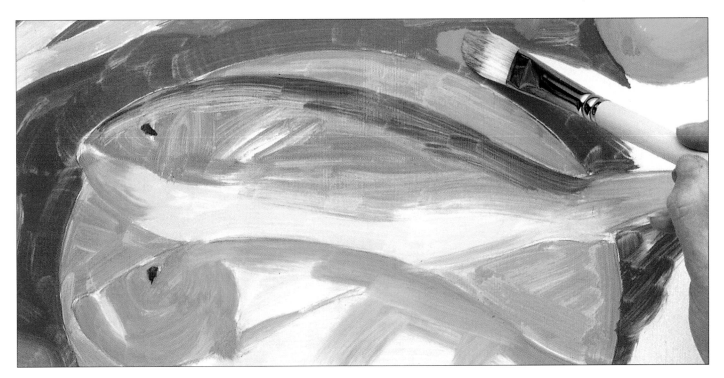

Working Up the Plate

3 The plate is a good example of the way I build the darker tones in the picture using pure color rather than dark mixtures. In this case I mix manganese blue, cerulean blue and viridian green with just a touch of white. I apply it in patches over the first layer of cerulean blue and white using my smaller filbert brush. Notice how this makes the plate seem more real while at the same time greatly adding to the vibrancy of the color.

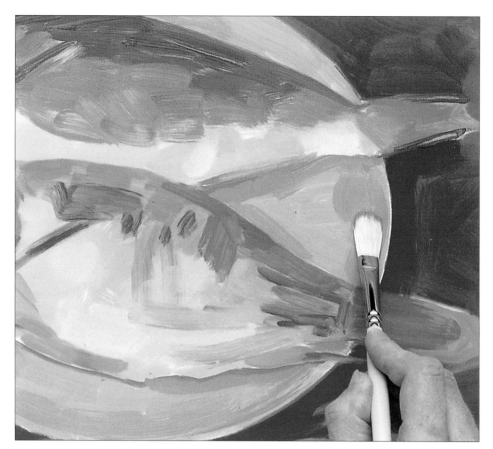

Coloring the Fish

4 The same technique (and brush) is used to build the tones and details on the fish—only this time with more color variation. For the blue fish I paint in various mixtures of ultramarine and raw sienna; for the red fish I combine raw sienna and permanent rose. As before, I add just a touch of white to the mixtures to keep them bright. Then I paint in the gills and fins and hint at the scales, using cerulean blue on the blue fish and raw sienna on the red one.

Strengthening the Colors

5 Before I paint in the darks and details using stabs of pure, bright color, I deepen the color of the cloth with permanent rose and a touch of white. For the darkest area of the cloth, I use pure magenta. I strengthen the lemon with lemon yellow and the onion leaves with viridian green. Then I return to the markings on the fish, which by now are really beginning to sing.

Picking Out the Highlights

6 The fish details are picked out using the same colors as before, but this time at full strength, with no white. Notice how luminous and transparent they look against the white-mixed underlying layers. Finally, using the small round brush and pure titanium white, I pick out the highlights on the undersides of the fish and strengthen the onion stalks.

Successive layers of viridian green, adding a little less white each time, are used to build up the texture and tone of the spring onions.

To define the shadows of the spring onion leaves, I allow myself the luxury of a more muted, low-key mixture—in this case, viridian green and ultramarine.

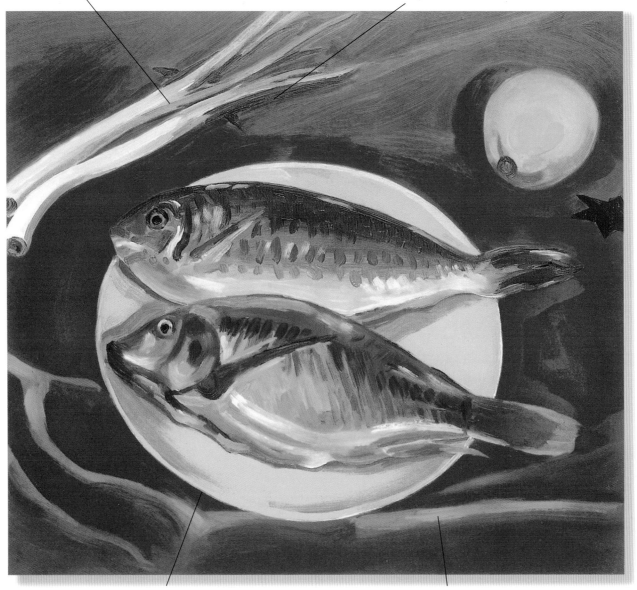

The red of the cloth and blue-green of the plate are almost complementary colors, which adds to the vibrancy of the composition.

Streaks of white painted wet-into-wet suggest the highlights created by the folds.

Classnotes...

To see how dramatically color can affect not only the look but also the entire mood of a painting, consider the fish study on the right. Using a limited palette of mainly muted, low-key colors, the painting is undeniably powerful, but in a very different way. Much of its drama comes from the contrast between the dark blue-gray background and the subtly painted opaque white highlights on the plate. For the most part, the colors of the fish lie somewhere between the two, creating a somber, reflective mood.

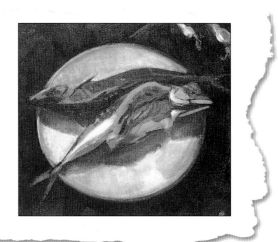

Learn from the Master: Paula Velarde
Summer Flowers

JUST AS A VASE OF VIBRANT FLOWERS lifts a room, so too should a high-key oil painting. In this vibrant, joyful flower study British artist Paula Velarde brings together the best of both worlds—without forgetting that colors, like flowers, need careful arrangement if they are to look their best. Although the flowers themselves command the most

attention, much of their impact comes from the way they are positioned against the unashamedly abstract background. Notice how the red carnation lights up against the surrounding high-key blue (detail) and how the violet flowers appear to burst out of the canvas against a background of complementary yellow-greens. And the moral of the story? No matter how bright your colors, it's where you put them that counts!

Try It for Yourself

Try some simple flower studies to see how bright you can get them. This one exploits the fact that yellow and purple are complementary and therefore play off one another. For the background use dioxazine purple, permanent rose and white, varying the proportions to give a textured look. When dry, apply short strokes for the flowers (cadmium yellow and lemon yellow) and leaves (phthalo turquoise, cadmium yellow and white).

Maritime Still Life

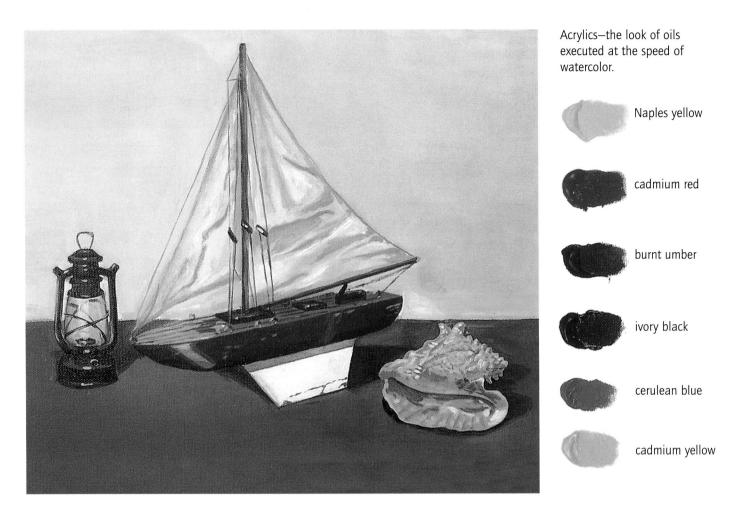

Acrylics—the look of oils executed at the speed of watercolor.

Naples yellow

cadmium red

burnt umber

ivory black

cerulean blue

cadmium yellow

Artist: Ian McCaughrean

WHEN I CAME ACROSS this lovely old model sailboat, I leaped at the chance to paint this unusual still life. I decided to set off the boat with two other maritime objects and to work in that most versatile of mediums—acrylic. Because acrylic paints are so fast-drying, you can layer them opaquely to achieve a depth of color and a richness of texture that would take an eternity with slow-drying oils. And this was an image that I wanted to capture with all the immediacy associated with such a captivating childhood toy.

You will need...

Size 4 round sable

Size 9 round synthetic

Large flat synthetic

PLUS: white acrylic; putty eraser; wood or disposable paper palette; page from a pad of canvas sheets

Getting Started

The brilliant colors and strong shapes in this nautical still life go well together. Even with just three elements, I still took care over their arrangement, balancing the simple triangular shape of the sails against the more complex outlines of the shell and lamp. But at the heart of the composition is that lovely old wooden hull, its natural warmth reinforced by the deep red paint. Such richness of color is ideally rendered in vivid quick-drying acrylic paint.

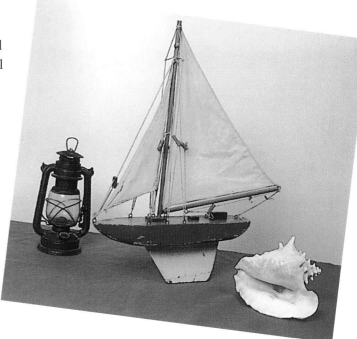

Because of the strong nautical theme of this still life, a blue cloth seemed like the obvious choice for the base. The background is a piece of art board lit gently from above.

Outlines

1 I like things to be easy, so for my support I use a page from a pad of canvas sheets. The first step is to sketch the composition in pencil. This is a light sketch, with very little detail—it's really more of a positional outline than anything else. But remember to use a putty eraser to correct any mistakes when you're sketching in pencil, because an ordinary India eraser will smear.

2 I start by underpainting the blue cloth with a wash of cerulean blue, using a large, flat brush and taking reasonable care to paint around the outlines of the lamp, shell and boat. Then I repeat the process for the yellow background, this time using a wash of Naples yellow applied with the same brush. In both cases it's simply a matter of filling in large areas of canvas with the right choice of color. Don't worry about fine-tuning; simply ensure that the washes are a fairly even tone.

Shipshape

3 I change to a synthetic round brush to block in the colors of the boat using cadmium red for the hull and a mixture of cerulean and ivory black for the shadow beneath. A mixture of cadmium red and cadmium yellow (giving me a deep orange) is my starting point for the deck.

First Details

4 I use more of the orange and a small round brush to paint in the mast and boom. Then I edge them both in burnt umber, which I also use to block in the dark, rectangular areas on the deck. Next I make a start on the conch shell. Refusing to be daunted by its complex shape and color variations, I mix a light purple from red, blue and white to outline the inner lip. I follow by adding a touch of the same mixture in the lower part of the shell to indicate the darker tones. The shell is beginning to take shape already.

Background Adjustment

5 Before returning to the background, I underpaint the sails with a light wash of white, red and cadmium yellow to give a warm, pinkish tone. Then I compare the sail and the background color. If the background looks a little too yellow by comparison (as mine did), tone it down with a more watered-down version of the sail mixture. Brush this on loosely, using broad strokes of a large, flat brush.

Sail Tones and Shadows

6 Next I build up the tones denoting the folds of the sail cloth using a mixture of purple, blue and white. Then I start paying attention to the shadows cast by the three elements and paint them in with a dark purple mix of blue and red. The shadows help to make the objects look as if they are sitting on the blue cloth.

Lamp and Details

7 For the lamp I paint in the black body and let it dry. Then I define the curve and transparency of the glass by adding touches of gray (a simple mix of white with a little black) to the sides and base, and a blob of pure white for the highlight. I return to the shell, applying subtle mixes of pinks and grays and dabs of yellow to the fold, and defining the knobbly top with strokes of white.

8 Finally, I review the painting to see what details I've overlooked. I give the blue cloth added depth by building up the color with successive layers of wash and then add more texture to the sail and shell. Then I paint in one or two more highlights on the lamp to denote its shinier surface.

The folds and shadows on the sails have been vividly colored by the artist, but you might opt for a simpler sail of white with gray shadows.

Add streaks of burnt umber, applied with the tip of your size 4 brush, to suggest the rigging.

The rippled texture of the outside of the shell is created by alternating layers of dark and mid-toned color, then adding short brushstrokes of pure white for the highlights.

Carefully placed highlights define the contors of the lamp's body.

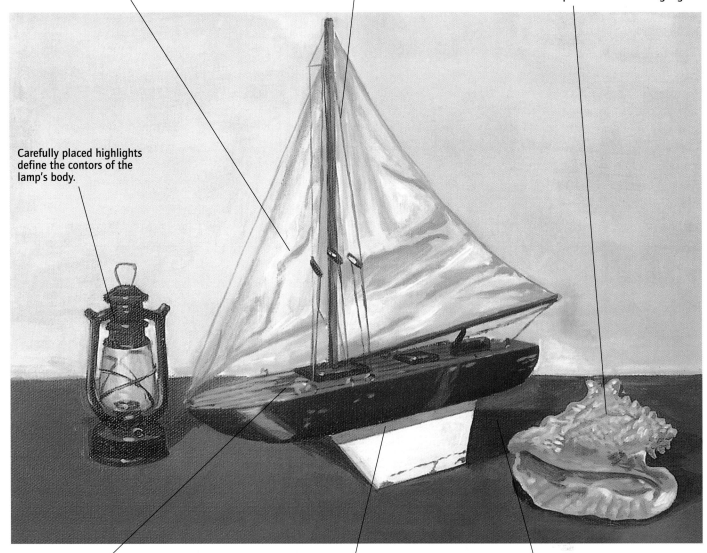

Details of the planking and deck furniture are added once the main hull colors have been blocked in and given a chance to dry.

The keel is mainly white canvas, apart from a streak of the blue cloth wash denoting the shadow of the hull. The paint spillages give a pleasing weathered effect.

The shadows are painted sparingly. Their position is carefully thought out to lend solidity to the elements without muting the vividness of the cloth.

Classnotes...

For all their many virtues, acrylic paints sometimes pose a problem when you are working outdoors or in hot weather. They may dry so quickly that you don't have time to manipulate them on your painting—or even on your palette. A first step toward avoiding this is to make sure you squeeze out only the amount of paint you need at any one time. You can also keep spraying your palette with water (being careful not to overdo it and make the colors run), or you can use a special stay-wet palette (above).

Keeping Cool

You can buy stay-wet palettes (left) lined with a special paper that you dampen with water before you squeeze on your paints. These palettes considerably increase the length of time you can keep acrylic paints workable under hot conditions.

Learn from the Master: Gillean Whitaker
First Shoes

THIS CHARMING STILL LIFE on canvas by British artist Gillean Whitaker is a glowing advertisement for the versatility of acrylics and how they can convey textures. The tiny scuffed shoes are so realistic that they almost demand to be picked up—an effect achieved by exploiting the way acrylic paints can be built up layer upon layer with minimal drying time. The painting is done on a colored ground, giving depth to the opaque whites, yellows and blue-grays that will be laid on top. The artist then blocks in the shoes with an opaque blue-white mixture, surrounded by a subtly blended ochre wash that gives them a magical glowing quality. With the light overhead the tones of the shoes have to be modeled with extreme care to maintain the highlights. The creases in the leather are applied a stroke at a time, while the shadow areas and scuffed toes are blended into the opaque white of the highlight using dabs of water to keep the paint moving. Then come details such as the stitching and the edges of the straps, using watery paint applied with a very fine brush. The final master stroke is the white stipple over the toes to bring out the texture of the scuffs.

Try It for Yourself

The opacity of white acrylic mixtures means that you can start with a mid-toned base and work back toward white for the highlights. For this exercise lay down a burnt sienna and yellow ochre background, then block in the shoe and strap with a mixture of cerulean blue and white. Now try bringing tonal variation to the leather, blending in pure white for the highlights and a touch of cadmium red for the darks.

Bell Tower

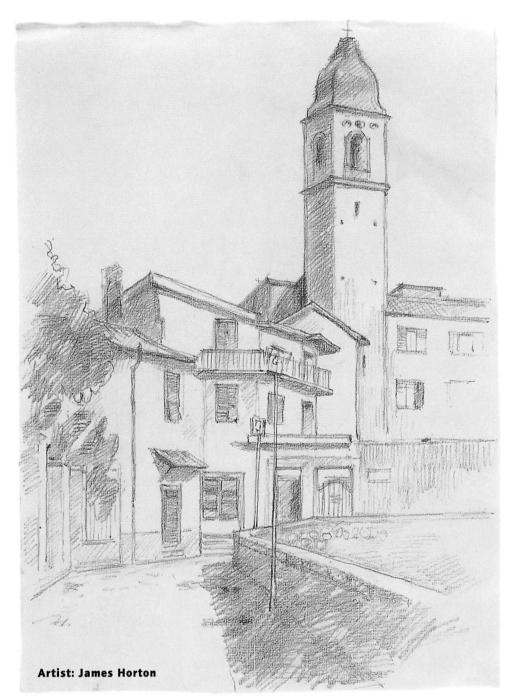

Artist: James Horton

The shapes in this drawing may not be obvious at first, but only because the eye gets distracted by shadows and details. Train yourself to see through these and you will already be halfway down the road to a successful picture.

O NE OF THE SECRETS of successful drawing is knowing where to start—and that means careful composition. Although it might not seem so at first glance, this townscape is in fact composed of a series of simple rectangles and triangles. Get these shapes in the right place and in the right proportion and you will have a framework on which to base everything else in the picture. It's an old method, but it works.

You will need...

4B pencil

PLUS: pad of semi-smooth drawing paper

Getting Started

The first step is selection. In the reference photograph on the right, the buildings initially appear to be a jumble, with rooftops tumbling into the scene from all angles. But a closer look reveals some strong lines and clearly delineated shapes that will suit the medium perfectly. Remember, too, that you don't have to include everything; often what you leave out of a drawing is just as important as what you put in, and it's pointless making life difficult for yourself later.

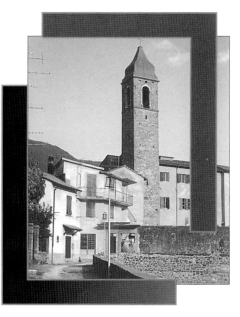

Cropping: As always, it pays to experiment with different crops of the photo, too. The bell tower is obviously the focus, but where to place it? Cropping will help you decide.

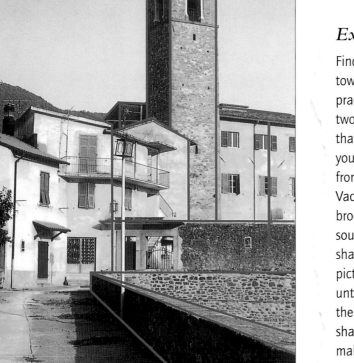

Expert Tip

Finding the shapes in townscapes is an art worth practicing, but don't limit yourself to two dimensions. The best shapes are those that convey depth and solidity as well; they'll stop your drawings from looking flat. Vacation snapshots and brochures are a good source of material for shape-finding: Study the picture for a few moments until you see through the detail, then get the shapes down on paper, making sure they are in the right proportions.

1 Deconstruct the image into its component triangles and rectangles, not forgetting those formed by the foreground wall and the roadway. Drawing the shapes on the reference photo may help you see them more clearly, as will studying the corresponding negative shapes of the skyline on either side of the tower. Transfer the shapes to your paper, measuring the proportions as you go. If things look like they're going wrong, you may care to use the grid-transfer system instead. Notice that for a more pleasing composition, I choose to position the tower off center.

Defining Outlines

2 With your framework of shapes in place, you can start to pencil in the outlines of the buildings and their various architectural features. Resist the temptation to get lost in the detail of a particular object; instead, keep moving and work over the drawing as a whole.

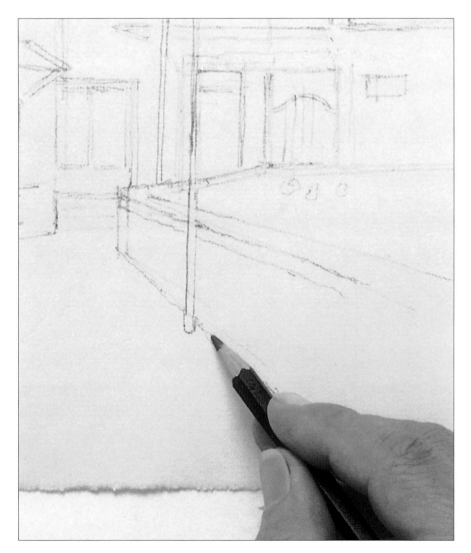

3 Converging lines on the wall in the foreground are mostly responsible for the picture's strong sense of perspective, so take extra care to get them right. Remember that the lines should all meet at a single point on the horizon line, which, although you can't see it, is roughly level with the middle of the first doorway.

THE PROJECTS

Adding Details

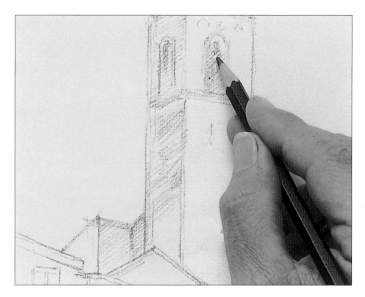

4 With the framework complete, you can start adding details. Be selective: You don't need to draw every tile, stone or shutter (and if you do, you'll find the drawing looks heavy-handed and flat). Instead, make sure the details you do include—for example, doors and windows—are in proportion with the buildings. And be sure to decide where the light is coming from; lightly shading in the shadows will give the picture real depth and solidity.

Building Tones

5 With the details in place, it's time to start building the tones. Scrunching up your eyes as you look at the reference photo will help you see the areas of light and shade more easily, but when you come to render them, be warned: It's easy to ruin the overall tonal balance by rushing some parts of the picture at the expense of others. Try instead to build the tones a layer at a time, working over the drawing as a whole—you'll find it gives far more control.

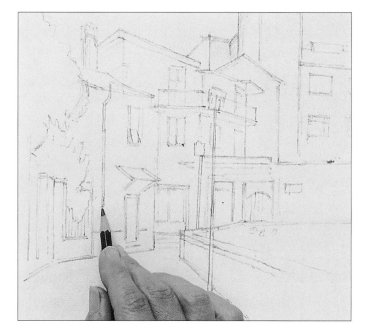

Classnotes...

Shadows help to make pencil drawings convincing, but only if the shadows themselves are drawn convincingly. The secret is to be aware of your light source, and outdoors this means keeping an eye on the sun. It's not only the direction of the sunlight that's important but also its height in the sky. As the sketch on the right shows, a high sun casts sharply defined shadows over a relatively small area. As the sun goes down, the area in shadow increases and the tones of the shadows themselves begin to diminish.

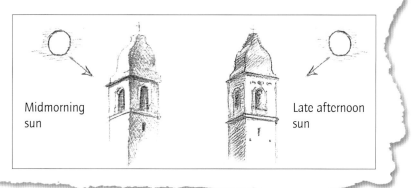

Midmorning sun

Late afternoon sun

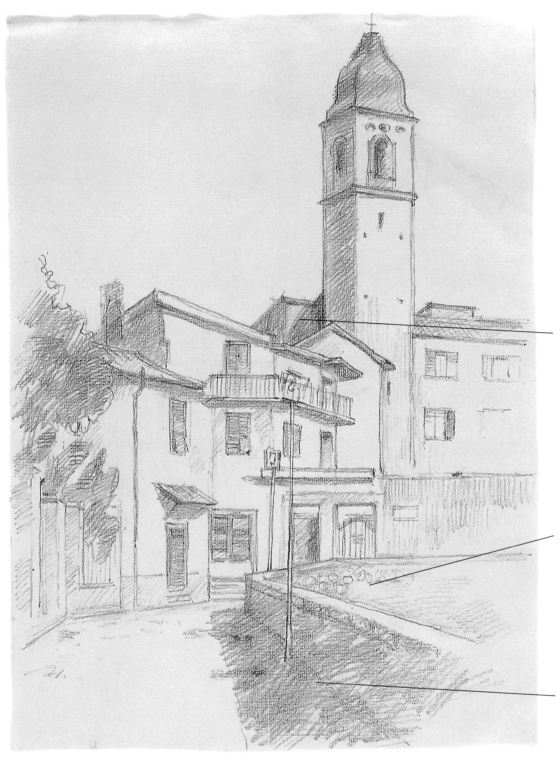

Take extra care to get the lighting right on the jumbled rooftops. They may be small, but they convey important information about the depth of the scene.

Though the line of the wall plays an important role by leading you into the drawing, what lies within serves no useful purpose and is omitted.

Loose shading marks the patchy shadows cast by the wall.

6 Finishing a drawing can be as tricky as starting it, so make a conscious decision about when to stop. I've continued to build up the layers of tone to the point where I feel the drawing has impact, but I haven't made too much of blending and smoothing the pencil marks. I think a sketchier feel suits the subject better.

Learn from the Master: John Constable
Overbury Hall, Suffolk

THIS DELIGHTFUL PENCIL DRAWING of a rambling
Suffolk country house by the celebrated English
artist John Constable is notable for the way in
which he creates a focal point by his handling of light and

shade. By limiting the detail on one
part of the building (detail, left)
relative to its surroundings, the walls
appear bathed in light and
immediately catch the eye. Notice
how the tones in this part of the
drawing are either washed out or
very dark, much as they would be in a black-and-white
photograph. This is a useful device to employ when drawing
buildings; even if you get the perspective right, draw
the building with a consistent level of tone and detail
throughout and the chances are it will look flat and two-
dimensional. Once again, it helps to divide the subject into
its component shapes—triangles for the gables, oblongs for
chimneys, and so on. In fact, if you concentrate on modeling
each shape individually, you'll already be halfway there.

Try It for Yourself

Practice drawing different types of
wall under different lighting
conditions to see how much detail
you need to convey the correct
impression of their texture. Notice
how the stronger the light, the lesser
the detail. A good tip is to sharpen
your pencil with a craft knife so that
the lead is chisel-shaped. You'll find
that alternating the broad side with
the sharp side gives a far wider
variety of marks.

Tuscan Town House

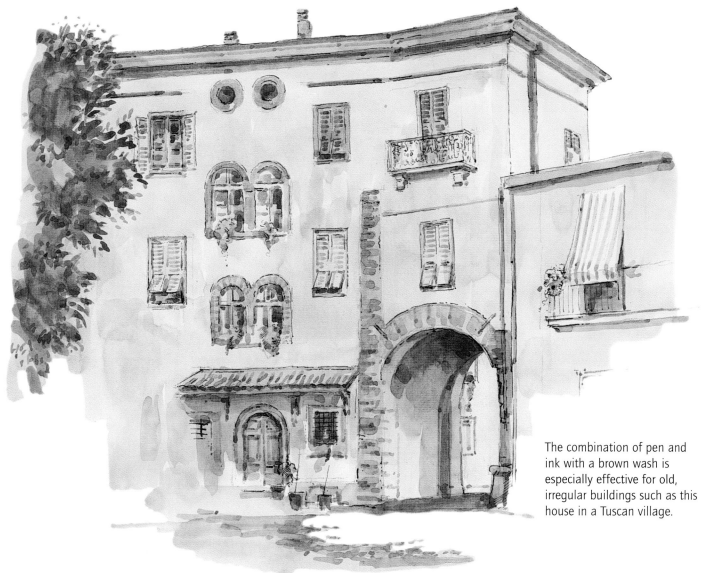

The combination of pen and ink with a brown wash is especially effective for old, irregular buildings such as this house in a Tuscan village.

Artist: James Horton

THE GREAT THING ABOUT BUILDINGS is that they don't move, so you can take your time to look at them, pick the best viewpoint, and plan your composition. My favorite medium for portraying buildings is watercolor wash and ink: The wash creates a fluid look that somehow brings even the plainest structure to life, while the fine point of a pen nib is the perfect tool for delineating major shapes and details. The wash color is a matter of personal preference; I felt that here a low-key brown mixture was most in keeping with the subject.

You will need...

4B pencil

Size 10 round brush

Size 3 round brush

Dip pen and sepia ink

PLUS: pad of smooth drawing paper; burnt sienna watercolor

Getting Started

Once you have chosen your subject, pick a quiet spot where you can study the entire structure for compositional ideas. A viewpoint that shows more than one side of the building will automatically give your drawing a greater feeling of solidity. It's also worth experimenting with eye level—for example, to emphasize the height of a particularly imposing structure.

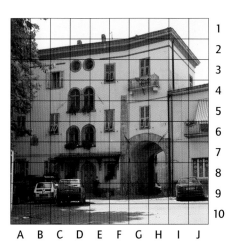

With a Grid...

1 If you're unsure of your drawing skills, rule out your paper in a grid to the same scale as the one in the photograph (above right), then transfer the details of the building square by square (right). Don't overdo the detail; concentrate on what interests you and getting the proportions right. Also, keep the pencil lines as light as possible or they will show through.

...or Freehand

If you're handier with a pencil, try to view the building as a series of simple geometric shapes and transfer these to the paper using a soft pencil (below). The front of the building is slightly curved, so I am also aware of the shapes made by the light as it plays across the facade.

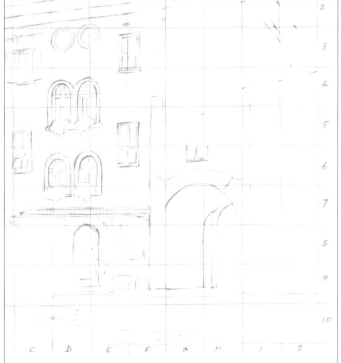

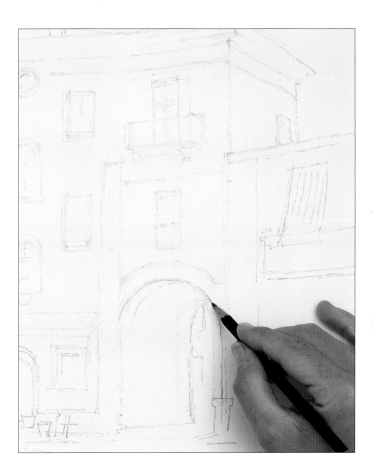

Expert Tip

Buildings are seldom as straight as they seem, so use a plumbline—a small weight on the end of a string that gives a true vertical line—to check the relationship of one vertical to another; you may be surprised at the result.

First Washes

2 Mix up a pale brown wash from the three primaries. Apply it liberally over the drawing to define the basic tonal shapes using the side of a size 10 round brush. Then mix a slightly darker wash to define the areas in shadow and apply it deeper as you work toward the arch.

Expert Tip

When painting outdoors, make life simpler by leaving your ink behind and just taking your watercolors. Mix the watercolor to the desired tint and consistency, and load it onto your pen nib with a brush. You'll find that the nib holds as much paint as it does ink and draws just as well. This practice also gives you a wider choice of color for your drawings.

Add Textures

3 Let the first layers of wash dry, then use a darker brown and a size 3 brush to depict objects such as the tree and the building's main architectural details and textures with gentle stabs of color. Sable brushes, with their fine points and ability to retain paint, allow you to draw details far more precisely than other types of brush—but at a price, of course.

Dip-Pen Details

4 Fine detail such as the ornate wrought ironwork of the balcony can now be added using the dip pen and sepia ink. On a project like this, take care not to put too much pressure on the nib; heavy lines will detract from the quality of the rest of your pen work. And be sure not to overwork the drawing— after all, there's no going back now.

Finishing Touches

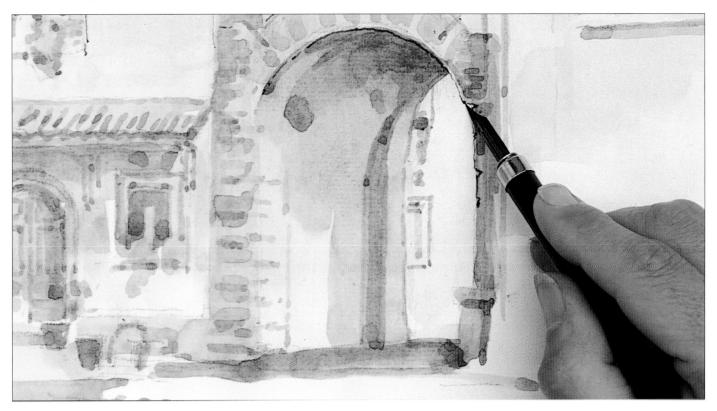

5 Finally, use the pen to emphasize the details that really catch your eye. For me, on this building, it's the archway and the porch: I don't hesitate to work these areas more fully so that they provide a sharp contrast with the looser handling elsewhere on the building—a technique that keeps the drawing from looking flat.

The leaves of the trees are suggested rather than picked out, using random dabs of the concentrated wash color.

The angled viewpoint gives a feeling of solidity, while the low eye level provides the building with more presence than it commands in real life.

Reserve your deepest, darkest washes for the areas receiving little or no sunlight.

Unnecessary details have been excluded or generalized.

The texture of the brickwork and the wooden shutters is suggested using tiny dashes of wash, applied with the very tip of a size 3 brush.

The areas of light and shade help to reinforce the sense of perspective as well as enliven the drawing.

Expert Tip

If you like the variety of line produced by a dip pen but prefer a more consistent ink supply, try a sketching pen (right). This looks and acts much like a fountain pen but has a more flexible nib.

Learn from the Master: John Ward
Piazza del Popolo

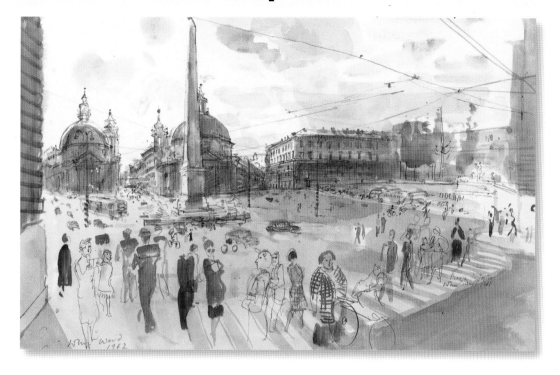

T HIS STUDY OF A BUSTLING ITALIAN PIAZZA is a fine
example of how being selective with detail can help
to give pen-and-ink drawings a more lively feel. The
buildings on the far side of the square, the background and

the obelisk slicing upward through
the sky are outlined with a fine-
point brush and modeled with
successive layers of rapidly applied
watercolor wash. The suggestion is
one of permanence and solidity.
In the foreground, by contrast, the
artist suggests the constant activity
of the crowd by choosing to render some parts in detail and
others only sketchily—just as the eye, faced with rapid
movement, registers some things more clearly than others.
Compare the detail of the sailors walking away from us
(detail above) with the barely suggested outlines of the figures
around them. The tension between the two styles keeps the
eye moving and brings the drawing to life.

Try It for Yourself

Another interesting feature of
Piazza del Popolo is the pedestrian
crossing that cuts diagonally across
the scene. The lines of perspective
here draw the eye in two directions
at once—across the square and into
it—which adds to the depth and
liveliness of the drawing. Try
sketching a similar scene, using
only the receding stripes of the
crossing to define it. Then, if you
feel brave enough, sketch in a
couple of figures and use the
perspective lines to determine
their relative proportions.

Basket of Vegetables

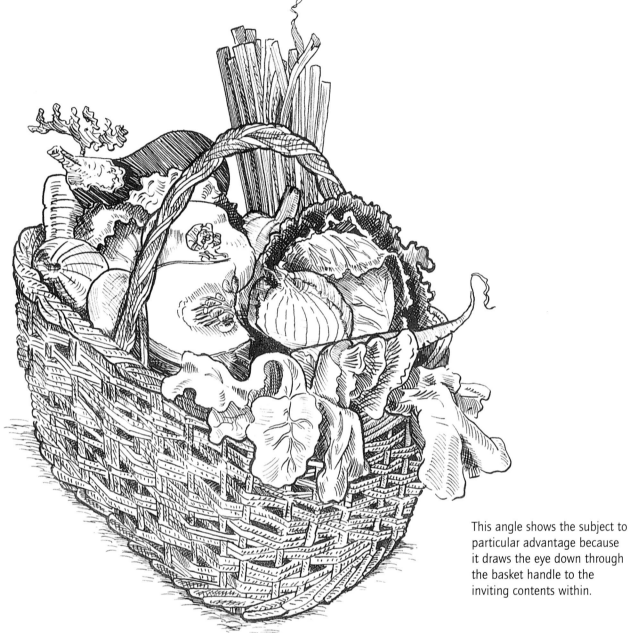

This angle shows the subject to particular advantage because it draws the eye down through the basket handle to the inviting contents within.

Artist: Rob Bennett

A WICKER BASKET filled to the brim with fresh vegetables makes a delightful subject for a still life, as well as providing the ingredients for a deliciously warming soup. But before I enjoyed the fruits—or should I say, the vegetables—of my labors, I had to draw them. Working in pen and ink, my aim was to capture the incredible variety of textures contained within the latticework of my wicker basket, from the floppiness of the spinach leaves to the intricacies of the onion skins.

You will need...

2B pencil

Dip pen

PLUS: Black ink; pad of smooth drawing paper

Getting Started

It may look like a casual arrangement, but nothing could be further from the truth. I spent a great amount of time preparing everything, from choosing this particular basket because it allowed for an almost equal balance between wicker and vegetables, to balancing the various shapes and textures. Not by chance does the leafy spinach spill out of the front or the fleshy eggplant perch at the back.

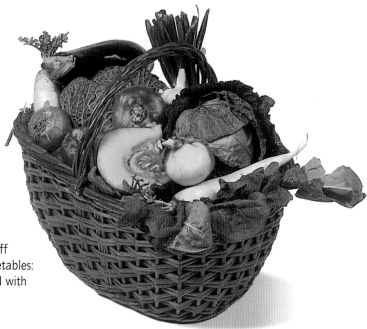

There is no need to stuff your basket full of vegetables: This one is mostly filled with newspapers!

Initial Pencil Sketch

1 As always, I start with a simple pencil sketch to outline the composition and establish the principal shapes in relation to one another. If I get anything wrong at this stage, I can simply rub it out and redraw it…

…which is why I continue adding detail. I want to get a feel for the different textures—and the lines that will convey them—before I commit myself to putting pen and ink to paper. Even so, I still have to be careful not to overwork the drawing.

Inking In

2 My first job with the pen is to ink in the lines of the pencil sketch and to begin to define the darker tones, such as the eggplant and the folds of the cabbage leaves. This is good practice for what follows. It gets you accustomed to varying the nib pressure while keeping up a constant flow of ink. And although I often forget this, it's a good idea to work from the top down so that you don't drag your arm over wet ink!

3 If you find yourself getting into difficulties with the pen at this stage, switch back to pencil and work up the sketch some more—after all, any unwanted marks are easily removed with a putty eraser after the ink has dried. Otherwise, keep working downward. When I get to the basket, I take care to get the weave running in and out of the uprights. Since the wickerwork accounts for roughly half the drawing, I feel it deserves the attention.

4 Now to the tones that will transform my jumble of shapes into lifelike, tactile objects. I have to be careful here: Although I've mapped out the darker tones already, there's a risk that I'll overwork the lighter areas, such as the spinach leaves, and find myself with nowhere to go. So I take it, literally, a line at a time, crosshatching here and feathering there. I feel able to take a bolder approach with the spaces in between the wickerwork, and I finally notice the drawing coming to life.

A Wealth of Shapes and Textures

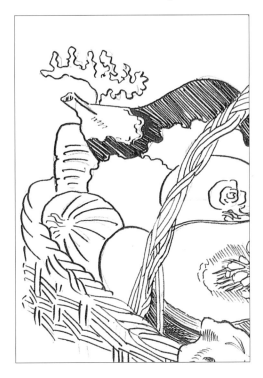
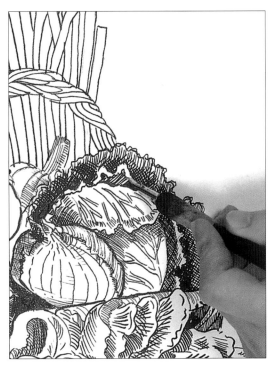

5 The smoother, lighter vegetables won't stand much modeling: Ironically, their textures are better defined by working on the contrasting textures that surround them.

6 At the opposite extreme are curling cabbage leaves and the broken skin of the onion, both of which benefit from some heavy crosshatching. Even so, I ease off on the highlighted areas.

Putting On the Finishing Touches

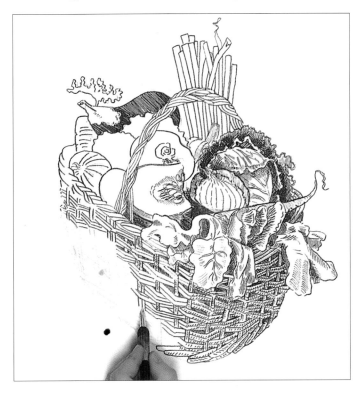

7 With the tones and textures clearly defined, I return to the basket, where more crosshatching gets me closer to the shape and texture of the weave. Then, looking at the drawing as a whole, I darken the overall tones of the vegetables at the back of the basket to push those in the foreground into sharper relief. I want them to look as if they are about to cascade toward the viewer.

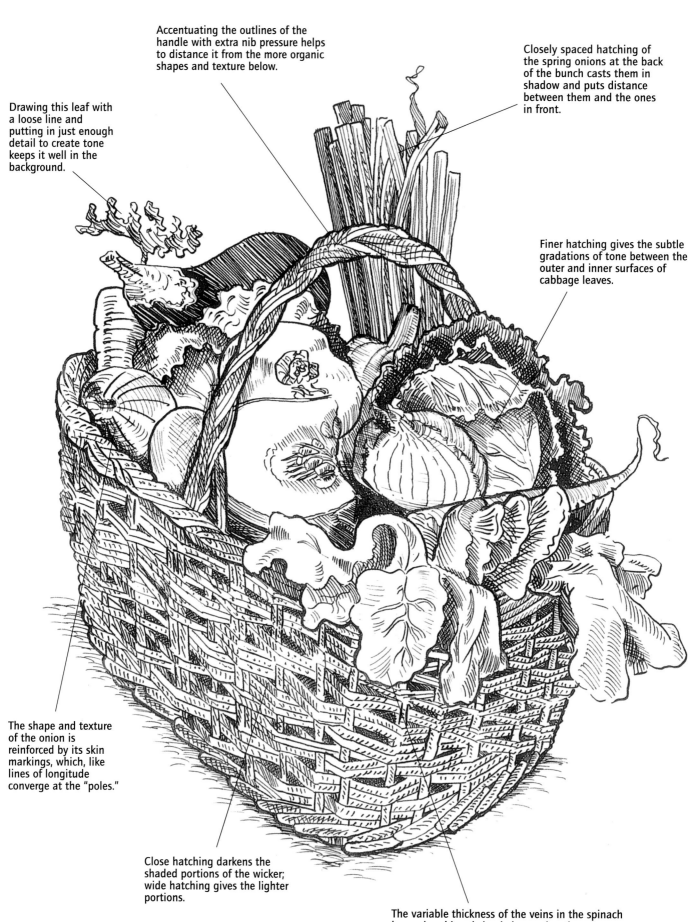

Accentuating the outlines of the handle with extra nib pressure helps to distance it from the more organic shapes and texture below.

Closely spaced hatching of the spring onions at the back of the bunch casts them in shadow and puts distance between them and the ones in front.

Drawing this leaf with a loose line and putting in just enough detail to create tone keeps it well in the background.

Finer hatching gives the subtle gradations of tone between the outer and inner surfaces of cabbage leaves.

The shape and texture of the onion is reinforced by its skin markings, which, like lines of longitude converge at the "poles."

Close hatching darkens the shaded portions of the wicker; wide hatching gives the lighter portions.

The variable thickness of the veins in the spinach leaves is achieved simply by varying the pressure on the nib.

Learn from the Master: Michael Woods
Study of Exotic Fruits

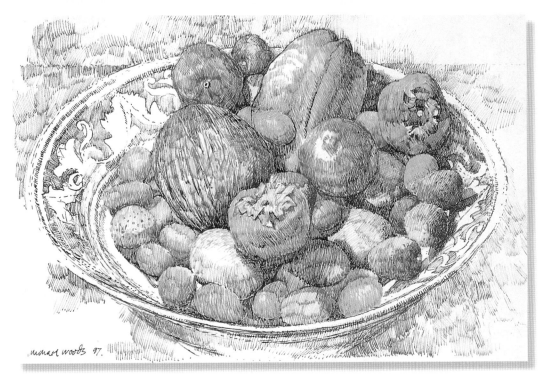

michael woods 97.

YEARS OF PRACTICE IN PEN AND INK have made Michael Woods acutely aware of the medium's strengths—and its limitations. Because colored inks tend to go muddy when mixed, Woods chooses instead to model the tones and colors of this fruit still life optically. Using 15 pure colors, he applies them a line at a time with a mixture of hatching and crosshatching (detail left) to build up the form and texture of his exotic subjects. Notice how, in the highlights, the strokes fade away to almost nothing, allowing the white of the paper to show through. But even in the darkest areas, the artist is careful not to overwork his strokes for fear of losing the ink's natural brilliance.

Try It for Yourself

Yellow, blue and pink are the only colored inks you need to draw this succulent lychee. First hatch the fruit all over in pink, spacing the hatch marks farther apart where the tones get lighter. Then hatch strokes of yellow over the pink to warm the sunlit side of the lychee and add in strokes of blue to darken the shadow areas. For the shadow beneath the fruit, cross-hatch strokes of all three colors while the inks are wet.

Flower Study

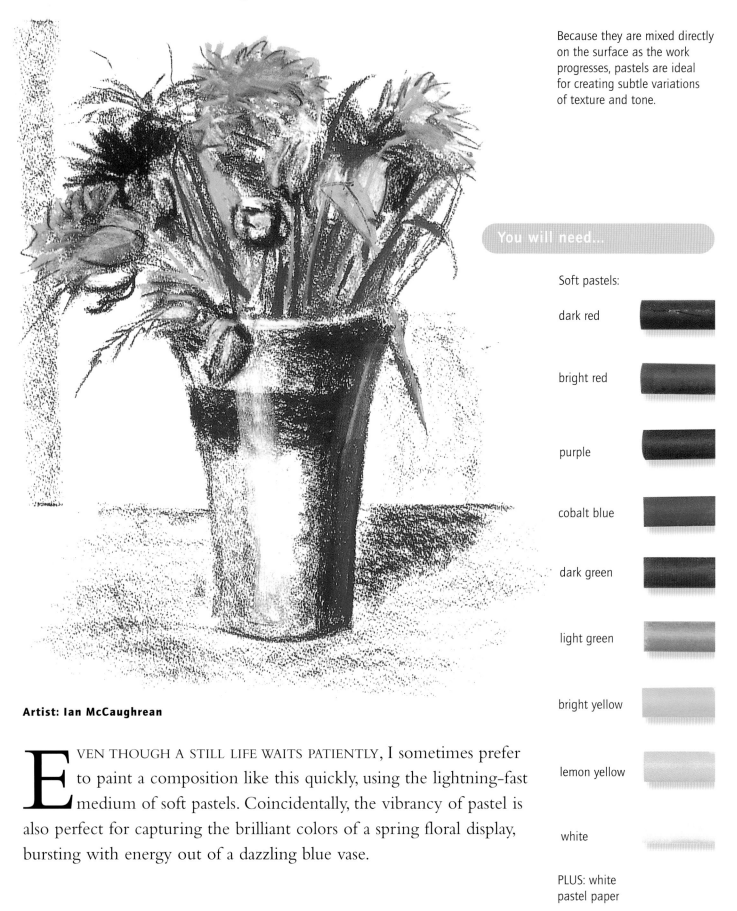

Artist: Ian McCaughrean

Because they are mixed directly on the surface as the work progresses, pastels are ideal for creating subtle variations of texture and tone.

You will need...

Soft pastels:

dark red

bright red

purple

cobalt blue

dark green

light green

bright yellow

lemon yellow

white

PLUS: white
pastel paper

E VEN THOUGH A STILL LIFE WAITS PATIENTLY, I sometimes prefer to paint a composition like this quickly, using the lightning-fast medium of soft pastels. Coincidentally, the vibrancy of pastel is also perfect for capturing the brilliant colors of a spring floral display, bursting with energy out of a dazzling blue vase.

Getting Started

Half the pleasure of painting a floral still life is deciding what flowers to include. I wanted to work with a fairly restricted palette and decided that the pink gerbera worked well with the red and white tulips, even though in the end I decided not to paint the white ones. But to avoid having the colors blend together, I set the flowers off against a jarringly vivid blue vase.

Shaping Up

1 I begin by outlining and roughly blocking in the vase in cobalt blue pastel. At this early stage I consciously keep the color muted: I prefer to bring all the colors up to full strength roughly in parallel with one another; otherwise, that vivid blue might prove distracting while I'm trying to harmonize the colors of the flowers. Also, I haven't decided at this stage just how faithful I will be to the overwhelming blue of the vase; I may decide to bathe it in light from the front, which will cast it in highlight and downplay the intensity.

2 Still working with blue, I outline and color the dark band that creates a sense of the roundness of the vase. Then I use purple to establish the shadow cast by the vase, thereby locating it in three-dimensional space. Next, I block in the foliage in broad strokes of light green, varying the pressure to distinguish the darker areas from the lighter areas and rotating the pastel stick to create different surfaces and textures.

Developing the Foliage and Flowers

3 Next come the dark green portions of the foliage: the ferns and the shaded areas of the tulip leaves. These are sketched in with broad strokes using both the side and the tip of the pastel stick. Working with pastel creates a lot of dust, so it's a good idea to periodically blow off any excess, away from the painting.

4 I move on to begin blocking in the flower petals, at this stage mainly in bright red, but with a little purple and lemon yellow, too. Because these shapes are rounded, I apply the pastels in a sweeping, circular motion to help establish the curvature of their lines.

5 By this time I'm beginning to see a picture emerging and getting a feel for the final color balance. Somehow the white tulips in the original arrangement don't look right, so I decide to ignore them. Instead, I add in some bold strokes of yellow.

Balancing the Colors

6 Returning to the vase, I decide that I do want to soften the vivid blue a little—not by toning it down, but by breaking up the color with large areas of white highlight that simulate light reflected off the smooth surface. I apply purple over the blue in the dark band. The color is heavy in places to make it opaque, but I'm careful to leave gaps for the highlights.

7 Working back and forth between the flowers and the vase, I gradually strengthen all the colors. Since color balance is the key to success here, I do this one step at a time, applying a little of one color after another, rather than trying to get to the finishing line with a single hue. So the reds and yellows of the flowers are worked up a little, then the blue of the vase, and so on.

Final Details

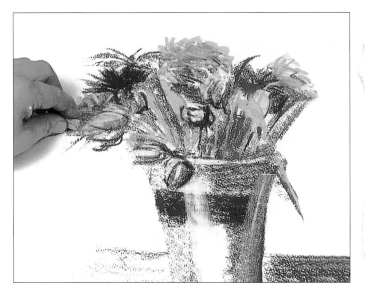

8 Knowing when to stop is important: Pastels are so bright, they can easily begin to overwhelm if not used with some restraint. Once satisfied with the color balance, I begin the final touches—the highlights on the flowers (the very brightest sun-kissed yellows) and on the vase (the reflections from the glazed surface).

Classnotes...

Fixing pastels is an essential final stage. Do it outside or in a well-ventilated but wind-free area, using a sweeping movement across the surface from the top to the bottom. Don't overspray or the fixative may darken the colors and obscure their purity of hue. You can use either a commercial fixative or a scent-free lacquer-based hair spray, which is much cheaper than fixative and just as effective.

Hard edges on this petal throw it into relief against the colors behind. Despite the mix of colors, the shapes emerge as strongly three-dimensional.

Strokes of red and yellow pastels are crisscrossed over each other to create various shades of pinkish orange.

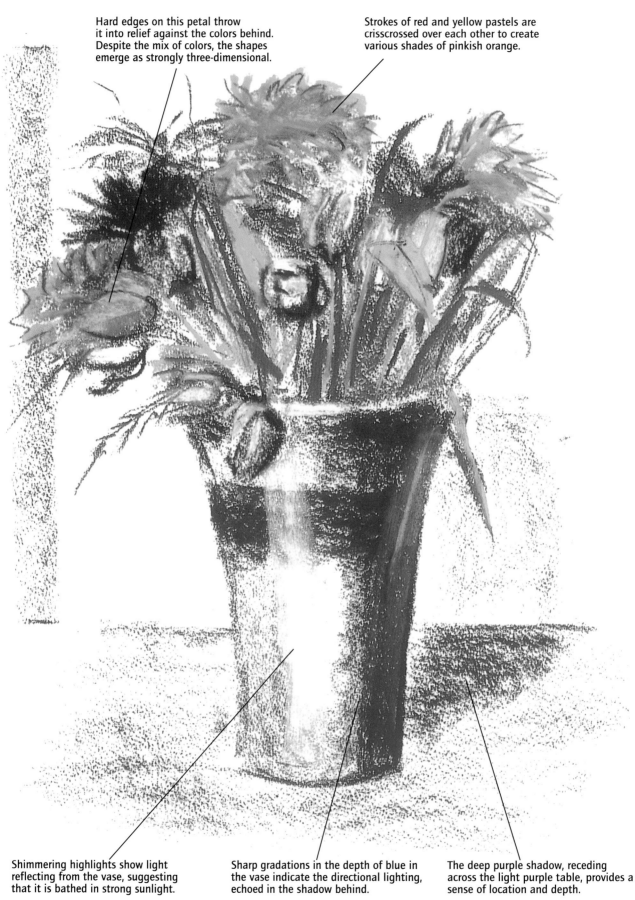

Shimmering highlights show light reflecting from the vase, suggesting that it is bathed in strong sunlight.

Sharp gradations in the depth of blue in the vase indicate the directional lighting, echoed in the shadow behind.

The deep purple shadow, receding across the light purple table, provides a sense of location and depth.

Learn from the Master: Frances Treanor
Alhambra Jug

PURE COLOR IS THE KEY to the dazzling pastel pictures of contemporary British artist Frances Treanor. The freedom of composition evident in this still life reflects Treanor's spontaneity. Without making any preliminary sketches, she jumps straight into painting and uses her pastels to create strong juxtapositions of color: bright green and

yellow in the flowers; brilliant pink and blue on the jug. The colors are pure and bright, with little mixing or blending. The artist works on a dark paper support, which shows through the white pastel marks of the background and sets off the striking tablecloth. Treanor's love of patterns is evident in the exotic swirls on the Moorish jug (detail above) and in the warm, primitive shapes of the cloth. Even the flowers—although simply rendered—form a pattern, with the leaves gently echoing those in the cloth.

Try It for Yourself

The fascination of patterns lies in the infinite variety you can achieve with just a few simple shapes. To mimic the design of the tablecloth above, choose a small selection of colors that work well together as pure, unblended hues, plus a dark support—blue or black—that will help them shine. Experiment with a selection of strong shapes—stylized leaves, polygons of color and groups of lines. You could even cut them out of paper first and shuffle them around to see how they work together. When you are happy with the pattern, start reproducing it in pastel. Block the colors in firmly using the sticks on their sides and allow the dark support to show through in places. Even with just a handful of pastels, you'll be amazed at the dramatic effect.

Twilight Scene

Artist: Felicity Edholm

F OR SUBTLE ATMOSPHERIC LANDSCAPES, pastels are my first choice every time. There's something wonderfully uninhibiting about their immediacy and the degree of control you can exert. In this painting, I drew with them, laid broad areas of color, and ground them to dust and sprinkled them. Then I rubbed, smudged and smeared, working with my fingers to achieve a seamless transition between the colors. In fact, as styles of painting go, this is about as hands-on as you can get.

bright blue

dark olive green

cream

peach

magenta

brown

PLUS: scalpel cotton ball; A3 pastel paper; small dish

THE PROJECTS

Getting Started

Working in pastels is never dull, and the more I can physically interact with a painting, the better I like it. Here, because of the strong tonal contrasts and broad, deep areas of color, I use the dry-wash technique: I grind the pastel sticks to a fine powder directly over the paper and spread the pigment with my hands.

It's hard to work with soft pastels outdoors. I prefer to make pencil sketches of my subject (right) and work them up into a proper composition later.

Dry-Washing the Foreground

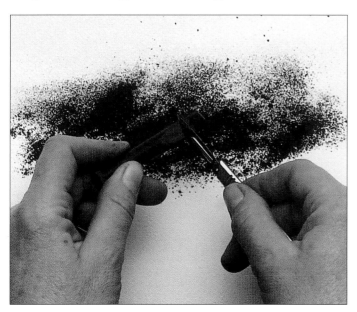

1 Always use pastel paper when dry-washing soft pastels. That way, you can be sure that the surface will have sufficient tooth to hold the pigment dust. The first job is to prepare a fine powder of dark olive green pastel for the undercoat of the hillside. I do this directly on the paper, carefully scraping the end of the pastel with a scalpel. This takes a little practice: Scrape too hard and you will end up with chips of pastel rather than a fine powder; apply too much pressure to the stick and you're likely to break it completely. You need to cover a large expanse of paper, so start scraping....

2 Once I've ground what seems like a reasonable amount of the dark olive powder, I work it across the lower half of the paper with my fingertips. I smear it from left to right, trying to keep a fairly clean edge for the crown of the hill. Then I clean the scalpel, wash my hands and move on to the next color. To create a greater sense of depth, I enliven the foreground by sprinkling on a little bit of powdered magenta pastel and gently working it in.

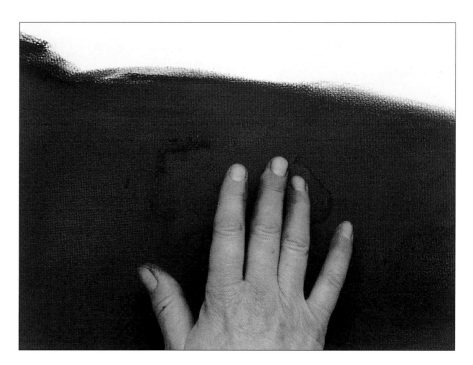

Dry-Washing the Sky

3 To dry-wash the sky, I use a cream-colored pastel. But this time I scrape the powdered pastel into a small dish and apply it to the top half of the paper with a ball of cotton. Because the cotton fibers retain some of the powder, this creates a less dense effect than dry-washing directly onto the paper and blending with your hands. The powder tends to stick only to the high points of the paper, allowing the crevices in the surface to show through.

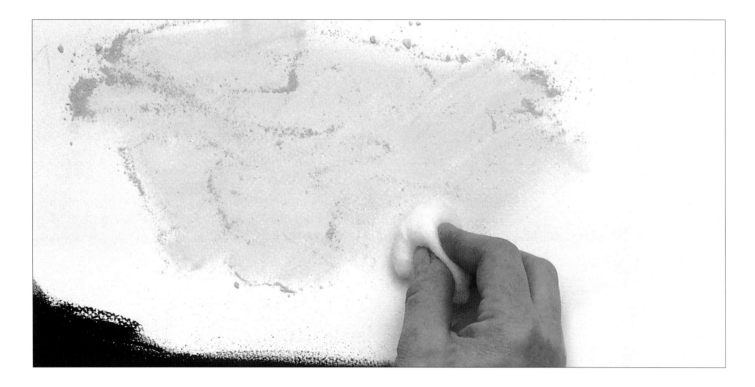

Adding the Trees

4 I want the trees to glow in silhouette, so I start by under-painting them with a peach pastel. I use the tip to draw the trunks and a flat side to block in the basic shapes of the foliage. This gives me a framework to build on. I then switch to darker colors to build up the brown and green tones. The trunks are very fine, so I rub the tip of the brown pastel on some rough paper to create a delicate edge to draw with. Using this edge on the tip of the pastel, I can define the trunks and map the outlying branches in a more conventional drawing style.

Adding the Foliage

5 For the foliage I apply a dry wash of powdered dark green pastel using my fingers. Finally, I scumble color onto the wider branches with the side of the pastel—in other words, I apply it with a light enough pressure so that the underlying color and some of the paper still shows through.

Dry-Washing the Clouds

6 Next come the clouds. I scrape some peach pastel onto the sky area to the left of the trees. This will form the undercoat—a rosy layer on top of which I will overlay a light layer of brown to create a hazy effect.

7 I manipulate the pastel powder with my fingertips to form the cloud shapes. Later I sprinkle a little brown pastel dust over the center of the shapes and blend it—but not completely; I let some of the peach show to give a rosy haze around the clouds.

Heavy blending creates the subtle, hazy feel of the sky.

The broken silhouette of the branches is obtained by drawing with the side of the pastel, using light pressure so that the tooth of the paper shows through.

Underpainting the trees with a peach wash creates the glow of light as the sun dips in the sky.

Overlaying a cool, dark wash over a warmer, lighter one is a favorite trick for conveying the glow of clouds at sunset.

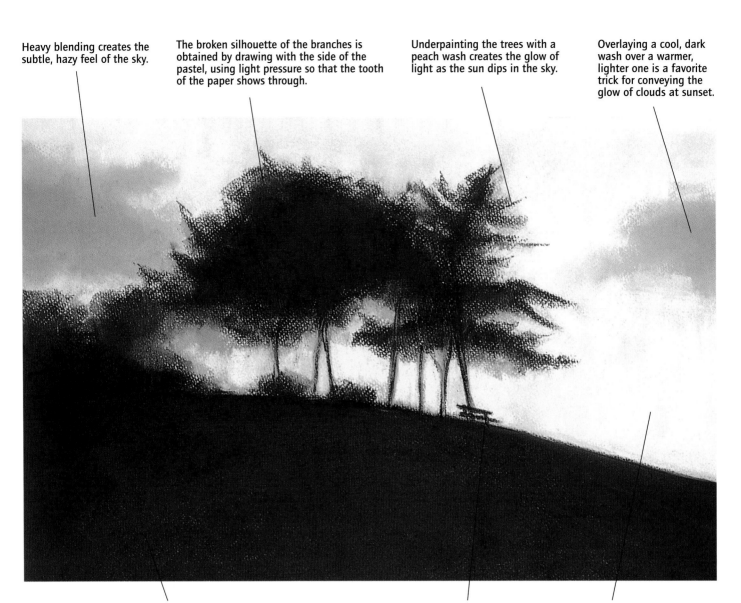

The blended foreground colors—green with dashes of red over blue—create a hint of the texture and undulations of the hillside as they fall into deep shadow.

Paint the bench in blue to add a finishing touch.

The lightest tones denote the last throes of the setting sun. They provide a powerful compositional contrast with the slope of the hill.

Expert Tip

Working with soft pastels always creates a lot of dust, and the dry-wash techniques shown here generate more than usual. Pastel pigment is nontoxic, but it's still best to avoid inhaling the dust. Work in a well-ventilated room, preferably near an open window, and wipe or vacuum away the excess powder at regular intervals. Unless you're lucky enough to have a studio, it's best to cover the entire working area with a dust sheet before you start. A good way to avoid contaminating one area of the painting with dust from another is to gently lay sheets of paper over the areas you're not currently working on.

Using Fixative

As with all pastel paintings, once you've finished, spray the painting with fixative to hold the dust in place. Take care to apply the fixative thinly and evenly, though, or you might find it spoils some of the finer blending of your colors.

Learn from the Master: Richard Cartwright
The Departure

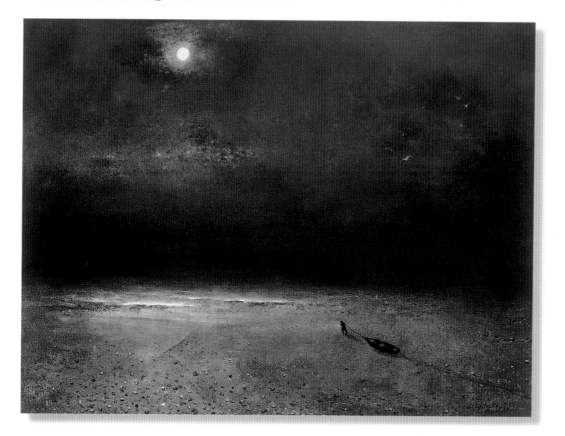

Artist Richard Cartwright works almost entirely in pastels. Yet he gets so much depth of color and richness of texture into his work that some mistake it for oil painting. His technique is to use the softest sticks he can find so that when he lays in areas of flat

color, he gets the maximum amount of pigment on the surface. He builds on that using dry wash, molding the pigment with his fingers. Then he draws in details such as the fisherman's towline (detail above). To get even more pigment into play, Cartwright sprays his paintings with fixative when he reaches saturation point, then carries on adding layers. This mixture of fixative and pigment dust also lends a lacquered look that enlivens the highlights still further.

Try It for Yourself

To capture an atmospheric moon effect like this, start with a pastel stick, then apply dry wash on top. Draw an outline of the moon and apply black pastel thickly around it. Then scrape and smudge in dry-wash layers of blue and white to create the clouds, which are illuminated to varying degrees by the moonlight. Finally, using a white pastel stick conventionally, color in the moon itself.

Watermelon

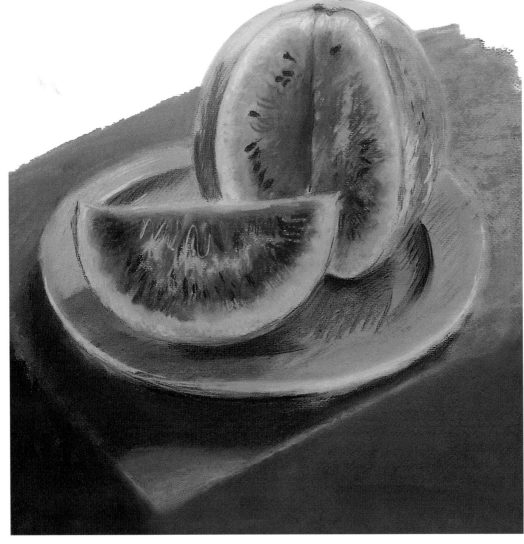

The green skin and bright red flesh of a watermelon make the perfect subject for a pastel still life. But look closely and you'll see that much of the painting's vibrancy comes from using a wider range of colors, each carefully layered and blended on the paper.

Artist: Sharon Finmark

FOR ME PASTELS ARE ALL ABOUT COLOR. The beauty of the medium is that you can throw colors together to see what happens, knowing that they can be blended in or lifted off in seconds if the effect doesn't work. Here, I've tried to accentuate the natural vibrancy of the melon by layering and blending related colors—reds, pinks and purples for the flesh and tablecloth; yellows, ochres and greens for the skin—and by "bouncing" colors between the subject and its background.

Cotton swabs

Torchons

Soft cloth

Cotton ball

PLUS: medium pastel paper

You will need...

Soft pastels:

pink

red

purple

yellow

light green

dark green

brown

ochre

black

white

Getting Started

There's no standard system for naming pastel colors, so don't worry if your pastels don't match exactly. It's far more important that you learn how to blend your chosen colors and build up their tonal values—in fact, it may pay to practice these techniques before you start. Remember, too, that blending pastels can be messy. So once you've laid out your paper and cleared the working area, you may want to lay down a sheet to catch the dust.

As with all still lifes, play with the lighting and composition to see what kind of tonal effects suit the subject best.

1 After studying the subject for a while to take in the basic shapes, I sketch them in using yellow and ochre. Most of these lines will be covered later, but some of the yellow will shine through, adding to the vibrancy—especially around the melon's skin. The next job is to block in the main areas of color on the melon and the plate, using the pastels on their sides. I use yellow for the skin of the melon, pink for the flesh and gray for the plate. At this stage I'm using a lot of pressure so that the texture of the paper "bites" and creates plenty of dust for blending later.

Building Tones

2 With the melon and plate blocked in, I turn my attention to tones. For the shadow on the plate, I run some more black into the gray, but on the foreground shadows I use a mid-toned blue; this will effectively kill the reds and purples that will be laid on top, creating a suitably murky effect. Also at this stage, I start to play with the tones on the flesh, running in some white and pink and blending it with my fingertip to see if I can achieve a glistening, watery effect. You may find that using your little finger stops you from being too heavy-handed.

Building Color

3 Now comes the fun part: building up and adding to the richness of the color. Mimic the way the red of the flesh and the purple of the tablecloth bounce off one another by streaking in loose, light strokes of each other's colors. Don't worry if it all seems a bit much; you'll have plenty of opportunity to tone it down again.

Lifting Off and Lightening

4 By this stage the colors are really beginning to sing and I can go back to adjusting the tones—for example, where the flesh merges into the melon's skin. Using white would be too harsh. Instead, I lift off some of the existing pigment with a cotton ball, which gives a fuzzier edge than a putty eraser; the gentler effect suits the subject perfectly. Substitute a cotton bud for lifting off the really fine details, and don't forget to use a clean piece for each dab or you'll spread the lifted pigment where it isn't wanted.

The Background

5 I continue building up the color of the tablecloth until it's rich and dense, then turn my attention to the shadows of the folds and the highlights created by the edge of the table. For the shadows I add streaks of brown and blue to the already saturated pigment. For the highlights I gently stroke in some white and then blend it with my finger. By the time I've finished, the white barely shows.

226

Definition and Details

6 With the broad areas of color and tone defined, it's time to turn to the details that will bring the painting alive. First I add the seeds, blending black strokes into the reds very gently with a small torchon to suggest their being lost in the flesh. Then I draw a brown line down the center of the melon and blend it lightly into the surrounding pigment to denote the softer center of the fruit.

Final Highlights

7 Last of all come the highlights on the plate and the watermelon. As with the edges of the tablecloth, I start by defining the plate's rim fairly boldly in white pastel. Then I soften the highlight by dabbing around the edge with a cotton ball. Finally, I blend light and dark green into the melon skin and dab on a few white highlights.

Disperse some of the brown pigment marking the center line into the flesh to reinforce the sense of depth.

For the skin, blend streaks of light and dark green into the yellow/ochre base. Use dabs of white for the highlights and blend in to denote the skin's waxy texture.

Pulling in some ochre from the skin color stops the gray of the pewter plate from looking flat.

The final layer of yellow, well blended, warms up the parts of the tablecloth bathed in sunlight and adds to the overall richness of the painting.

Classnotes...

Blending and lifting are as important to the pastel painter as applying the pastels themselves, so make sure you have a full supply of blending tools at hand. It's worth experimenting with tools; every pastel painter has his or her personal favorites.

A putty eraser shaped to a point is useful for lifting off and blending fine details.

Fan brushes are great for creating graduated tones over a larger area.

Torchons are useful for fine blending and spreading pigment.

Use a soft cloth to flatten large areas of color and to sweep pigment dust around.

Learn from the Master: Stanford Gibbons
Plants, Pots and Fruit

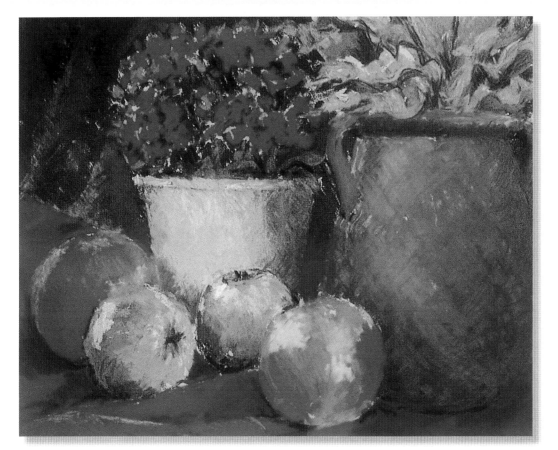

W HEN COLOR REALLY MATTERS, contemporary British artist Stanford Gibbons opts for pastel every time. But interestingly, he prefers to lay colors over one another rather than blend them. Blending, he feels, tends to dull the brilliance of pastels. So instead, he works layer upon layer, optically mixing the colors by gently hatching and crosshatching them so that the different shades show through. For example, in the white porcelain pot

(detail left), crosshatched strokes of blues, greens, mauves and yellows all combine with a white base to suggest the pot's rounded form and shiny surface.

Try It for Yourself

Try pastel painting a rounded earthenware pot. Start with your mid-tones, browns and ochres, and gradually build up the lights and darks. Crosshatch reds and oranges for the area closest to you, browns and black for the side of the pot in shadow, and yellows and white for the highlight.

A View Outside

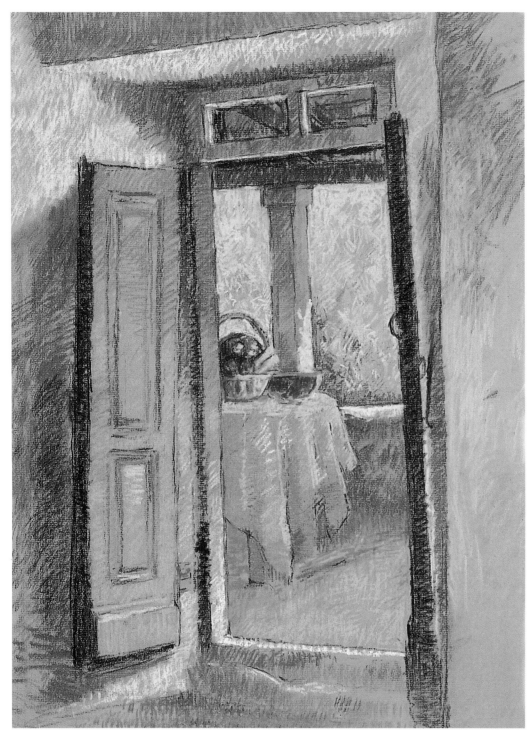

Artist: James Horton

Framed by the doorway, the vibrant colors of an exterior view contrast with the muted shades of the shadowy interior.

You will need...

Soft pastels:

olive green

mauve

fresh pink

yellow

strong pink

light blue

apple green

PLUS: white pastel; charcoal; light brown pastel paper

DAZZLING SUNLIGHT—LOTS OF IT. That's what I think of when I remember Italy. In the mornings shards of intense light illuminated my balcony, and the combination of fresh fruit and sunshine was irresistible. I wanted to hold on to that feeling, that intensity, so pastels seemed an obvious choice.

Getting Started

Combining an exterior view with an interior scene automatically adds depth to your picture. I particularly like this shot because the doorway acts as a natural frame, leading the eye to the bright fruit on the table and the garden beyond. The light of the interior is suffused and mellow and contrasts with the bright, even light of the exterior. This is reflected in my choice of pastel colors; vibrant for outdoors and more muted for inside.

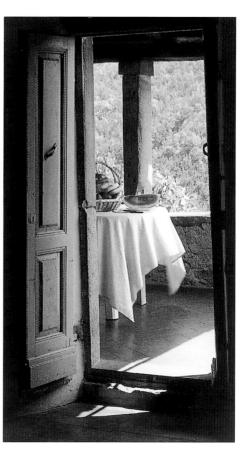

Sketching the Outline

1 I chose a mid-toned brown pastel paper to work on so that its color will contribute to the overall effect. My first step is to start lightly sketching in the basic outline of the scene in charcoal. Notice how the colors of the exterior are bright and vivid; the colors of the interior are cool and muted. I begin by applying the pale pastel colors—the light blue, fresh pink and some touches of mauve to the lightest highlights.

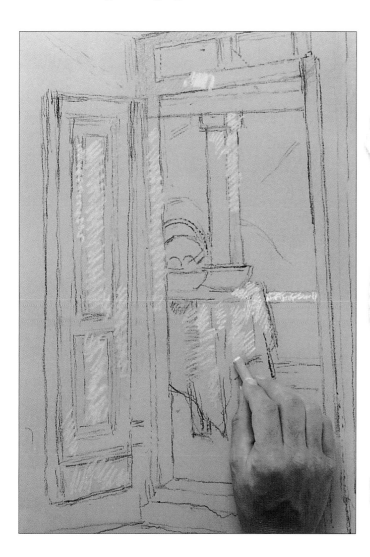

Expert Tip

Keep It Clean
Pastels create a lot of powder when they are worked and are easily smudged. To protect the painted surface as you work, place a clean sheet of paper under your hand, but be careful with the paper—if you inadvertently drag it across your picture, you will almost certainly smudge the image very badly.

Paper Protection
Avoid smudges by resting your hand on a sheet of paper as you work.

Establishing Light and Cool

2 It's all a question of getting the tones right, so I spend a little more time looking at the contrasting areas of light and dark. The door frame seems virtually black—certainly the darkest area in my picture—so I start to put in some of the dark charcoal and mauve pastels on the right-hand side of the doorway. I hatch tiny lines of color—that is, I lay short, parallel strokes side by side rather than blending pastels on the paper. It may seem perverse to work this way, given how easily pastels blend, but I want a light, impressionistic effect for this wonderful sun-drenched balcony. I keep working around the whole picture, putting patches of color on the fruit bowl and the garden vegetation.

Adding Richer Tones

3 Once I have laid down the general areas of warm and cool color, I decide to work up the shadowy area of the balcony with some richer tones—purples over blues, hot pinks over purples. By using tiny strokes of the strong pink over the mauve, I produce a lively, sparkling effect as the colors vibrate against each other.

Applying Light and Dark Tones for the Interior

4 Next, I go back to my charcoal to work up the most shadowy areas of the interior—in this case, the doorframe. Its absolute blackness is a fantastic contrast to the brightly glowing pastels. You can see how this use of dark outline indicates the deepest shadows of the doorframe while it separates visually the lively colors of the exterior from the muted tones of the interior.

5 The interior is illuminated by patches of hazy, reflected light—light that has bounced off objects in direct sunlight. I use white or fresh pink pastel to work up these areas, such as the ceiling above the door frame and, as shown here, the wall behind the top of the door. Notice how this paler effect sets off the splashes of yellow, apple green and olive green in the garden.

Adding Some Finishing Touches

6 Looking at my composition as a whole, I decide to rework some of the areas of bright color. For example, I add some detail to the fruit in the basket on the table and give a bit more color to the garden greenery, taking care not to overwork. It's important to keep the background undefined to create the sense of distance beyond the balcony. I work up the interior to balance the strong

colors on the balcony, applying light and dark tones to the interior walls. It's at this point that you can really see the importance of the toned paper—it is integral to the color harmony. For the finishing touch, I use the charcoal again to accentuate the shadows around the door frame.

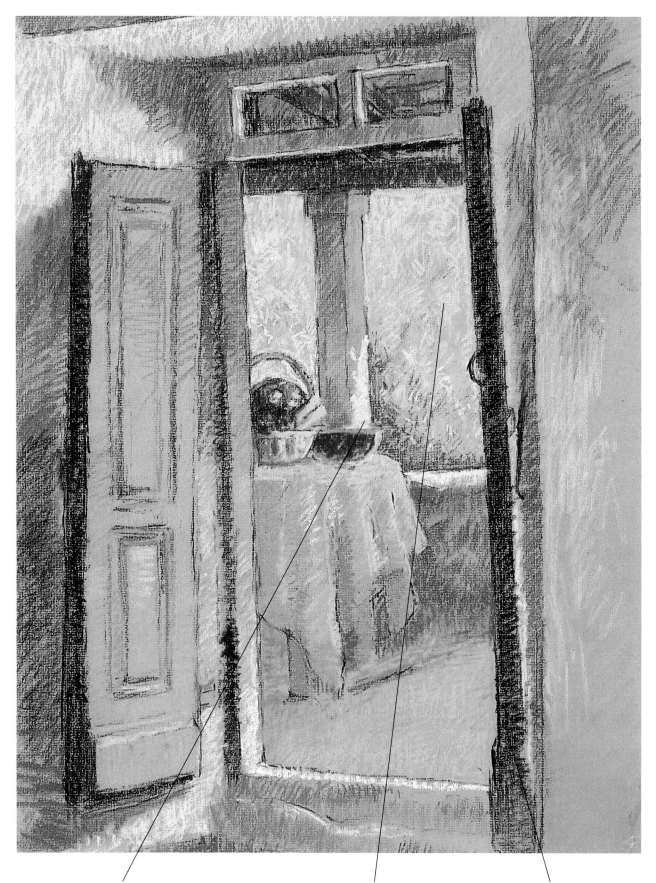

Bright colors, either pale or strong, have been used in the areas of strong sunlight.

Pastel marks are not blended on the page; this gives the picture a sharp clarity.

Dark and light tones are used to contrast the bright exterior and the shady interior—and to create a sense of depth.

THE PROJECTS

The Hall of the Manor House in Waltershof

GERMAN ARTIST HANS OLDE, working at the turn of the twentieth century, was a master of light and shade. In this picture he has used soft pastels on paper to paint the dining hall of a baronial home. The room is dark and cool yet suffused with the light that bursts through the windows and French doors. That light pulls the

eye deep into the painting to the radiant but barely defined garden beyond. The tones in the foreground of the painting gradually become deeper and more muted the farther we retreat from the light source.

Even so, Olde's grasp of detail ensures that much of the hall shimmers with light—the reflecting glass surfaces of the paintings on the walls, the gleaming china cups and dishes on the dining table (detail, above), the polished terra-cotta of the steps beneath the door at the left and even the cloud of luminous cigar smoke that surrounds the seated figure.

Try It for Yourself

To show light through a window, start with a pencil sketch. Build up the view with green and yellow pastels, then block in the wall in pale blue. Spray this layer with fixative. For the curtain use the thin edge of a white pastel to draw the overall shape. To create the impression of gauze, scrape some white pastel dust over the area and blend it in.

Coral Reef

Artist: Rob Bennett

The bold, curving shapes and brilliant colors of Rob Bennett's collage deliberately echo those used in the colored-paper collages created by the French artist Henri Matisse (1869–1954).

You will need...

I MPROVISATION IS FUN, and in a collage you have the wonderful freedom to move the elements of your composition around until you feel the picture is just right. I decided to work with strong abstract shapes in a paper collage in the style of Matisse. The abstract shapes are powerful, yet when combined with the simple, easily recognizable shapes of fish, they suddenly transform themselves into coral and seaweed.

Scissors, colored craft papers

PLUS: glue pen; sketch pad; pencil; 1 sheet 16.5 x 23.4 in. (420 x 594 mm) of ultramarine blue card

Getting Started

First, choose your colors. And for a collage like this, think bright. There are dozens of different-colored papers available from art-supply stores. A blue background is the obvious starting point for an underwater scene, so I chose a sheet of ultramarine cardstock for my support. However, there's no reason why any of the other colors should reflect nature, so I include some bright acid colors among my paper sheets, as well as more subdued tones.

Experimental Shapes

1 I begin by sketching flowing shapes in pencil on my sketch pad—tight angular spirals, rounded coral "combs" and stylized fish. I experiment to see what works and what looks interesting. Next, I do a couple of rough sketches combining shapes that look good together. When I think I'm on to something, I sketch the shapes lightly onto my sheets of craft paper and begin cutting out.

Background

2 A large, majestic shape is needed for the background—something to hold the composition together and give the collage a sense of depth. I decide on a large blue-black "coral" shape with curving, fluid cuts; its subdued color and flowing outlines blend nicely into the ultramarine. I move the shape around the support to see where it looks best but hold off from sticking it down.

Foreground

3 Next, I add some shapes to establish the foreground and middle ground. I choose bright "advancing" colors for the green coral on the right, the red seaweed on the left and the pale blue frond at the top. Then I establish the middle ground by adding some more subdued colors. Again, keep your options open and move things around to see what works—and don't adhere anything just yet.

Classnotes...

You don't have to limit yourself to paper to create exciting collages. Instead, try experimenting with more unusual materials. Patches of cloth, strands of wool, candy wrappers, buttons, feathers, sequins, pieces of cork, linoleum, twigs, pasta—anything goes. A look through your kitchen drawer or even your wastebasket is sure to turn up a challenging selection of materials. One approach is to choose relevant materials, such as colored feathers for birds, or, equally, irrelevant materials, like flowers made from pasta. The only limits are your imagination and finding a glue strong enough to adhere the materials to the support.

Bringing the Picture to Life

4 Yellow is my brightest color, which makes it the natural choice for the fish—the most prominent element in the collage. My paper also has a mottled texture that suggests scales, which is pure luck. To give a sense of perspective, I make some of the fish shapes larger than others. I position them in a little shoal but take care not to make them appear regimented.

Adding the Details

5 Now is the time to stick everything down, but only once you are absolutely satisfied with the composition. Even at this late stage you can still move pieces around. After adhering, cut out a variety of small shapes in bright colors to signify eyes, gills and fins. Mix and match them on the individual fish.

Although small in area, the emphatic "waviness" of the floating plant frond plays a key role in creating a sense of being underwater.

The different-size fish reinforce the sense of depth created by the careful choice of colors for the foreground, middle ground and background.

Intricate shapes like this convey a sense of movement, conjuring up the impression of plant strands being swept around by underwater currents.

Although green is normally considered a cool—and therefore recessive—color, the intensity and contrast of this particular hue pushes it forward from the background and helps to establish the foreground.

Classnotes...

You've just made a beautiful collage. It all went perfectly—the colors glowed; the shapes worked well together. So now you want to display it. But how? Collages are not always easy to preserve, especially because they are only as strong as the support and the glue used to stick them. People tend to brush against them, and paper shapes have a habit of curling at the edges. The answer is to frame them, but standard frame kits are suitable only for flat collages. Fortunately, you can now buy box frame kits (right) that keep the glass well clear of the support, giving both 2-D and 3-D collages an added sense of depth.

Learn from the Master: Sarah Hammond
Fruits de Mer

CONTEMPORARY ARTIST Sarah Hammond creates witty collages in paper, using bold colors and primitive shapes. She is more interested in the way the colors and shapes bounce off one another than in scale or perspective, both of which she happily distorts to suit the theme of her picture. Here, Hammond plays with the French phrase *fruits de mer,* meaning seafood. The food is certainly there in abundance. But in the artist's topsy-turvy world the means of its collection and consumption are delightfully confused: The table spread doubles as a tropical island, set like a jewel in a deep blue sea. Similarly, the bowl becomes a coral atoll, the cutlery takes on the shape of palm trees, and the tablecloth has the texture of a sandy beach. You may find that "theming" your collages this way helps to bring method to what might otherwise be taken for madness.

Try It for Yourself

The great thing about collage is that you can use just about anything in your pictures—newspapers, bus tickets, bits of string. To add color to a composition, try using photos or ads from old magazines. Tear out a few sheets and use them to cut out some fish shapes. The shoal of fish above were all cut from a fashion

magazine— snipped from images of a T-shirt, perfume bottles, a model's eyelashes and a woman's skirt.

Stenciled Beach Huts

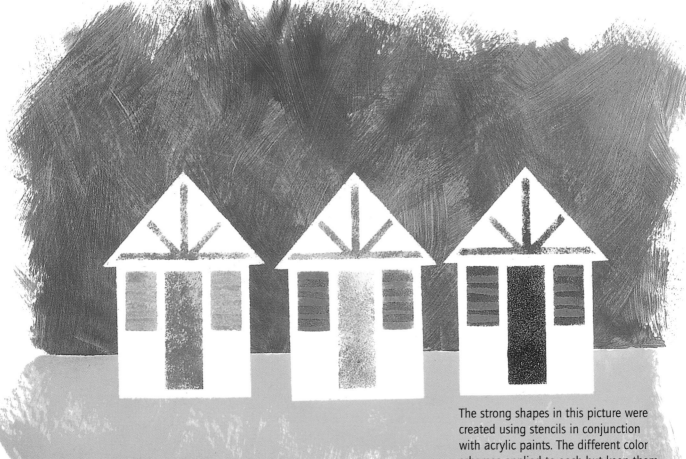

The strong shapes in this picture were created using stencils in conjunction with acrylic paints. The different color schemes applied to each hut keep them from looking repetitive.

Artist: Rob Bennett

WHEN WAS THE LAST TIME YOU USED STENCILS? When you decorated the bathroom, or perhaps even as far back as elementary school? That was me, until recently. Then a friend asked me to paint a mural for his café and to make it "sunny" so that it would put people in a happy frame of mind. We decided on a theme of beach huts. I started small, just to see if the idea worked. It did. Now there are 24 cheerful huts lining the café walls.

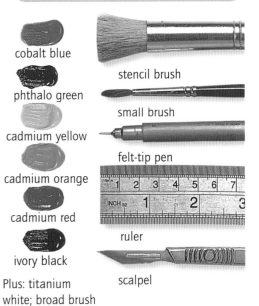

You will need...

cobalt blue

phthalo green

cadmium yellow

cadmium orange

cadmium red

ivory black

Plus: titanium white; broad brush

stencil brush

small brush

felt-tip pen

ruler

scalpel

Preparing and Cutting the Beach-Hut Stencil

Stencils need not impose uniformity in your composition.
Just think what variety of color or texture will introduce.

1 You can buy card stock in any art-supply store. I like waxed stencil card stock because it is slightly stronger, more moisture-resistant and lasts longer than ordinary card stock. Start by drawing your outline with a felt-tip pen. I use a ruler both for making the outline and for cutting out the interior details with a scalpel. Before cutting, place your stencil on thick cardboard or plenty of old newspaper to protect your tabletop. Cut out the door, gables and windows.

Using Negative Shapes

2 Next, cut around the outside of the hut. Take care to make accurate cuts, particularly at the corners of the stencil. It is important to make sure that the lines are clean, with no cuts going into the body of the stencil card. Once cutting is completed, you will have two stencils, or templates: an outside one for the overall shape of the beach huts and an inside one for the door and decorative details.

Simple Stencil for the Background

3 Next, lay the edge of a sheet of stencil card horizontally across the middle of the support. With a broad brush mix a large amount of cobalt blue acrylic paint. Apply the blue to the sky, working your brushstrokes away from the stencil card and taking care not to let any paint seep under the edge.

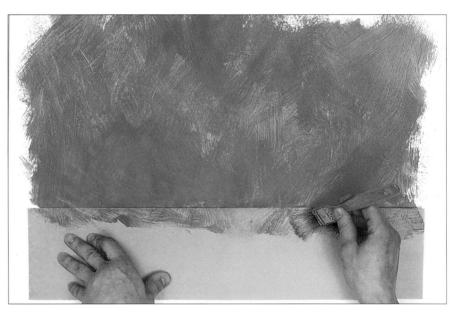

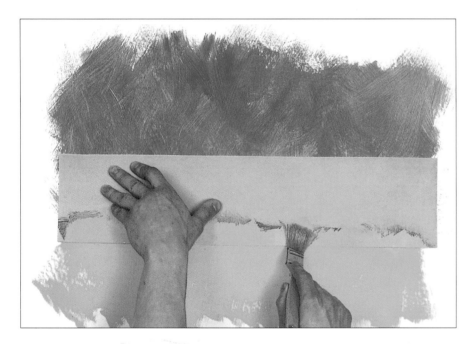

4 Let the paint dry. Then take a dry piece of stencil card and lay it along the horizon. Clean your broad brush and mix a large amount of cadmium yellow. Apply the yellow to the lower half of the picture, again brushing away from the card. You now have two broad areas of bright primary colors—the sky and the sand.

Classnotes...

Stencils can be used to add extra detail to your picture. For example, rather than paint the blinds on the windows, cut strips in a sheet of waxed stencil card and brush on the pattern. Using a felt-tip pen, make a series of strips about 0.2 in. (5 mm) thick and all the same length. Draw the lines of the strips freehand to add a little spontaneity to the composition. Then cut out the stencil (right). Stencil the blinds onto each hut after the windows have been colored and allowed to dry. There's no reason to stop there: You could try making stencils for sea birds, deck chairs, shells or other beach-related objects.

Preparing the Beach-Hut Shapes

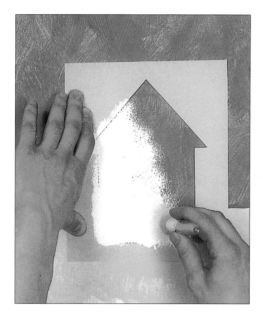

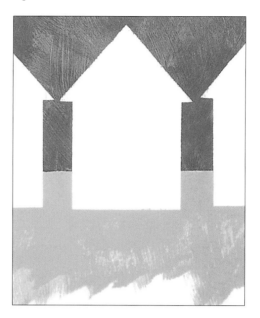

5 Place the hut template in the middle of the picture with the hut's base line a little into the sand. Holding the card firmly, start applying titanium white over the inside with a stencil brush.

6 Stipple the white over the entire hut shape, making sure paint doesn't seep under the card. Repeat two or three times to ensure an even coverage. Then add the adjacent hut shapes in exactly the same way.

Adding Decorative Details

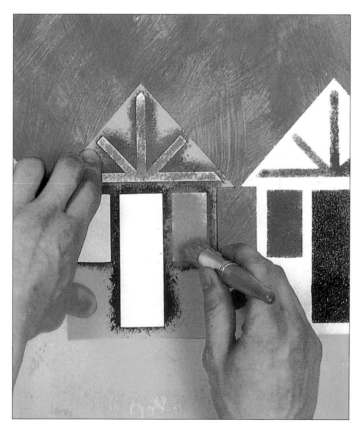

7 Once the paint is dry, start adding individual details to the three beach huts. Lay the inside stencil carefully over the hut on the right. Make sure that the stencil is perfectly aligned within the white shape of the hut. Then use the stencil brush to apply black to the door. Acrylic paint is quite thick, so make sure you remove any excess blobs from your brush by dabbing the end on a piece of rough paper before you begin to apply the color.

Clean the brush in water between colors and take care not to let any paint seep under the stencil card onto the white. Now remove the stencil gently and let the paint dry. (You can shorten the wait by applying a quick blast with a hair dryer.) When the paint is dry, replace the stencil and add some red for the gables. Let that color dry. Finally, mix up a little purple (from blue and red) and apply to the windows. Then move on to the central beach hut.

The broken-color effect is achieved by not recharging the brush.

Fairly thick paint, applied with broad brushstrokes, creates interesting patterns in the sky.

Stippling on the paint here with short, stabbing strokes helps to create textural variation.

Contrasting slats are stenciled over the windows but can also be painted freehand with a small brush to add spontaneity to the composition.

8 Different colors are used for each hut. I chose green gables, a light blue door and orange for the shutters of the central hut, then changed the colors again for the third hut. Finally, I added bold stripes with a new stencil to create the shutters' slats.

THE PROJECTS

Learn from the Master: John Lancaster

Sacred Interiors, Series No.2

Thıs paınting by Brıtısh artıst John Lancaster seems almost architectural in style and structure. Lancaster is inspired by the Moorish arches of the Alhambra Palace in Granada, Spain, and the way in which its marble screens both reveal and conceal what lies beyond. Working on a large-scale canvas, he re-creates the palace's intricate geometric patterns using elaborately cut stencils that achieve near-perfect repetition of shape and design. Lancaster builds up the image in layers, starting with the repeated

keyhole-shaped arches and their mirror images in the water below, through which he sprays either yellow or blue acrylic paint. To the right stands a larger arch of the same shape, again with its mirror image, and smaller shapes fill the intervening spaces. To re-create the screen effect, Lancaster then sprays over the flat shapes with a series of dotted and lined stencils using different tones of blue and yellow. This ensures that no two arches look the same (detail, above) and plays against the symmetry of the shapes to give the composition a haunting, meditative quality.

Try It for Yourself

With a single stencil, based on the arabesque arches created by John Lancaster in his intricate painting, you can obtain a glowing effect. Cut a bar, with an "onion shape" on either end, into stencil card. Lay the template vertically on paper and stipple red acrylic into the cutout, leaving unpainted areas near the center. Turn the stencil 90 degrees and stipple yellow acrylic in the shape. Next, turn the stencil 45 degrees and stipple in blue and then another 90 degrees to add green.

Glossary

Absorbency
The degree to which a paper absorbs paint or water. Absorbency is governed by the amount of "size" built into the paper. Waterleaf paper contains no size and is highly absorbent. Papers with very little size are referred to as "soft." A paper's absorbency has a major effect on the way a medium behaves on it, especially in watercolor painting: A highly absorbent paper will soak up brushstrokes immediately, while a well-sized one allows more time for manipulation.

Acid-free paper
Paper with a neutral pH. An acidic paper, such as one made from untreated wood pulp, will yellow as the acid breaks down the fibers. Chemically treated wood pulp papers are generally neutral. Artist's rag papers, made from cotton fibers, have a much higher standard of purity. Acid-free paper is recommended for any drawing that you wish to preserve in good condition. See also *Artist's quality paper*.

Acrylic
Synthetic resin used as the binder for acrylic colors.

Acrylic paints
Paints bound by an acrylic resin. They are water-soluble, but—unlike watercolor and gouache—they dry as an insoluble plastic film more akin to oil paint. Acrylics are ideal for creating surface texture in a painting because they can be worked in a thick impasto or given added texture. Manufacturers have developed additives to alter the texture of the paint, and to increase drying times to allow a controlled blending of colors. See also *impasto*.

Adjacent colors
Colors close to each other on the color wheel; also used to describe colors that lie next to each other in a painting.

Advancing color
Effect where colors toward the warm (red) end of the spectrum appear to move toward the viewer. Compare *Receding color*.

Aerial perspective
See *Atmospheric perspective*.

Afterimage
The phenomenon of staring intently at a strong color and then looking away and seeing a "ghost" image in its complementary. Also called "color irradiation."

Alla prima
From the Italian for "at first;" a term for the creation of an oil painting in a single session while the colors remain wet. Also called "direct painting."

Anamorphosis
The distortion of an image by transferring it from a regular rectangular grid to a stretched perspective grid, so that when it is seen from an oblique angle, it reverts to its original appearance.

Art board
Artist's quality paper mounted on card. Its stiffness reduces the risk of pigment loss caused by flexing.

Artificial perspective
See *Linear perspective*.

Artist's quality paints
Premium-quality paints with a high pigment strength and content.

Artist's quality paper
Paper with a neutral pH balance and a high rag content which, unlike wood pulp paper, does not yellow or become brittle with age. See also *Acid-free paper*.

Ascending vanishing point
Point above the horizon line at which two or more parallel lines in the same plane and receding away from the viewer appear to converge—for example, on a pitched roof.

Atmospheric perspective
Effect of the Earth's atmosphere on the way we perceive tones and colors as they recede towards the horizon. Tones lighten and decrease in contrast; colors drift to the cool (blue) end of the spectrum. Also known as "aerial perspective."

Axonometric projection
A system where a plane is set up at a fixed angle to the horizontal, such as 45 degrees, and verticals are drawn true to scale to show the sides of the object.

Binder
A substance that holds particles of pigment together and enables them to adhere to the support. In oils, the binder is usually linseed oil; in acrylics, the binder is synthetic acrylic resin; in watercolors, the binder is water-soluble gum.

Bleeding
The tendency of some organic pigments to migrate through a covering layer of paint.

Blending
Creating a gradual transition from one color or tone to another. This can be done with physical or optical mixing of pigments, or with shading techniques such as cross-hatching. In oil painting, the term often describes the softening of hard outlines against their background.

Block printing
A technique of relief printing that involves carving or cutting a design into a block of wood, linoleum, root vegetable or other material. The surface of the block is inked and a sheet of paper pressed onto it. When the paper is pulled off, the cutaway areas appear as negative white lines or shapes in the printed image.

Blocking in
See *Laying in*.

Bloom
The characteristic powdery "shine" of surfaces painted in soft pastel.

Bodycolor
See *Gouache*.

Bracelet shading
A form of shading in which semicircular lines are repeatedly drawn close to one another.

Bristle brushes
Brushes with coarse hairs that hold plenty of thick paint, yet retain their shape. Used extensively in oil painting for covering large areas with a uniform tone and for blending. Also called "hog hair brushes."

Broken color
An application of color that allows the underlying color to show through in an irregular pattern. Often achieved using dry brush or scumbling techniques.

Burnisher
A polished stone used to smooth down paper fibers.

Canvas
Fabric used as a support for painting. There are two main types of canvas: artist's linen (made from flax) and cotton duck. You can purchase pre-primed canvases or prepare your own. See also *Support*.

Carborundum pastel board
A board coated in powdered carborundum which creates an exceptional degree of tooth that can hold a thick application of pastel.

Center line of vision
See *Line of vision*.

Center of vision
Point at which the line of vision intersects the horizon line. In one-point perspective, it forms the one and only vanishing point.

Chalk, precipitated
A very fine chalk used in the manufacture of pastels to create paler colors, or tints, of the original pigment.

Chalk pastels
See *Soft pastels*.

Charcoal
Traditional, natural drawing material consisting of sticks or lumps of carbonized wood. Compressed charcoal is a commercial product made from a mixture of black pigment and a binder.

Charcoal pencil
A harder form of charcoal. Can be sharpened to a fine point for precise work.

Chroma
See *Saturation*.

Chromatic
Drawn or painted in a range of colors.

Cold-pressed paper
See *NOT paper*.

Collage
An art form in which an image is built up out of pieces of cloth, paper, photographs, card, or other materials pasted onto a board or similar support.

Collagraph print
A print taken by pressing a sheet of paper onto the inked surface of a low-relief surface constructed in the same way as a collage.

Color irradiation
See *Afterimage*.

Color wheel
A method of depicting natural and artificial spectrums as circles to show the relationships between colors.

Colored charcoal pencils
See *Pastel pencils*.

Colored ground
See *Toned ground*.

Colored pencils
Wax-based crayons in a pencil format, available in a wide selection of colors.

Complementary colors
Colors of maximum contrast that oppose each other on a color wheel. The complementary of a primary color is the combination of the other two primaries; for example, the complementary of blue is orange (red plus yellow).

Cone of vision
A cone of up to 60 degrees, within which a subject can be comfortably represented without perceived distortion.

Conté crayons
Chalk-based, square crayons, halfway between soft and hard pastels in texture. Sold in a range of up to 80 colors. Popular for figure drawing because they hold their shape well and give a rich, strong color.

Contour shading
A form of shading in which curved parallel lines are used to show the rounded forms of the human body. Contour shading echoes the natural curves of the human figure and is useful for defining musculature.

Convergence
The apparent coming together of parallel lines that recede from the viewer toward a fixed point.

Cool colors
Colors toward the blue end of the spectrum.

Cross-hatching
Parallel marks overlaid roughly at right angles to another set of parallel marks. This process can be repeated until the desired depth of tone is achieved.

Curvilinear perspective
Perspective in which straight lines appear curved. Often applied to images seen from close-up or with an abnormally wide angle of vision.

Dammar
A resin, soluble in turpentine, that is used to make gloss varnish.

Darks
Dark tones; the parts of a painting that are in shadow.

Descending vanishing point
A point below the horizon line to which two or more parallel lines in the same plane and receding away from the viewer appear to converge—such as a street sloping downhill.

Diagonal vanishing point
The vanishing point for lines receding at 45 degrees from the picture plane.

Diffuser
See *Spray diffuser*.

Dip pen
A pen that does not have a built-in ink source; must be repeatedly dipped into ink.

Direct painting
See Alla prima.

Distance point
A point on the horizon line from which a line is drawn to establish the intersection points of transversals with orthogonals. In one-point perspective, it corresponds to a diagonal vanishing point.

Dragged brushstrokes
Brushstrokes made across the textured surface of canvas or paint, or at a shallow angle into wet paint.

Drawing chalk
Chalk that is similar in texture and appearance to pastels; leaves a finer deposit than crayons. White chalk is only effective on toned paper or over another color.

Drawing grid
A grid made for transferring a sketch proportionately onto a large-scale support.

Dry brush
A method of painting in which paint of a stiff consistency is stroked or rubbed across the canvas. The paint is picked up by the ridges of the canvas, leaving the underlying color still visible to produce a broken color effect.

Dry wash
A technique of working pastel powder into the support to create even areas of color. Soft pastels are pared with a knife or crushed to create a powder, which is then spread with fingertips or a brush.

Easel
A frame for holding a drawing while the artist works on it. Artists working outdoors tend to use easels of light construction. A good sketching easel allows the drawing to be held securely in any position.

Elevation
A two-dimensional scale drawing of the side of a building.

Ellipse
A regular oval shape formed when a circle is put into perspective.

Extender
An additive such as chalk or china clay added to paint pigment, usually to make it last longer and thereby reduce cost. May also be used to prevent strong pigments from streaking.

Eye-level
The plane of vision from the viewer to the horizon, i.e. the horizon line.

Fat-over-lean
The rule for oil painting in layers, in which each layer of paint contains a little more oil than the one beneath it. This ensures that when dry, each layer is more flexible than the one below, reducing the risk of cracking.

Feathering
Laying roughly parallel marks, often over a previous area of color, to modify the strength of color or tone.

Ferrule
The metal part of a brush that surrounds and retains the hairs.

Finder
A cardboard viewer in which the shape of the paper or canvas is cut out to scale. The viewer is held up at arm's length by the artist, who views the scene through it in order to establish what will be drawn or painted and roughly where it will be on the canvas.

Fixative
A resin dissolved in solvent that is sprayed onto a charcoal or pastel work to fix the particles of the medium to the surface. Fixative is also used between layers of color to stop the previous layer of color from blending with the next one. Fixative should be used sparingly because a heavy application will cause the colors to darken. You should also avoid inhaling fixative—it is harmful.

Flat color
An area of color of uniform tone and hue.

Flat wash
A wash of uniform tone and color.

Flocked paper
A pastel board or paper sprayed with a fine coating of cloth fibers to grip the pigment.

Focal point
The main area of visual interest in a painting.

Foreshortening
An effect of perspective in which uniformly spaced, parallel horizontal lines appear to get closer together as they recede into the distance. It also causes the part of an object closest to the viewer to appear proportionately larger than the rest of the object. The degree of foreshortening depends on the angle at which you view the scene.

Form
The shape of a three-dimensional object, usually represented by line or tone in a two-dimensional drawing.

Frottage
A technique of taking a rubbing from a textured surface. A sheet of thin paper is placed onto the surface, and the side or blunt end of a stick of charcoal, crayon or other medium is rubbed over the paper, depositing pigment over the raised areas of the surface.

Fugitive
Colors that are not lightfast and will fade over a period of time.

Gesso
Plaster of Paris or chalk mixed with glue, traditionally used as a ground for oil painting on panels. Acrylic gesso contains different ingredients and is most appropriate as a ground for acrylics.

Glassine
A paper with a smooth, shiny surface, used to protect a pastel work from smudging.

Glaze
A film of transparent or translucent paint laid over another dried layer or underpainting. The paint is usually mixed with medium to make it more workable.

Glycerin
The syrupy ingredient of watercolor paints used to keep them moist.

Gouache
Opaque watercolor paint. Also known as "bodycolor."

Gouache resist
Application of gouache paint to protect areas of paper or paint film from additional applications of watercolor. The gouache is subsequently washed off.

Graded wash
A wash in which the tones move smoothly from dark to light or from light to dark.

Granulation
The mottled effect made by coarse pigments as they settle into the hollows of a textured paper.

Graphite pencil
A more accurate name for the "lead" pencil. Standard pencils are made from a mixture of graphite and clay encased in wood. The proportion of graphite to clay varies, and it is this proportion that determines the hardness or softness of the pencil. Graphite has a silvery sheen if used densely.

Graphite stick
A thick graphite pencil, used for large-scale work. Graphite sticks are usually fixed in a graphite holder rather than encased in wood.

Grid system
A method of superimposing a grid over an image or view, and then copying the image square by square into a corresponding grid on the support.

Ground
Surface coating of the support on which the paint is applied. A colored ground is often used in low-key paintings, where it provides the halftones and unifies the other colors. A colored ground can also be applied as an imprimatura. See also *Toned ground, Support*.

Ground line
The bottom edge of the picture plane, where it cuts the ground plane. Parallel to the horizon line.

Ground plane
Level at which the viewer is imagined to be standing in order to view a scene. Stretches to the horizon.

Gum arabic
Gum from the acacia tree, used as a binding material in watercolor paints.

Gum arabic resist
A gum arabic solution used to protect the paper or paint film from more applications of paint. The gum arabic is subsequently washed off.

Gum solution
A dilution of gum in water, used as a binder to hold the pastel pigment in stick form.

Gum tragacanth
The gum used as a binder for soft pastel.

Halftones
Transitional tones between highlights and darks.

Hard pastel
A pastel with a high gum content that produces a hard texture suitable to preliminary drawing and detailed work. Hard pastels can be sharpened to a fine point and come in up to 80 colors.

Hard watercolors
Blocks of straight pigment-and-gum mixes with no added humectant.

Hatching
In drawing, making tonal gradations by shading with parallel marks. In painting, making tonal gradations by shading with long, thin brushstrokes; often used in underpainting.

Heel
The base of the hairs of a brush.

Height line
Vertical line on the picture plane with heights marked to scale of objects that are behind or in front of it. Also known as "measure line."

High-key color
Brilliant and saturated color. High-key paintings are usually painted on white or near-white grounds.

Highlight
The lightest tone in a drawing or painting; usually white or near-white. In oil painting techniques, white constitutes the lightest tone. In transparent watercolor techniques on white paper, highlights are represented by the white of the paper; in opaque watercolor techniques, highlights are represented with opaque white gouache.

Horizon line
The location of all horizontal vanishing points. It is the line at which land and sky appear to meet and is always at eye-level.

Hot-Pressed paper
Paper with a very smooth surface; the smoothest of the three main surface types for artist's-quality paper. Also called "HP."

Hue
The basic name or description of an object's color, such as red, yellow, or blue. The term does not describe how light or dark the color is (see *Value*) or how saturated or intense it is (see *Saturation*).

Humectant
A moisture-absorbing additive, such as glycerin, which keeps watercolor paints moist.

Impasto
A thick layer of paint, often applied with a palette knife or bristle brush, that creates a heavily textured look. Also refers to a dense application of pastel.

Imprimatura
A thin overall film of translucent color that is applied over a white primer before painting. This film does not affect the reflective qualities of the ground, but provides a useful background color and makes it easier to paint between the lights and the darks.

Ink
Colored liquid used for writing and drawing. The main types are water-based and shellac-based. Shellac inks are waterproof when dry and are suitable for overpainting.

Isometric projection
A form of axonometric projection that denies the apparent convergence of receding lines. Height lines are true and to scale. The angle of receding lines relates to the angles at which the planes of the cube meet.

Laminating
A process of gluing thin sheets of tissue paper over each other between layers of glue; the glue transforms the tissue paper into transparent sheets of color. An extension of Collage.

Laying in
Initial painting stage in which broad areas of flat color are applied over a preliminary drawing. Also known as "blocking in."

Lead pencil
See *Graphite pencil*.

Lifting out
Modifying a color or creating highlights by removing paint with a wet brush, or a sponge or kitchen paper. Also called "lifting off."

Lightfastness
The permanence or durability of a color; its resistance to fading.

Line drawing
A drawing technique in which the subject is defined through the use of outline rather than with tonal shading.

Line of vision
Imaginary line from the viewer to the horizon, bisecting the angle of the cone of vision and at 90 degrees to the picture plane. It intersects the horizon line on the picture plane at the centre of vision. Also called "center line of vision." See diagram at *Picture plane*.

Linear perspective
System of representing three-dimensional space on a two-dimensional surface by recording the intersection on the picture plane of rays of light from the scene as they converge on the viewer. Also known as "artificial perspective."

Linseed oil
An oil derived from the seeds of the flax plant and used as a binder for oil paint. The oil does not dry by evaporation, but forms a solid film.

Loomstate canvas
A canvas which has not been "finished."

Low-key color
Subdued, unsaturated color that tends toward brown and gray.

Mahl stick
A pole about 4 ft. (1.25 m) long with a ball-shaped end that is used to support the painting arm when working on a very large canvas.

Masking fluid
A peel-off rubber solution that can be applied with a brush or dip pen to mask out areas of an artwork before applying a wash. Available in white or pale yellow (for use on white paper).

Masking out
A technique for leaving areas of paper unpainted when applying washes by first covering them with paper or masking fluid.

Masking tape
Pressure-sensitive tape used to protect areas of paint.

Measure line
See *Height line*.

Medium
A substance that alters the consistency of paint, such as for glazing. In oil painting, a typical medium is made up of 50 percent boiled linseed oil and 50 percent turpentine.

Metamerism
Where two color matches can appear to differ under different illumination. This is actually caused by the varying compositions of each color.

Modeling
Describing the form of a solid object using solid shading or linear marks.

Monochromatic
Made with a single color. A monochromatic drawing can still show a full range of tones.

Monoprint
A technique that results in a single print.

Mortar and pestle
A bowl and grinding tool used to reduce pastel sticks to a powder for dry wash techniques and for reconstituting pastel fragments into new pastels.

Muller
A glass grinding tool used to grind and mix pigments on a glass slab.

Negative shape (space)
The shape created between objects or parts of objects. If a figure is standing with one hand on his or her hip, the triangular space between the arm and the body forms a negative shape.

NOT paper
As in not hot-pressed paper, it is paper with a medium or fine grained surface, midway between HP (smooth) and rough. Also known as "cold-pressed paper."

Oblique projection
In oblique projection, an elevation is drawn and receding lines are added all at the same angle, for example 45 degrees to the horizontal. The length of these receding lines is reduced by the same ratio of the 90 degree angle to the angle of the elevation that the receding line represents.

Oil paint
Paint bound by poppy or linseed oil. The most popular medium for easel painting because of its ease of manipulation and saturated colors. With the addition of resin such as dammar varnish or gel medium, it is possible to create glazes or washes.

Oil paper
Textured paper coated with an oil-resistant primer; used for oil pastel work.

Oil pastel
Pastel bound by oil as opposed to gum. The oil gives this type of pastel a slight transparency and a strong adherence to the support. It comes in a less extensive range of colors than soft pastels.

Oil sticks
Oil paint blended with waxes to form sticks and applied directly to the canvas. Colors are modified with the fingers or a piece of cloth. Oil sticks are extremely creamy in texture and are good for working wet-in-wet.

One-point perspective
Simplest form of linear perspective in which all parallel lines at 90 degrees to the picture plane and parallel with the ground plane appear to converge at the same vanishing point on the horizon.

Opaque painting
A painting technique that relies on the opacity of the paints used.

Optical mixing
Color mixing by laying one color over, or next to, another, rather than mixing the colors in a palette.

Orthogonals
Lines that recede at right angles from the picture plane to a vanishing point on the horizon.

Orthographic projection
The standard method of showing a plan and elevation.

Overlaying washes
Laying one wash over another in order to build up intensity of color or tone.

Pastel pencils
Pencils similar to soft pastels but harder and encased in wood. Suitable for drawing and detailed work. Also known as "colored charcoal pencils."

Physical mixing
Creating colors by mixing them on the palette or, wet-in-wet and wet-on-dry, on support.

Picture plane
Plane on which the image of a scene lies. Optically, the point at which rays of light from the scene meet in the viewer's eye. Normally at 90 degrees to the ground plane but this angle changes if you look up at, or down on, a scene.

Pigment
Solid-colored material in the form of discrete particles that form the basic component of all types of paint; color in its raw state.

Plan
A two-dimensional scale drawing of a horizontal section of an object, such as a building.

Plein air
Painting in the open air, generally using *alla prima* techniques.

Preservative
A substance such as fungicide or bactericide added to painting materials to protect them from microbial growth.

Primary colors
The three colors—red, blue, and yellow—that cannot be produced by mixing other colors.

Primer
Preliminary coating, usually made from a white pigment and extender in a binding medium, to prepare a support for painting. Stops the support from being damaged by the paint and provides a surface with the right key, absorbency level and color.

Projection
In linear perspective, carrying lines from the station point to points on the plan and thereafter to the picture plane where the points of intersection are marked.

Proportion
Specifically related to figure drawing, referring to the establishment of an accurate relationship between the parts of the body and the body as a whole.

Putty eraser
Erasers suitable for removing a range of dry drawing media such as pencil, charcoal, chalk, and pastel. The medium's particles adhere to the putty and are lifted from the fibers of the paper when it is pressed against the surface of the drawing. Putty erasers can be kneaded into a fine point for detailed work, where you can effectively use it as a highlighting drawing tool.

PVA
Polyvinyl acetate; a glue medium used for gluing paper and binding pigments to the surface of the paper.

Quill
A bird's feather that has been made into a pen.

Rag paper
Artist's quality paper made from cotton fibers to a high standard of purity.

Receding color
Effect where colors toward the cool (blue) end of the spectrum appear to move away from the viewer.

Resist
A method of preventing paint from coming into contact with the paper, or other paint layers, by interposing a paint-resistant coating such as wax or gum. Often used to preserve highlights, or for specific textural effects.

Retarder
An additive for acrylic paint used to delay the drying process. (If overused, the quality of the color may be impaired.)

Rollerball
A pen that has a small moving plastic, metal, or nylon ball as its writing point.

Rough paper
The most heavily textured of the three main surface types of artist's paper.

Sgraffito
A technique in which dried paint or pastel is scratched or scraped off to reveal the color below. Often used for textural effects.

Sable
Mink tail hair used to make fine watercolor brushes.

Sanguine
A red chalk used in its natural form by sharpening a piece to a point and fixing it in a holder.

Saturation
The intensity of a color. Saturated colors are vivid and intense; unsaturated colors are dull and muted. Also known as "chroma."

Scratching out
A technique similar to Sgraffito, in which wet or dry paint is scratched to reveal the paint or paper beneath.

Scumbling
A painting technique in which semiopaque or thin opaque colors are loosely brushed over an underpainted area so that patches of the underlying color show through.

Secondary colors
Colors that contain a mixture of two primaries.

Section
A scale drawing showing a two-dimensional slice through an object, such as a building, in the vertical or horizontal plane.

Semirough paper
See NOT paper.

Shade
Color mixed with black.

Shading
Usually refers to the way areas of shadow are represented in a drawing and is invariably linked with tone.

Sight size
The measurement of the size of a distant object as you see it, which is then transferred exactly to the paper.

Size
The surface coating, built-in or brushed on, of paper. Ready-made size generally contains a mixture of gelatine, water, and preservative. Sizing affects the hardness and absorbency of the paper, which in turn affects how the paint behaves. In oil painting, a coating of glue used to protect canvas from the potentially damaging effects of oil paint before priming and to seal or reduce the absorbency of wooden panels. Also the binding material for gesso.

Smooth paper
See HP paper.

Soft-hair brushes
Brushes with soft, flexible bristles of sable or synthetic material. Mainly used for watercolors, but also suitable for precise brushwork in oil painting.

Soft pastel
The most common and traditional form of pastel, manufactured in the widest range of colors and tints. Made with a weak gum solution to give a soft texture suitable for painting techniques. Also known as "chalk pastels."

Sparkle
The effect of an irregular, broken application of pastel on a support that contrasts with the tone or hue of the applied pastel.

Spattering
Flicking paint off the hairs of a bristle brush or a toothbrush to create irregular patterns.

Spectrum
The band of frequencies at which light is visible, running from low (red) through to high (blue).

Sponging out
Soaking up paint with a sponge or paper towel so that areas of pigment are lightened or removed from the paper. Can be used to correct mistakes or to create particular effects. See Lifting out.

Spray diffuser
A tool for spraying either a liquid pigment or fixative in atomized droplets onto the surface of a support. Operated by blowing through a plastic mouthpiece. The density of the spray varies according to the pressure of your breath and the distance of the diffuser from the support.

Squaring up
A grid system used to transfer a sketch or other image accurately to the painting surface.

Staining power
The degree to which a pigment stains the paper and resists being washed off or scrubbed out.

Station point
Point on the ground plane from which a subject is viewed.

Stenciling
The application of designs, shapes or characters to a surface using a plastic, metal or card sheet in which the image has been cut out. Ink or paint is applied to the surface through the cutout areas.

Stippling
A method of painting or drawing that involves the application of tiny spots of color to create an area of tone, for example by stabbing and dotting with the tip of a brush or pastel.

Stretcher
The wooden frame on which a canvas is supported.

Stretching
In watercolor and acrylic painting, preparing lighter weights of paper so that they will not buckle when wet. Normally done by taping the paper to a flat surface with masking tape, coating it with water and leaving it to dry.

Stump
See Torchon.

Subdivision
Method of putting images into perspective by subdividing them into simple shapes, then putting the outlines of these shapes into perspective.

Support
Material on which a painting or drawing is made, such as paper, pastel board or, canvas.

Surface
The texture of the paper. The three standard grades of surface are HP (hot-pressed), NOT (cold-pressed), and Rough.

Surface sizing
Decreasing the absorbency of a paper by sizing.

Technical pen
A pen with a hard, inflexible tip, designed to give a consistent width of line regardless of the pressure placed on it.

Tertiary colors
Colors that contain a mixture of all three primaries.

Three-point perspective
System in which the subject is angled vertically, as well as horizontally, to the picture plane; requires an extra vanishing point for the third (vertical) plane.

Tint
Color mixed with white. Soft pastels have as many as eight tints of any one color depending on the amount of white chalk added to the original pigment. In the case of watercolor, a similar effect is achieved by thinning the paint with water and allowing more of the white surface of the paper to reflect through it.

Tinting strength
The strength of a particular color or pigment.

Toe
The tip of the hairs on a brush.

Tonal key
The degree of light that dominates a subject. For example, a very bright subject such as a beach in full sunlight would have a high tonal key.

Tonal value
The extent to which a color reflects light.

Tone
Degree of darkness or lightness of a color.

Toned ground
An opaque layer of colored paint of uniform tone applied over the priming before starting the painting. Also known as "colored ground."

Tooth
The grain of the paper that holds the pigment. The coarser the texture of the paper, the more the more medium is retained by the paper surface.

Torchon
A pencil-shaped tool made of tightly rolled paper and used to soften or blend tones during drawing. Also known as "tortillon."

Tortillon
See *Torchon*.

Transparent painting
A painting technique that relies on the transparency of the paints used.

Transversals
Receding horizontal lines parallel to the picture plane.

Turpentine
Distilled spirit used to thin oil color and to make resin varnishes. White spirit is a less-expensive substitute.

Two-point perspective
Perspective in which an object or scene has its vertical edges parallel to the picture plane, but its horizontal sides set at an angle. Needs two vanishing points, both of which will be on the horizon line.

Underpainting
Preliminary painting, often in flat color, that gives the final painting more reflectivity or density.

Unsaturated color
A pure, saturated color becomes unsaturated when mixed with another color into a tint (lighter) or shade (darker).

Value
The extent to which a color reflects or transmits light; how light or dark a color is.

Vanishing axis
A vertical axis at right angles to the horizon line. Descending or ascending parallel lines in the same plane have their vanishing points on this axis.

Vanishing line
A line that converges on a vanishing point.

Vanishing point
The point at which any two or more parallel lines that are in the same plane and receding from the viewer appear to converge.

Variegated wash
A wash in which different colors have been applied so that they run into one another.

Varnish
A protective coating that gives a glossy or matte appearance to the surface of a finished painting.

Viewfinder
Two L-shaped pieces of card that form a framing device. This tool is usually held at arm's length and the scene to be drawn is seen through it.

Viewpoint
The point, particularly the height, from which a scene is viewed. Determines the height of the horizon line.

Viscosity
A measure of the flow characteristic of a color or medium. Oil paint with some viscosity is described as having "body."

Warm colors
Colors toward the red end of the spectrum.

Wash
An application of well-diluted paint or ink. Washes of water-soluble colors are made by diluting the colors with water in a mixing dish before application; oil-based washes are diluted with medium. In pastels, a dilution of color created by grinding a pastel to powder and dispersing it across the support, or by using a brush and water, or spirits in the case of oil pastels, to disperse the pastel in the manner of a watercolor wash.

Washing off
Dislodging an area of water-soluble paint, usually with a bristle brush dipped in water or a damp sponge.

Watercolor
Paint made by mixing pigments with a water-soluble binding material such as gum arabic.

Waterleaf
A highly absorbent paper with no built-in size.

Water-soluble pastel
A type of pastel that functions like an oil pastel in a dry state and is then reworked using a brush and water to convert the pastel lines into a wash.

Water-soluble pencils
Pastels similar in consistency and texture to wax crayons. Can be used wet or dry and either drawn straight on to a damp surface, or softened with a wet brush that disperses the pigment.

Wax crayons
Pigment bound into sticks with wax. Their marks are water-resistant and can be combined with watercolor washes to provide interesting texture to a drawing.

Wax encaustic
A painting medium made by mixing powdered pigments into melted beeswax. The advantage of wax is that it does not darken with age in the manner of oil paint. It is more complicated to use because to keep the medium in a liquid state, the pigment is manipulated using heat. An alternative is to thin the melted wax to a malleable paste by adding turpentine. When it sets, this medium is mixed with oil paint.

Wax resist
The process by which wax crayons or slivers of candle are used to protect areas of paper or paint from further applications of paint.

Weight
Watercolor paper is measured in pounds per ream (lb) or grams per square metre (gsm). Watercolor paper comes in a wide range of weights, but standard machine-made papers are 90 lb. (190 gsm), 140 lb. (300 gsm), 260 lb. (356 gsm) and 300 lb. (638 gsm). Heavier papers—260 lb. and over—generally do not need stretching.

Wet-in-wet
Working with wet paint into wet paint directly on the support.

Wet-on-dry
Applying a layer of wet paint onto a dry surface.

Wove paper
Paper that retains the pattern of the wire mold on which it was made, giving it a woven appearance.

Index